21ST-CENTURY HOLLYWOOD

21st-CENTURY HOLLYWOOD

MOVIES IN THE ERA OF TRANSFORMATION

WHEELER WINSTON DIXON
AND GWENDOLYN AUDREY FOSTER

RUTGERS UNIVERSITY PRESS
NEW BRUNSWICK, NEW JERSEY,
AND LONDON

Library of Congress Cataloging-in-Publication Data

Dixon, Wheeler W., 1950–

21st-century Hollywood : movies in the era of transformation / Wheeler Winston Dixon and Gwendolyn Audrey Foster.

p. cm.

Includes bibliographical references and index.

ISBN 978-0-8135-5124-1 (hardcover : alk. paper) — ISBN 978-0-8135-5125-8 (pbk. : alk. paper)

1. Motion pictures—United States—History—21st century. 2. Motion picture industry—Technological innovations.
3. Digital cinematography. 4. Digital media—Influence. I. Foster, Gwendolyn Audrey. II. Title. III. Title: Twenty-first century Hollywood.

PN1993.5.U6D475 2011

791.430973—dc22

2010049935

A British Cataloging-in-Publication record for this book is available from the British Library.

Visit our Web site: http://rutgerspress.rutgers.edu

Manufactured in the United States of America

FOR *Peter Brunette*
——FRIEND, COLLEAGUE, ROSSELLINI FAN

CONTENTS

ACKNOWLEDGMENTS

The authors wish to thank Leslie Mitchner, of Rutgers University Press, for commissioning this project; our colleagues at the University of Nebraska, Lincoln, Department of English, for their unstinting support of our work; Susan Belasco, chair of the Department of English; and David Manderscheid, dean of the College of Arts and Sciences. We also want to thank our many friends in the film community as a whole, especially Rebecca Bell-Metereau, Tom Conley, David Sterritt, Mikita Brottman, Murray Pomerance, Marcia Landy, David Ehrenstein, Judith Mayne, Patrice Petro, Lucy Fischer, Dana Polan, Steven Shaviro, Valerie Orlando, Maria Prammagiore, Paula Massood, Robert Eberwein, Lloyd Michaels, Adrian Danks, Michael Downey, Greg Ostroff, Patricia Cossard, Dennis Coleman, Diane Carson, Brian McFarlane, and many others for their insights and inspiration over the years. Dana Miller, as always, did a superb job with the typing of the manuscript, Dawn Potter offered sound guidance and clear insight as our copyeditor, and Jennifer Holan provided a thorough and detailed index. This book contains sections of two previously published essays by Wheeler Winston Dixon: "Nollywood: The Video Phenomenon in Nigeria by Pierre Barrot," *Senses of Cinema* 53 (January 2010); and "Vanishing Point: The Last Days of Film," *Senses of Cinema* 43 (2007), both reprinted through the kindness of the journal's editor, Rolando Caputo. The book also includes portions of Dixon's paper "Flickering Images: From the Kinetoscope to YouTube," which was presented at the Modern Language Association's national convention, held in Chicago on December 29, 2007. All box-office figures cited throughout the text are from the industry website Box Office Mojo.

21ST-CENTURY HOLLYWOOD

I believe that the cinema is not so much an industry as people would have us believe, and that the fat men with their money, their graphs, and green felt tables are going to fall on their faces.

 —Jean Renoir,
 "Memories," 1938

The bigger the budget, the stupider the movie has to be.

 —Francis Ford Coppola,

 as quoted in Nick Roddick, "Back to Basics," 2010

Little movies by companies such as Magnolia and IFC have been happening for years. Only very few cinema companies will exhibit those movies. Those movies are not significant.

 —John Fithian, president, National Association of
 Theatre Owners,

 as quoted in Brooks Barnes, "A Hollywood Brawl," 2010

CHAPTER ONE

The Digital Century

There can be no doubt that the digitization of the moving image has radically and irrevocably altered the phenomenon that we call the cinema and that the characteristics of this transformation leave open an entirely new field of visual figuration. For those who live and work in the post-filmic era—that is, those who have come to consciousness in the past 20 years—the digital world is an accomplished fact and the dominant medium of visual discourse. Many of our students remark that the liberation of the moving image from the tyranny of the imperfect medium of film is a technical shift that is not only inevitable but also desirable. And this tectonic shift in cinema is only part of the overall digitization of society.

But it is also a tectonic shift in our culture as a whole, something entirely unprecedented in our lifetimes, or even in this century. With the digitization of culture, bookstores and record shops have nearly vanished; it's so much easier to purchase these totemic artifacts online. Virgin Megastores, which used to span the globe and offered one-stop warehouses of books, CDs, and DVDs (everything from hip hop to classical, with all imaginable styles in between), has all but gone out of business. In San Francisco, in March 2009, the last Virgin Megastore prepared to close down operations. As Greg Sandoval noted at the time,

One can hardly find a better symbol of the music industry's crossover from physical CDs to digital downloads than the intersection of San Francisco's Stockton and Market streets. On one corner sits a Virgin Megastore, once an icon of hipness and high-end music tastes. Now it looks more like a schlock discounter. Signs blare from the façade: "Store Closing" and "Up to 40 percent off." Just across Stockton is a stainless-steel storefront uncluttered by text. Only a single Apple logo glows from the metal, and the overall feeling created is of permanence and futuristic technology. Arguably, Apple [and its iTunes online music store] has done more than any other company to advance digital music, which has driven the CD into obsolescence and retailers like Sam Goody, Tower Records, and Virgin Megastores out of business. . . . Evan Adrian Gomez, 23, a Virgin Megastore employee, says he buys much of his music online and understands why consumers are going digital. Still he says, the crossover will mean he will lose his job, along with hundreds of other store employees. "I understand why people buy online," Gomez said. "It's easier and we're a lazy culture. But I'm an artist and I'm going to miss album artwork. It's sad."

And in Manhattan, the last Virgin Megastore closed with "90 percent off" sales on June 15, 2009, in a final act of desperation. Located in Union Square, the store was the last major outlet for commercial CDs in the city. As Ben Sisario reported,

With the music industry stuck in a decade-long crisis, the sight of a record store closing is hardly surprising. But for many shoppers at Union Square on Sunday the loss of a big outlet in one of the most heavily trafficked areas of the city was particularly dispiriting. "Unfortunately the large retail music store is a dinosaur," said Tony Beliech, 39, a former Virgin employee who was lugging around an armful of CDs that he said would cost him no more than $20. "It does matter because it was also a social gathering space, and that's one thing that buying music online lacks." . . . Max Redinger, 14, who was walking his dog, picked up some anime books and Guitar Hero figures. He said he buys most of his music on iTunes but still likes going to record stores and mentioned that a friend had recently introduced him to an independent shop upstate.

"I don't really buy stuff from it," Mr. Redinger said, "but it's a really cool place."

Bookstores are suffering a similar fate, as Kindle readers, promoted by Amazon.com, encourage customers to download new books at a flat rate of $9.99 per title (comparable, in a fashion, to iTunes' 99 cents per song, although these benchmark figures are variable), when a physical print copy of the same book may cost $30 or more. When Amazon tried to hike the $9.99 price for certain bestsellers, it was met with an unexpectedly vitriolic backlash from consumers; Amazon almost immediately capitulated.

Booksellers are going out of business; they can't compete (see Birdie). Indeed, one might persuasively argue that there are really only two large DVD, book, and music stores left in the world: iTunes and Amazon.com. While CDs and DVDs are still popular with older consumers, younger audience members see no need to own a physical copy of a book, a piece of music, or a movie; they're all available, instantly, as downloads. Of course, only a small percentage of titles are *actually* available, which is part of the problem. Older films, unless they are iconic classics, and older books exist on DVDs or in print copies only, if they exist at all; and such sites as Advanced Book Exchange (ABE .com) do a brisk business with those who can't find a favorite volume as a digital download.

In contrast, one can see more easily why iTunes has done away with conventional retail outlets because all but the most obscure titles, covering everything from pop to classical, are available online and downloadable with the click of a mouse. If iTunes doesn't have what you want, there are other sites such as Juno, Track It Down, and Play It Tonight, which offer contemporary pop music eschewed by major distributors. No more CDs, vinyl, books—they're all online, easily downloaded onto your iPod or Kindle, while movies from Netflix, Blockbuster, and Amazon are available as equally instantaneous downloads. Who needs to search through stacks of books and records to find what you want? . . . *if* you know precisely what you want.

For as convenient and user-friendly as instant downloads are, they also have an unintentional (or perhaps intentional) side effect; they

erase the past. They also do away with the ability to browse through a wide selection of music with the assistance of a knowledgeable guide, who has been replaced by Amazon's (and similar sites') suggestion boxes, which are rigidly defined by genre and ignore the possibility of moving beyond a specific set of cultural values. Then, too, what's latest rules; the newest books and CDs are primarily promoted by their parent companies and then jump to the top of the download charts; older titles, perhaps the very texts or melodies that inspired these newer products, are ignored.

Video stores are also a thing of the past, though the Blockbuster chain currently hangs on with a system of instant downloads and physical copies, offering only the latest mainstream films at the expense of all other forms of cinema. Barnes and Noble, the world's most ubiquitous bookstore chain, similarly survives by marketing only the most sensational and/or salable titles; as for other books, DVDs, or CDs, the store can "order it for you," but who's got time to wait for that? Download it, and your search is over. Newspapers, too, are losing audience share; the *New York Times*, perhaps the world's leading newspaper, is drowning in a sea of red ink as it hemorrhages cash and readership in a desperate attempt to remain economically viable.

The model of the traditional reporter is vanishing as well. Anyone with a cell phone or a computer can generate content and "report" on unfolding events, with varying degrees of accuracy and bias; and online sites such as the *Huffington Post* (on the Left) and the *Drudge Report* (on the Right) continue to proliferate and gather new readers. Information is online; it's easily accessible, easier to sell, easier to buy—and so conventional media seems doomed to be, at best, a niche market. As Time Warner Cable CEO Glenn Britt noted in early February 2009, "We are starting to see the beginnings of cord cutting, where people, particularly young people, are saying, 'All I need is broadband. I don't need video.'" As Martin Peers observes,

Straws in the wind in recent weeks suggest that the recession may be accelerating a structural change toward free or low-cost Web video— either television or movies—and away from traditional delivery methods, such as cable TV or DVDs. . . . Walt Disney CEO Robert Iger . . .

had to explain a 64 percent drop in studio operating income in the December quarter caused by lower DVD sales. He said the DVD business may be suffering more than just a cyclical downturn. Increasing consumer choices, including videos available in many different outlets, may have a long-term impact on the DVD business, he said. Indeed, Netflix last week said its "instant-watch" online service, which lets mail-order subscribers stream TV shows or movies, is being used in "ever greater numbers." Major studios generate about 75 percent of their nearly $19 billion in annual U.S. feature-film revenue, post-theater from sources like DVDs and TV sales, estimates Adams Media Research. Cable networks often generate more than half of their revenue from fees paid by cable and satellite operators. Both these pots of money are at risk.

At the same time, Hollywood is chewing up old narrative styles in favor of faster editing, time compression, and a visual palette of increasingly baroque special effects, all designed to keep audiences in a dazzled stupor. Editing has been replaced by frantic pastiche, and the 24-hour news channels have created a voracious demand for new (or recycled) programming, so that when a fading pop icon like Michael Jackson dies, CNN, CNNI, MSNBC, Fox News, and other cable outlets go into overdrive, exploiting Jackson's demise from every possible angle to create instant "programming" comprised of old clips from his career, interviews with fans and family members, as well as "expert" talking heads to dissect the story in excruciatingly minute detail, looping out interminably until a new "news event" comes along, preferably one with a good deal of scandal, rumor, and speculation attached. "Reality" programming, as offered in such series as *I'm a Celebrity; Get Me Out of Here*, as well as game shows (*Deal or No Deal, Million Dollar Password, The Price Is Right*) and seemingly endless blocks of opinion programming from such pundits as Bill O'Reilly, Glenn Beck, Rachel Maddow, Sean Hannity, and others dominate the airwaves.

And yet, no matter how much the world changes, the old myths, stereotypes, and dreams still prevail—escape, wealth, consumption, power, death, and violence, but now packaged for instant access and consumption, bathed in the sheen of digital half-life. For younger viewers, the scratch-free, grain-free, glossily perfect contours of the

digital image hold a pristine allure that the relative roughness of the filmic image lacks. Indeed, as film disappears, many of our students persuasively argue that we are witnessing the next step in what will be a continual evolution of moving image recording, which, in turn, will be followed by newer mediums of image capture now unknown to us. For the more traditional viewer, the filmic medium is a separate and sacrosanct domain, and the coldness of the digital image, stripped of any of the inherent qualities of light, plastics, and colored dyes, betrays a lack of emotion, a disconnect from the real in the classical Bazinian sense.

Indeed, the fragility of the filmic medium has been effectively highlighted in recent years by "To Save and Project: The MoMA International Festival of Film Preservation," organized at New York City's Museum of Modern Art by curator Joshua Siegel with the assistance of Anne Morra and Katie Trainor, which focuses on films that have fallen between the cracks: they're not commercial enough for a DVD release, even a small-scale one, and filmic preservation is their only hope. In the fall of 2010, for example, the series ran Luchino Visconti's *The Leopard* (1963), Volker Schlondorff's new extended cut of his film *The Tin Drum* (1970), Manoel de Oliviera's *Rite of Spring* (1963), Stephen Roberts's classic Pre-Code film *The Story of Temple Drake* (1933), as well as restored films by experimental filmmakers Paul Sharits and Andy Warhol, along with numerous other titles. Whenever possible, original camera material was used to create new prints of these films; and in the case of some of the earlier films, such as *Temple Drake*, even nitrate negatives were used to obtain the best possible result. "The goal of preservation is to get a film back up on the screen," Siegel noted in an interview with Dave Kehr. "Film preservation is a Sisyphean task. . . . [A]t its heart this is a festival of photochemical or, at least, celluloid preservation. But in 10 years who knows where we will be? It's a never ending story" (Kehr, "Film Riches" C2).

Yet it is important to note that the majority of viewers, including many of the new generation of academics here, take a considerably more casual view of this ongoing problem. Watching Alfred Hitchcock's *The Birds* on DVD, for example, most 21st-century viewers realize that they are watching (optimally) a 35mm negative transferred to digital memory and then downloaded to a DVD for home use, and that the

final image they watch *copies* the filmic nature of the original image but at the same time gives only the *impression* of its original source material. But given this a priori assumption, 21st-century viewers quickly move past this empirical certainty to embrace the newly digitized image as the simulacrum of a 20th-century medium. In short, they have the same images, just a new platform.

Certainly it can be argued that this is an oversimplification of a rather knotty problem; film comes with one set of values inherently present in the stock itself (a tendency toward warmth in color for some film stocks or toward cooler hues in others, as well as characteristics of grain, depth, and definition that are unique to each individual film matrix), while the digital video image offers another entirely different set of characteristics, verging on a hyperreal glossiness that seems to shimmer on the screen.

To achieve a reconsideration of the basic states of representationalism inherent in a comparison of these two mediums is a difficult task, calling into question more than a century of cinematic practice and a host of assumptions shared by practitioners and viewers alike. Insofar as the moving image is concerned, it might well be termed what Friedrich Nietzsche cited in *Ecce Homo* as the reevaluation of all values, or "the old truth coming to an end" (86), opening up a series of questions, claims, and counterclaims that instantaneously obliterate almost all of our preconceptions of the nature of the moving image.

This is hard work, and yet it is work that must be attempted critically and theoretically because, paradoxically, it has already been accomplished as a physical fact; the film image is about to become the sarcophagus of memory, while a new medium of moving image recording takes center stage, for the moment, *its* moment, bringing with it a whole new host of aesthetic and practical issues, such as archiving, distribution, and audience reception. How different is it to view these images primarily in the privacy—or isolation—of one's own home as opposed to the communal nature of traditional filmic projection in an auditorium of strangers? As Paolo Cherchi Usai notes,

I won't shed tears over the death of cinema. This might be its first real chance to be taken seriously. It is estimated that about one and

a half billion viewing hours of moving images were produced in the year 1999, twice the number made just a decade before. If that rate of growth continues, three billion viewing hours of moving images will be made in 2006, and six billion in 2011. By the year 2025 there will be some one hundred billion hours of these images to be seen. In 1895, the ratio was just above forty minutes, and most of it is now preserved. The meaning is clear. One and a half billion hours is already well beyond the capacity of any single human: it translates into more than 171,000 viewing years of moving pictures in a calendar year. (111)

In short, cinema history is so vast that it can never be encompassed, no matter how assiduously one might try, and images are disintegrating or being erased faster than we can possibly archive them. Jean Cocteau was right when he observed in 1943 that "a cinema studio is a factory for making ghosts. The cinema is a ghost language that has to be learned" (131). But such a language, despite having widespread currency, is also a language that is inherently ephemeral, leaving a series of impressions that have more tangible currency than the fragile film stock on which they are fixed. The 21st century has given us a new ghost language with its own rules, ciphers, and grammar.

Such 20th-century fetish films as Peter Delpeut's *Lyrical Nitrate* (1991) and *The Forbidden Quest* (1993) document the evanescent ebbing and fading of the filmic image in its last stages of existence, as its hold on physical existence threatens to expire from moment to moment, finding a tragic beauty in the ineluctable decay of the film image. But the digital image is also given to similar displays of spectacular mortality, dissolving at a moment's notice in a whorl of pixels, image rips, rolling sync bars, and video grain. For contemporary moving image production, the line between film and digital has crossed this boundary as well; in each instance, the image is only temporarily fixed, as mortal as we are ourselves. Geoffrey O'Brien once posited that the act of viewing a film plunges the spectator into a world of endless self-references and permutations, in which one inhabits a world populated by, among other things,

Potemkin, Charlie Chaplin in drag, Filipino horror movies about mad surgeons, animated maps tracking the pincer movements of Rommel's

Panzer divisions, Egyptian soap operas in which insanely jealous hus-
bands weep for what seems like hours at a stretch, made-for-TV stories
about hitchhikers and serial killers, a long row of seventy-minute cav-
alry westerns, Russian science fiction intercut with nude scenes shot on
Long Island, the best of the Bowery Boys, and amateur bondage cassette
filmed on location in a dentist's office in Ronkonkoma, *They Drive by Night,*
All This and Heaven Too, The Barkleys of Broadway, Hindi religious musicals,
Japanese gangster movies, countless adaptations of the works of Wil-
liam Shakespeare, Charles Dickens, and the Brontë sisters, *L'Avventura,*
The Gene Krupa Story, Night of the Blind Dead, Betty Boop cartoons with
color added, touristic documentation of Calcutta and Isfahan, a Bulgar-
ian punk band captured live, and the complete photoplays of Louise
Brooks, Greta Garbo, and Veronica Lake. (24)

For O'Brien, viewing these images accomplishes one thing above all
others; it provides "minimal proof that you [are] not dead" (27). But
these images, now accessible to you primarily through the scan lines
of a flat-screen television, on DVD, or Blu-ray DVD, exist at a dis-
tance, separated from the faces and places that created their phantom
existence. A digital copy is a copy of a copy, transformed into another
medium and yet more concrete than the presence of the original nega-
tive of the film itself, stored in a different vault miles below the sur-
face of the earth, indifferently awaiting revival, retrieval, transfer, or
oblivion.

Gerard Malanga, Andy Warhol's right-hand man during his most
prolific period in the early to mid-1960s, noted of his own cinemato-
graphic work in 1989, long after Warhol's Factory had vanished, that
the most mundane images often held unexpected resonance for him: in
the archival process, "I discovered images I would not have seriously
considered at the time of having made them. But I truly believe photo-
graphs have [an] innate and unique ability to take on new significance
with age" (quoted in Maddow 123).

And yet, as Usai argues, even as he venerates the images that in-
formed the interior landscape of his youth, "nostalgia in any form gives
me the creeps. Brooding over the past bores me to death" (113), a para-
doxical stance to take when he simultaneously admits that "an archive

for moving images will end as a kind of museum—in the sense we currently give that term of an asylum for cultural artifacts" (115–16). As a medium, the cinema, whether digital or filmic, has always thrived on, and actively sought out, agencies of dramatic and transformative change. Paper film gave way to cellulose nitrate and then to safety film; black and white has fallen to color film, silence has given way to multidimensional stereophonic sound, digitally recorded for Dolby playback.

It is true that for some, the use of film seems sacrosanct, an inviolate trust that cannot be broken. In a Kodak advertisement in the professional industry journal *Filmmaker* in the fall of 2008, Samuel Bayer, a respected cinematographer, rants that

> I love film like I love my wife and I'll never cheat on either of them. I had to shoot HD [high-definition digital video]. I didn't like it. It felt alien. Not natural. Not human. People who don't know film talk about HD like it's some kind of secret weapon. But for me the only place digital belongs is in post, where it can help unlock film's potential. Technology is good at making things better. It fails when it tries to replace or synthesize something that's already perfect.

Kodak adds, "Samuel Bayer refuses to compromise. That's why he chooses film. It gives him the power to captivate an audience as well as the technology to push the limits like no other medium can. See why film capture continues to be the standard for making a statement. Film. No compromise."

Certainly, within the industry, Bayer has plenty of partisans. As Bayer sums up the issue, "the fact is, when you shoot HD you hope it looks like film. No one ever shoots film hoping to emulate HD." Yet it seems at each juncture in this evolutionary parade that it is the critics and theoreticians of the medium who are most resistant to change, not the practitioners, as when Rouben Mamoulian's *Becky Sharp* premiered in 3-step Technicolor in 1935 to one critic's comment that "the total impression is one of a brass band in color rather than a well-modulated symphony. . . . As long as color in film has the quality of a gaudy calendar lithograph, there is no future for it, artistically, except in the

embellishment of . . . the animated cartoon," while producer Walter Wanger enthused, "color is just as inevitable as speech. I don't believe that one black-and-white picture will be produced four years hence," and Samuel Goldwyn announced that all his new pictures would be made in Technicolor, predicting that "black and whites soon would be as rare as silent films" (quoted in Jonas and Nissenson 20).

VCRs, along with a host of other factors, eventually killed drive-ins, making it possible to view a film at home with ease and convenience; DVDs wiped the VHS format out of existence a few years after their introduction. In the same fashion, the burgeoning DVD market also killed off second-run theaters as the window between VHS and the theatrical release of a film and its appearance on DVD dwindled into nonexistence. And yet, as the public audience for 20th-century cinema film becomes increasingly specialized and narrowly segmented, to the point that Blockbuster stores no longer even bother with a token classics section—even such reliable standbys as Michael Curtiz's *Casablanca* (1942) are ignored in most of the chain's stores—for those who embrace the past, a wider range of films have become available. Often these DVDs go out of print in a matter of months, so one must purchase them immediately upon their release, as fetish objects that also have a temporal existence of their own, and a thriving bootleg industry exists as well, making copies of all but the most fugitive films available to the private collector.

The digital reinvention of the cinema is every bit as revolutionary as the dawn of cinema itself, and it comes with an entirely new set of rules and expectations. While James Cameron, Michael Bay, and George Lucas may embrace these new tools for more superficial ends (indeed, Lucas recently announced plans to reprocess all the *Star Wars* films into artificial 3-D at an approximate cost of $100,000 per minute, a complete failure of imagination), and the medium will never be any more democratic than it has been historically, newer works continue to pop up on the margins of moving image discourse, created by filmmakers who manifestly do not care if their images are captured on film, digital tape, or a hard drive so long as their phantom vision reaches the screen—the screen of your plasma TV, the screen of your local multiplex, the screen of your cell phone.

Just as a generation in the 1960s celebrated the inherent funkiness of the 16mm image, especially when blown up to 35mm, as being somehow more raw and real than its slicker cinematographic counterpart, the digital generation is comfortable with the roughness of low-end digital video and hails the watermarks of cell phone footage and YouTube downloads as artistic cultural artifacts. In addition, a South Korean company has developed a miniature laser video projector that can fit into mobile phones and digital cameras.

In April 2006, the Iljin Display Company publicly demonstrated various prototypes of a number of mini video projectors built directly into mobile phones. By the end of 2007, they were on the market. Since then, numerous other models of a similar nature have appeared, each one smaller than the last. Using this technology, users can project photos and video images on the wall from the built-in projector, making movies truly portable, downloaded through one's phone and projected at a moment's notice. Who needs to go to the movies anymore when you can carry them with you? This is yet another example of cross-platforming, which demonstrates that the theatrical film experience is being faced with numerous alternative delivery systems (see Jin-seo).

As A. O. Scott and David Denby noted in two separate articles that appeared almost simultaneously in, respectively, the *New York Times* and the *New Yorker*, young viewers today are, in Scott's words, "platform agnostic, perfectly happy to consume moving pictures wherever they pop up—in the living room, on the laptop, in the car, on the cell phone—without assigning priority among the various forms" (B1). While Scott is, in his own words, an "unapologetic adherent" (B1) to standard theatrical presentation as the preferred medium of choice for movie going, his children have opened up for him an entirely new way of seeing films, whether mainstream contemporary films or canonical classics. With a house full of DVDs, Scott's son and daughter mix the past and the present with impunity, cross-platforming between Turner Classic Movies, iPod downloads, DVDs, and trips to revival houses to see older films on the big screen. As Scott noted of the experience of taking his children to see an older film,

"Why is he purple?" my daughter asked in the middle of *West Side Story*, noticing the effects of an aging Technicolor print on Tony's face. In *The Man Who Shot Liberty Valence* the tint would periodically switch from sepia to silver and back again. My son, noting each shift, wanted to know why it was happening: a question about aesthetics that I could only answer with a whispered lecture about chemistry. Most of the old movies he had seen were delivered by means of new technology; this one was old in the physical as well as the cultural sense.

What he made of it I don't know. (He was amused that Lee Marvin, as the titular villain, calls Jimmy Stewart's character "dude.") But he watched with an unusual intentness, the same quality of attention he brought to *Monty Python and the Holy Grail*, *Oliver!* and *Samurai Rebellion*, some of the other stops on our haphazard tour of movie history. I'm convinced that these films' beguiling strangeness was magnified by the experience of seeing them away from home and its distractions, with the whir of the projector faintly audible in the background and motes of dust suspended in the path from projector to screen. (B22)

And yet Scott's son would never have had this experience if his father hadn't bothered to take him to the cinema; even as an older teen, he probably would be more likely to seek out the latest *Indiana Jones* sequel over a 1962 black-and-white film by John Ford. For the generation of students who now are involved in cinema as a critical and/or active pursuit, the digitization of the cinema is an accomplished fact. Some younger artists seemingly side with Scott in his preference for conventional filmic projection, a museum format if ever there was one. As Melissa Gronlund comments on some of these new image makers,

Hollywood pictures, newsreels and documentaries, film stock, cameras and projectors and the auditorium space itself have become the focal point for several artists' works—particularly since celluloid has come under threat from digital technology. The collaborative A1 and A1 are using their residency at FACT in Liverpool to transform a defunct train station into a blue screen studio. In *Kodak* (2006) Tacita Dean filmed the last standard 16-millimeter film factory in France on the final five rolls

of stock the factory produced. At Cerith Wyn Evans' show at London's ICA in 2005 a bulky 35-[mm] film projector screened a blank film, tracking the deterioration of the celluloid to create a changing abstraction of scratches and tears. (29)

Such an act memorializes the past of cinema, even as the industry itself rushes to become a part of the new digital domain. Barry Meyer, the chairman and CEO of Warner Brothers, sums up the current situation in two sentences: "digital distribution is easy, ubiquitous, and inexpensive. We have to adapt, or we'll become dinosaurs" (Denby 56). John Fithian, president of the National Association of Theatre Owners (NATO), is even more direct, noting that "we're competing with the high-tech entertainment crowd, and we're using technology in theaters that's a hundred years old. We need to modernize existing theaters, and tear down old ones at the same rate. . . . In ten years, I doubt there will be any more film" (Denby 62).

Critics Nathan Lee, Kent Jones, and Paul Arthur concur, noting that Bryan Singer's *Superman Returns*, Mel Gibson's *Apocalypto*, Robert Altman's *A Prairie Home Companion*, Tony Bill's *Flyboys*, Michael Mann's *Miami Vice*, and Frank Coraci's *Click* (all released in 2006) "have one thing in common: they were all shot in high-def [digital video]. And no one blinked. All the huffing and puffing about the purity of 35mm now feels very 2003. . . . all things considered, [2006] may have been the year when film and video became indistinguishable" (30). It's true that all these films were transferred from digital high-definition video to 35mm for conventional theatrical release, but that's just a holdover from the past. Soon high-definition movies will be projected in theaters worldwide in their original production format, and conventional film production will become, for better or worse, a thing of the past, a museum format.

There is another new development in the area of theatrical moving image exhibition related to our discussion here, which shoots off in new and interesting directions. In Madrid, Spain, theater owners are discovering that conventional films, no matter what their format (digital or film) or genre, are failing to attract all-important younger viewers. Thus, a new theater, Cinegames, has opened in Madrid, offering

theater-screen-sized video gaming for a predominantly male audience. "Forget the pathetic speakers of a PC or television!" exhorts one advertisement for the new facility. "Come feel the sound that puts you at the center of the action!" For a mere 3 euros, or about $4, much cheaper than a conventional movie admission, audience participants engage in spirited group contests of *World of Warcraft* and other popular video games, projected on a giant cinema screen (Carvajal C4).

As described by one observer, the resulting environment is "a hybrid movie theater with all the digital fire and fury of a video game: fog, black light, flashing green lasers, high definition digital projectors, vibrating seats, game pads, and dozens of 17-inch screens attached to individual chairs" (Carvajal C4) to monitor each person's game play, while the combined contest plays out on a huge screen in the front of the auditorium. "We're trying this concept because there are so many theaters in Spain, and admissions are down. We have to offer new products," notes Enrique Martinez, proprietor of Cinegames. "We see the future with multiplexes with five screens, one for the traditional Hollywood spectaculars and the others for screens for video halls and 3-D. That's the next step" (C4). Similar facilities throughout Europe and North America are scheduled to open throughout 2010, and the model seems to be working quite well, although it skews the audience almost entirely to "young men in their late teens and 20s," while "a few . . . female supporters . . . paid 1 Euro each to watch the action" but not to participate (C4).

Whether or not this will become a major new audience model remains to be seen. Big-screen video gaming may go the way of 3-D movies and Cinerama, or it may become a solid niche market appealing to a younger audience. But while the platform of film may vanish, we argue that, for most audiences, the films themselves will remain, and audiences, now adjusted to viewing moving images in a variety of different ways, will still want to see their dreams and desires projected onto a large screen for the visceral thrill of the spectacle as well as the communal aspect inherent in any public performance. *Film* is indeed disappearing, but *movies* are not. If anything, they are more robust than ever and are shot in a multiplicity of formats that boggle the mind; analog video, digital video, conventional film, high-definition video; on cell

phones and pocket-sized, hard-drive, fixed-focus, auto-exposure cameras and a host of other platforms now just emerging from the workshop of image making. The latest development is holographic filmmaking, which has hitherto seemed impractical. As Michelle Bryner notes,

> If you think FaceTime on the new iPhone is cool, you probably can't wait for the age of holo-chat. A new holographic technology being developed at the University of Arizona could eventually let us interact with lifelike images of friends living across the globe. Arizona researchers have made their first demonstration of a holographic display that projects 3-D images from another location in near-real time. The images are static, but they are refreshed every two seconds, creating a strobe-like effect of movement. The researchers hope to improve the new technology over the next few years to bring higher resolution and faster image streaming. . . . Potential applications for this technology straight out of "Star Wars" include 3-D video conferencing, medical and military imaging, and updatable 3-D maps. The real goal, however, is to replace all 2-D screens used in everyday life with the system, said lead study author Pierre-Alexandre Blanche, an assistant research professor in optical sciences. . . . "It's like having a frame instead of a TV in your living room," Blanche [said]. "We are using a new type of polymer called photorefractive that can record, erase and be rewritten many times." To deliver images to the photorefractive polymer, 16 cameras take simultaneous pictures of a real scene every second. These images are combined into a package of data and sent via the Internet to the holographic system. Each package of data is encoded into special lasers, which pattern hogels (holographic pixels) onto the polymer, creating the 3-D image in the other location. These hogels are updated continuously. . . . "It won't come to our living room [by this] Christmas," Blanche said. "But we can have systems ready for hospitals or command-and-control operation rooms in the near future—let's say a couple of years."

In short, holographic movies are, in 2011, where motion pictures were in the 1890s: in their infancy. But within a matter of a decade perhaps, full-blown 3-D holographic movies may well be leading us to a whole array of possibilities, including large-scale arena shows where

life-sized holographic figures live out their phantom existence in front of a live audience.

For those of us who see the cinema as a vast tapestry of films and filmmakers covering more than 100 years of cinema from all over the world, the use of digital technology is a plus because it allows us to access the images of the past with ease and efficiency. For those who know only the cinema of the present, pure Hollywood product for the most part, it nevertheless puts the tools of production into the hands of the rawest enthusiast, anyone capable of shooting a video and downloading it onto YouTube or Current TV. The literally hundreds of thousands of clips now on the web at Google, Yahoo!, and other sites (many of them lifted from existing films and television programs) present an inchoate glut of imagery that resembles a new forest of the imagination. This thicket of conflicting images, both homegrown and borrowed, reminds us of the British filmmaker Anthony Scott's conceptual feature film *The Longest Most Meaningless Movie in the Whole Wide World* (1969), which represented a similar cacophony of images to its viewers more than 40 years ago, entirely prefiguring our current image overload. As described by David Curtis, the film

> consist[ed] . . . of adverts, complete and incomplete sequences from feature films, out-takes, sound-only film, home-movie material and so on. Often a shot or a whole sequence will repeat *ad nauseam*, sometimes whole lengths of film appear upside down and running backwards. . . . By rearranging familiar material into new and often absurd relationships, the viewer's traditional dependence on continuity is rudely interrupted, and in that disturbed state, some kind of re-evaluation of the material shown (either to its advantage or to its detriment) is inevitable. (145)

This same sort of "re-evaluation of the material shown" is now taking place on a much larger scale, larger than nearly anyone could have conceived of even 5 years ago. Film is disappearing, but in its place a new platform has emerged, which can comfortably support all previously existing formats. As with all such previous technological shifts in moving image study and production, a host of new aesthetic and

practical considerations thus sweeps to the fore. Is a digital copy of a film still a film? It is, and it isn't. Is the digital image preferable to the filmic image, or the other way around? The answer is clearly a matter of personal opinion.

The archival concerns raised by the digital shift are many and varied, but as Val Lewton observed in the 1940s of his own work in film, making movies "is like writing on water." Some images will survive; others will not. One can easily argue that the digitization of our visual culture will lead to the further preservation of its filmic source materials rather than the other way around. With a whole new market opening up for these films of the past, the master negatives are being taken out of the vault and digitally transferred for popular conservation, with one especially desirable side effect: newer audiences now know of the film's *existence*. Entombed in 16mm and 35mm frames for projection equipment that is becoming less and less prevalent (especially in the case of 16mm), these films might otherwise never reach a 21st-century audience.

Where, then, is the theatrical feature film headed? For that matter, where is the moving image migrating—into theaters, onto television, or onto the web? Conventional cinema distribution has undergone numerous changes in the past century, going from short films of less than a reel's duration to epic spectacles in color, stereophonic sound, and, in a return to the 1950s, 3-D as the "new" theatrical weapon against the encroachments of home entertainment. We already have a 2-tier system for what can be termed standard theatrical feature films; the big-budget films go into theaters, and the foreign films and lower-budget efforts wind up going straight to DVD. But there's even more to consider; if one looks at the situation carefully, one can see that the entire model of conventional theatrical distribution is rapidly becoming obsolete. The 2008 Writers Guild of America strike is a clear demonstration of this. What the writers in that strike were fighting for was a share of the digital revenue from both their feature films and television shows: movies or TV programs that would ultimately wind up on someone's cell phone or as a streaming video on the web. As one media critic notes, many writers feel that "traditional [television] reruns [of movies and TV programming]—which have paid them residuals amount-

ing to tens of thousands of dollars . . . in the past—will disappear because of Web streams in the near future" (quoted in Cieply, Carter, and Moynihan).

Indeed, along with many other studios, Warner Brothers has set up a new branch of its production facilities specifically to create programming content for the web, producing 24 short "mini-shows" exclusively for consumption online as an alternative to their standard television offerings and theatrical feature films, including *"The Jeannie Tate Show,* a digital series about a mobile soccer mom and talk-show host" (see Barnes, "Warner Shifts"). Procter and Gamble, the company that pioneered the television soap opera in the early 1950s, carrying over a format from radio that dates back to the 1930s, has also joined a new wave of web programming with its series entitled *Crescent Heights,* aimed directly at PC and cell phone users.

Bob Tedeschi observes that "the series . . . focuses on a recent college graduate, Ashley, who moves to Los Angeles from Wisconsin to start a career in public relations, and her emerging circle of friends and romantic interests. Written, directed and produced by Hollywood veterans, the three-minute episodes are as polished as any television sitcom" (C1). Ten episodes of *Crescent Heights,* for example, replace the 30-minute format of conventional soaps and sitcoms; no one, it seems, has that much time to spare anymore.

Traditional television programming is impacted in other ways as well. When producers Marshall Herskovitz and Edward Zwick, creators of the network television series *thirtysomething* and *My So Called Life,* were given short shrift by ABC in the fall of 2005 for their new project, *Quarterlife,* about the lives of a group of "twentysomething" protagonists, they took their series, and all the rights to it, directly to the web, where it has attracted more than 2 million viewers since its debut on November 11, 2007, with a series of short episodes that are both addictive and visually stylish.

More recent forays into the field include *Dinosaur,* which posted just a few episodes about a time-traveling dinosaur; *Elevator,* which has roughly 100 episodes, running roughly a minute in length and uses the premise of a group of people thrown together in an elevator for comedic intent; *net work,* a self-referential comedy concerning some rather

desperate Internet producers; and *Street Fighter: The Later Years*, which takes a satiric look at the fates of characters in the popular video game some 15 years down the road.

The cinema industry is picking up on these concepts, as flimsy as they might seem at first glance; YouTube hosts an annual awards ceremony for the most popular (and thus the most reviewed) clips on its site, as does Yahoo!, with brief, often sophomoric vignettes taking pride of place in a rather predictable manner (Terryfic). But in an age in which films such as Jason Friedberg and Aaron Seltzer's *Epic Movie* (2007), a lame series of gags cobbled together that supposedly spoof the current spate of fantasy and spectacle films such as Andrew Adamson's *The Chronicles of Narnia: The Lion, the Witch, and the Wardrobe* (2005), can succeed quite profitably at the box office, the attention span of audiences seems to be definitely shrinking.

Indeed, what we think of as a "film" has become radically transformed by the culture and language of video games and interactive websites, and now film itself is poised to disappear as an obsolete format in an all-digital world. Feature films, which used to come in 35mm or 70mm format on enormous reels that had to be laboriously spliced together for "platter projection," are rapidly being replaced by hard drives, roughly the size of an old VHS cassette, which are inserted into a server and have an entire film stored in their memory (Fischbach E1).

Viral videos on numerous websites now spread around the world in a matter of minutes, gathering millions of viewers, transforming existing distribution models, as well as viewer expectations. Even contemporary television is embracing this new viral culture, most notably Al Gore's Current Television network, which debuted on August 1, 2005, and consists for the most part of viewer-created content, often with a definite Leftist political stance, in the form of pods, or short videos of anywhere from 4 to 10 minutes in length, on average, making it perhaps the first television cable network in which viewers are actually genuine participants.

But the web is another matter, and access to it is much easier to obtain. While conventional television (even cable and on-demand broadcast delivery systems) has a finite amount of space for programming,

the viewer space on the web is literally limitless, and those eager to share their handmade visions have found their own space on YouTube, which has, in many ways, transformed our collective visual culture. Created in "2005 by three former PayPal employees . . . Chad Hurley, Steven Chen, and Jahed Karim," the site's domain name was registered on February 15 of that year and, after roughly 4 months of development, previewed for the public in May 2005 in a beta version. The site went live to the general public in November 2005 and almost immediately, like MySpace before it, exploded into an international image-sharing clearinghouse (see Hopkins).

The site was so popular that, less than a year after its official debut, the search engine giant Google acquired YouTube for a staggering $1.65 billion, making its 3 young inventors, just recently out of college, multimillionaires literally overnight ("Google Closes $A2b YouTube Deal"). By July 16, 2006, the site's reach was ubiquitous, with more than 100 million video clips being viewed daily by nearly that number of visitors and an astonishing 65,000 new clips uploaded every 24 hours ("YouTube Serves Up"). In addition, YouTube's target audience is an advertiser's demographic dream: "44 percent female, 56 percent male, [with] the 12–17 year old age group dominant" ("YouTube").

For a site that is less than 6 years old, YouTube commands enormous clout in the imagistic marketplace, spawning its own award ceremony, and legally running clips from NBC's television shows under an agreement to boost conventional television viewership as well as music videos from Warner Music Group and EMI ("YouTube"). While much of the material posted in 10-minute (maximum) segments on YouTube is pirated from existing films, television shows, commercials, and other copyrighted sources, a great deal of the content is original material created by tech-savvy users, showcasing either their own assorted "talents" or creating mini movies with a strong genre backbone (science fiction, horror, and political thrillers being some of the most popular formats). Increasingly, however, the "wild west" aspect of the site is being tamed, and much of the material originally posted is being removed for potential copyright infringement, either at the behest of the copyright owners of the material in question or at YouTube's own instigation.

The unusual aspect of YouTube is that, as a technological advance, it is not really remarkable. It uses "Adobe Flash technology" ("YouTube") to deliver its clips to users, a medium that had been developed years earlier. But the founders of YouTube instinctively grasped the concept that had made the Lumière brothers' early films a success, along with those of Alice Guy Blaché, Augustin Le Prince, Thomas Edison, and later Dziga Vertov: people want to see themselves on the screen. The site's signature tagline, "broadcast yourself," sums it all up very neatly. On YouTube, the viewer is the star.

Several instant celebrities have already sprung from YouTube's cyclonic morass of images—clips created by people with enough novelty, imagination, or *difference* to stand out from the crowd. The British singer Paul Potts, an erstwhile cell phone salesman with a bashful "Gomer Pylesque" stage "non-presence," astonished viewers on the television show *Britain's Got Talent* by bursting forth into a reasonably proficient rendition of Puccini's "Nessun dorma," much to the astonishment of the show's judges, including the notoriously viperish Simon Cowell.

While Potts's success on the television show was a significant step in his nascent career, it was only when a high-definition clip from the show was posted on YouTube that his career really took off, and he became a web celebrity. Now, with his first CD, appropriately titled *One Chance*, released to stores, as well as straightened teeth and a wardrobe makeover, Potts is well on his way to becoming a popular performer who already has a hectic touring schedule of recitals at popular music venues.

All of this happened in a matter of weeks—publicity that a pop personality in the 1960s would never have dreamed of. Other instant YouTube successes include the fictional "lonelygirl 15," a creation of the "New Zealand actress Jessica Rose" ("YouTube"), as well as the pop group OK Go; the singer Terra Naomi; the plain-looking Susan Boyle, whose rendition of "I Dreamed a Dream" from the musical *Les Misérables* on *Britain's Got Talent* propelled her to instant fame when the clip went viral on YouTube; and the teenybopper pop star Justin Bieber, who was discovered entirely via YouTube and has since turned into a multiplatinum recording artist, produced by no less a celebrity than Usher, an established R&B performer and producer.

But there is, as with most websites, a darker aspect to YouTube; cell phone videos of gang street fights and "Jackass" stunts soon surfaced on the site, and even more disturbingly, hundreds of "torture porn" videos of animals being cruelly mistreated, specifically created for the site, such as crush videos, in which small animals are ground underfoot by women in high heels, have become popular among some users, uncomfortably recalling some of Thomas Edison's more violent early film clips, such as *Electrocuting an Elephant* (1903) (see Brooke).

Indeed, an April 20, 2010, Supreme Court decision, which will undoubtedly have far-reaching effects, struck down, by an 8 to 1 margin, a 1999 law that criminalized videos depicting cruelty to animals. The 1999 law was originally aimed at the "crush" videos, "barring the creation, sale or possession of any depiction of animal cruelty with intent to distribute or sell it" (see Richey); but a majority of the Court felt that the prohibition was too broad, with only Justice Samuel Alito dissenting. As Richey notes, "the law was written to ban photographs and videos depicting 'animal cruelty' in which a living animal is intentionally maimed, mutilated, tortured, wounded, or killed." But chief Justice John Roberts argued that the ban on such videos was "startling and dangerous," and created a

criminal prohibition of "alarming breadth." A depiction of entirely lawful conduct runs afoul of the ban if that depiction later finds its way into another state where the same conduct is unlawful. He noted that since hunting is illegal in Washington, D.C., the law would extend to "*any magazine or video depicting lawful hunting, so long as that depiction is sold within the nation's capital.*" Roberts rejected pledges by the government that federal prosecutors would only enforce the statute against acts of what it viewed as "extreme cruelty." The First Amendment protects against the government; it does not leave us at the mercy of *noblesse oblige.* We would not uphold an unconstitutional statute merely because the government promised to use it reasonably. (Richey)

This may be, but one shudders to think of the potential floodgates this opens in the annals of newly legalized videos of cruelty and brutality. As this book goes to press, the Supreme Court has also agreed to

rule on the censorship, advertising, and content of ultraviolent video games; perhaps the ruling on animal cruelty videos is a sad portent of things to come.

YouTube has also hosted, and continues to present, a variety of videos made by insurgents in the war in Iraq, videos made by American soldiers on the ground describing more accurately than any evening news report the horrors of war, as well as figuring in the presidential debate for the 2008 race in co-sponsorship with CNN and serving as "career ender" in a number of instances, most notably in the case of comedian Michael Richards, whose onstage rant at a comedy club, recorded on a cell phone, dealt him a blow from which he has yet to recover. It's also provided us with a window into the lives of a new breed of professional celebrities, such as Lindsay Lohan, Charlie Sheen, and Britney Spears, famous not so much for their actual accomplishments but rather for their continual presence on such sites as TMZ.com.

Not surprisingly, with YouTube's pervasiveness, certain countries have banned the site altogether, including most recently China, as well as Brazil, Iran, and Morocco, with a number of pointedly political videos blocked in the United Arab Emirates, Thailand, and Turkey ("YouTube"). Thus, in this world of instantaneous image creation and consumption, reputations and careers are made and destroyed literally in a matter of seconds. In addition, an understandable narcissism factor led *Time* magazine to somewhat ironically publish an issue with a silver foil mirror on its cover, celebrating "you" as seen as YouTube, MySpace, Facebook, and other self-promotional sites as the "person of the year" for 2006 ("YouTube").

But also in this mix of images are clips from movies beloved by fans, if not canonized by critics, that in many cases come to stand for the *entire film*, which contemporary viewers don't seem to have the time to view. When Ingmar Bergman died, there was a flurry of postings of brief segments from some of his most famous films as a sort of tribute to the departed filmmaker; Michelangelo Antonioni also received several similar tributes, all citing supposedly "key" moments from his work as selected by YouTube's viewer/participants.

Other websites, such as the Internet Archives, offer complete downloads of public-domain feature films and shorts, ranging from Luis

Buñuel's *Un Chien Andalou* (1929) to Sam Newfield's jungle epic *Nabonga* (1944), while Richard Prelinger has for many years maintained a website that offers downloads of instructional films and "industrials" from the 1920s through the 1970s; both sites are free to all. Indeed, the sheer quantity of visuals available online today is literally beyond comprehension; there are literally millions of videos and thousands of sites that offer them, presented with a sense of egalitarian freshness that works powerfully to erase the boundaries between canonized work and more popular material, as if all of visually recorded history is now available, for better or worse, to anyone with a Mac or a PC.

In 2007, a new website, Hulu, joined the competition, creating a portal that, as one observer puts it succinctly,

> offers commercial-supported streaming video of TV shows and movies from NBC, Fox and many other networks and studios. Hulu videos are currently offered only to users in the United States. Hulu provides video in Flash Video format, including many films and shows that are available in 480p. In addition, some TV shows and movies are now offered in high-definition. Hulu also provides web syndication services for other websites including AOL, MSN, MySpace, Yahoo! and Comcast's Fancast.com. Hulu is a joint venture of NBC Universal and Fox (News Corp), with funding by Providence Equity Partners, which made a USD $100 million equity investment and holds a 10 percent stake [in the site]. ("Hulu")

The programming on Hulu is almost all old television programming, dating back as far as the 1950s but with materials from the 1970s and 1980s predominating (much like the recently launched Retro Television Network, which recycles 1970s and 1980s American series programming to conventional television audiences via cable and satellite).

The site's first television advertising occurred during the conventional television broadcast of Super Bowl XLIII with an ad starring Alec Baldwin purporting to reveal the "secret behind Hulu," with the memorable tagline "Hulu—an evil plot to destroy the world," and created an almost instantaneous buzz. "You're not going to put away both

your television *and* your computer, are you?" Baldwin rhetorically asks the viewer, demonstrating how Hulu's programming "melts the minds" of viewers with utterly commercial, lowest-common-denominator programming—in short, television reruns. As a final touch, during the ad's last moments, several digitally created tentacles reach out from the interior of Baldwin's immaculate suit, tucking in his handkerchief and dusting off his lapels. The truth of the site is, supposedly, even more sinister because, as Baldwin puts it, "we're aliens, and that's how we roll" ("Hulu").

Hulu is a neat way for the networks, both broadcast and cable, to create an end-run around YouTube for a number of reasons: all of the programming is legitimately licensed, so there is no question of legal problems; even with Flash technology, the image quality is far superior and can easily be expanded to full-screen viewing; and despite a few ads that run with each offering, the programming is entirely free. In addition, Hulu's vast library of television programming is accessed entirely on demand, giving viewers the power to schedule their own programming entirely at their convenience rather than watching it in real time or even DVRing it for playback at a later date. On Hulu, the programs are waiting to be accessed by an ever-increasing army of eager viewers.

The curious mix of nostalgia and futurism is also a draw; a significant number of Hulu's viewers, surprisingly, are members of the boomer generation, who normally aren't drawn to the latest in web-based technical innovation. But by marrying Hulu's delivery system to programming that is both familiar and comforting, the audience size for the site has moved forward by leaps and bounds, making it a popular destination for even the most technically phobic users. Thus, Hulu is gaining an increasing foothold in the United States and, in time, with the legal problems ironed out, will probably be available worldwide, perhaps with a fee or more commercials added to the mix. Indeed, Hulu announced on June 30, 2010 that it would be offering unlimited access to full seasons of television shows for a $9.99 per month fee, designed to appeal to viewers who long ago jettisoned conventional television from their lives but who still want to watch TV shows, films, and videos on their computers at their leisure (Stelter, "Rise" B4). Due to

the success of this program, in November 2010 Hulu dropped the price to $7.99 to compete with Netflix's new streaming video service (see Edwards and Rabil).

For many traditional television viewers, disenchanted with the ever-rising cost of cable television, Hulu and the other sites mentioned in this chapter make contemporary cable or satellite delivery methodologies obsolete; just hook up your computer to a flat-screen monitor or a television, if you still have one, and you can easily stream any of Hulu's programming. The networks are clearly embracing Hulu; at this writing, Comedy Central, PBS, USA Network, Bravo, Fuel TV, FX, SPEED Channel, Style, Sundance, E!, G4, Versus, and Oxygen are all signing on to the service, providing programming in return for a share in the advertising revenue the site generates ("Hulu").

As a bonus, some of the programming is also available as video downloads on iTunes, especially the popular web series *Dr. Horrible's Sing-Along Blog*, starring sitcom and theatrical actor Neil Patrick Harris, which was

> initially produced exclusively for Internet Distribution. It tells the story of Dr. Horrible, the aspiring supervillain alter ego of Billy; Captain Hammer, his nemesis; and Penny, their mutual love interest . . . written by writer/director Joss Whedon, his brothers Zack Whedon (a television writer) and Jed Whedon (a composer), and Jed's fiancée, actress Maurissa Tancharoen [and was created] in a way that would circumvent the issues that were being protested during the [2008 writers' strike]. [The series was] first released online as individual episodes, with two-day intervals between each release. ("Dr. Horrible")

Dr. Horrible is one of many web series that are up and running on a regular basis, but most don't get much attention from viewers because they're buried under an avalanche of available online entertainment. Unlike conventional television, there isn't (yet) a 1-stop programming guide for Webisodes, although the prospect of tunneling through all the various programs is truly daunting. Some come and go like mayflies and die a quick death; others build up a long-term audience and return year after year to a cadre of loyal viewers. As Mike Hale notes,

Has any art form—or entertainment category or visual medium or whatever you want to call it—grown so large so fast as the online serial, while remaining so consistently outside the mainstream cultural conversation? . . . If you're an aficionado, or just have a lot of time on your hands, you may actually be watching better serials, like Felicia Day's role-playing-game satire, *The Guild*, which recently completed its fourth season, or Lisa Kudrow's latest deconstruction of 21st-century self-absorption, *Web Therapy*, which just resumed its third. But you're probably not reading or hearing about them anywhere but online. And still the Web series get made, hundreds of titles numbering thousands of short episodes: dramas, comedies, Webisodes accompanying television series, cartoons, talk shows, reality shows, newsmagazines, documentaries—a cheaper and quicker parallel universe to television and film.

Hale, who writes about the web for the *New York Times*, announced on November 12, 2010, that the *Times* would now be offering an ongoing index for this avalanche of niche programming, if only to help him and other industry observers choose some of the more interesting series for further analysis. *Web Therapy*, for example, has now amassed 46 episodes, with Meryl Streep featured as a recent guest star in a 3-episode story arc. Syfy Television (formerly Sci-fi, until the need to copyright the channel's name forced a somewhat awkward respelling) has been churning out 10-minute segments of the web serial *Riese*, with an eye to combining the sections into a 2-hour TV pilot for the network; and Showtime has created an odd animated web companion for its hit live-action serial-killer television show *Dexter*. Titled *Dark Echo*, the web series offers brief (3- to 6-minute episodes) of additional back story for *Dexter*'s numerous devotees (see Hale).

There's much, much more out there for those willing to take the time to troll the web for diversion or enlightenment—though there's also apparently more of the former than the latter. But with the advent of Google TV, discussed later in this book, it seems likely that web and conventional television programming will soon mesh into an endlessly interactive experience far removed from what one traditionally associates with the "turn off your mind; relax and float downstream"

ethos of zoning out in front of the tube as a way to unwind at the end of day. A seemingly infinite array of programming choices will confront the viewer, and the means and the temptation to switch from one programming source to another will be almost overwhelming. It will be interesting to see how this new image mesh works out for both viewers and advertisers, to say nothing of those who actually produce both traditional and web programming.

Thus, we have a large number of competing sites, each vying for the viewer's attention, and each playing in a fast and loose manner with programming, some of it legal on certain sites, some of it either pirated or viewer created. In many ways, this is an encouraging development, as it breaks down the boundaries of traditional distribution in a manner hitherto impossible. Despite official sanctions against YouTube and its brethren by repressive regimes around the world, the site keeps rerouting itself past its would-be censors, much as an oft-jammed conventional radio broadcast during the Cold War 1950s would shift to another transmission frequency to disseminate its message. And, as with most nascent technologies, it is starting in short-burst rather than feature-length iterations, although, as sites such as Hulu and more elaborate productions such as *Dr. Horrible's Sing-Along Blog* show us, this is rapidly changing.

The Kinetoscope, conceived by Thomas Edison in 1888 and created by his technician W.K.L. Dickson between 1888 and 1892, was an immediate sensation on its commercial debut in New York in April 1894, bringing moving images to the general public in a peepshow machine that ran brief film clips for individual viewers—flickering images that transfixed the imagination through the medium of realistic motion, something that had never before been achieved on such a large scale ("Kinetoscope"). Much the same thing is happening now in the digital universe. In its earliest stages, we were happy enough to see static images on the worldwide web, which were occasionally crudely animated through the use of Shockwave and other pioneering digital technologies. Now we demand motion graphics with quality sound as a matter of routine, and the current state of technical progress on the web is certainly not the last step in the medium's evolution.

And yet the digital era brings with it a host of new complications

and archival issues, as demonstrated in *The Digital Dilemma*, a report commissioned and executed by the science and technology council of the Academy of Motion Picture Arts and Sciences (AMPAS). Milton Shefter, a pioneering film archivist and the lead author of the report, notes that, despite its pristine visual quality, the digital image is inherently unstable, constantly in a state of flux, and that storage of digital imagery is a never-ending process of maintenance and upgrading. As Michael Cieply added in the *New York Times*,

> To store a digital master record of a movie costs about $12,514 a year, versus the $1,059 it costs to keep a conventional film master. Much worse, to keep the enormous swarm of data produced when a picture is "born digital"—that is, produced using all-electronic processes, rather than relying wholly or partially on film—pushes the cost of preservation to $208,569 a year, vastly higher than the $486 it costs to toss the equivalent camera negatives, audio recordings, on-set photographs and annotated scripts of an all-film production into the cold-storage vault. (Cieply, "The Afterlife")

For Milton Shefter and his colleagues at the AMPAS, the problems inherent in digital image storage, "if not addressed, could point the industry 'back to the early days, when they showed a picture for a week or two, and it was thrown away'" (quoted in Cieply, "The Afterlife"). For the moment, there is a "solution" that bridges both the past and present. As Cieply comments,

> at present, a copy of virtually all studio movies—even those like *Click* or *Miami Vice* that are shot using digital processes—is being stored in film format, protecting the finished product for 100 years or more. . . . But over the next couple of decades, archivists reason, the conversion of theaters to digital projection will sharply reduce the overall demand for film, eventually making it a sunset market for the main manufacturers, Kodak, Fujifilm and Agfa. At that point, pure digital storage will become the norm, bringing with it a whole set of problems that never troubled film. To begin with, the hardware and storage media— magnetic tapes, disks, whatever—on which a film is encoded are much

less enduring than . . . film. If not operated occasionally, a hard drive will freeze up in as little as two years. Similarly, DVDs tend to degrade: according to the [academy's] report, only half of a collection of disks can be expected to last 15 years, not a reassuring prospect to those who think about centuries. Digital audiotape, it [has been] discovered, tends to hit a "brick wall" when it degrades. While conventional tape becomes scratchy, the digital variety becomes unreadable. (Cieply, "The Afterlife")

Indeed, many contemporary films avoid the use of tape entirely. The entire production is recorded on a hard drive, as in the case of David Fincher's Zodiac (2007), and only transferred to film for final exhibition. Fincher would shoot as many as 28 takes for a single scene in Zodiac and then erase them, pushing on with still more takes until he got what he wanted (see Goldman). Thus, the whole project boiled down to "how much memory do you have on your hard drive?" In his 2010 film The Social Network, a biopic documenting the rise of Facebook, Fincher became notorious among cast members for allegedly shooting as many as 99 takes for simple dialogue scenes, to no discernible effect. Developed from a script by West Wing creator Aaron Sorkin, the final result was nothing more or less than a handsomely mounted TV movie— linear, easy to follow, bereft of nuance or subtlety, despite the Oscar buzz the film generated. It's one of those films that spells everything out for the viewer, and as such, garners mass approval from both audiences and critics.

This brings up another interesting question: the non-availability of phantom digital takes that are erased during the production process. Who knows what values might have been lost forever? In the classical era, director William Wyler was known as "Forty Take Willie" because he insisted on repeating a scene until his actors gave him what he wanted; as a result, he then had the luxury of 30 or so takes on film from which to make his final selection. But Fincher and other digital directors keep only a handful of the material they shoot, erasing the rest and thus losing much of the process of shooting.

How does this approach affect the actors, who know in all probability that their first several dozen takes will almost inevitably be

lost? When you erase 30 or so takes of an actor's work, aren't you, in a sense, erasing the actor him or herself? How can we ever find out? In truth, what one sees on the set is very different from what one sees on the screen when the image is projected many times larger than life. Gary Cooper, for example, famously seemed to do nothing during the close-ups in his films; experienced technicians and other veteran actors would watch him at work and wonder what would finally appear on the screen. But when the rushes were projected, values that weren't visible on the set were magnified by the inherent intimacy of the cinematic process, creating an image that seemed both natural and convincing. Similarly, Brando and other method actors sought not to project but simply to "think" their roles and so brought a more authentic performance style to the cinema. As Michael Caine has observed, "you must be thinking every moment [in a film performance] because the camera looks into your mind, and the audience sees what the camera sees" (10).

But now, theoretically at least, the director can do as many takes as she/he wants. The cost of film is no longer part of the equation since only the final cut is committed to celluloid, and even that won't last long, with the rise of all-digital exhibition, which looks poised to take over theatrical presentation as the dominant mode of technology as early as late 2012. Today, an increasing number of films are shot directly on hard-drive video equipment. It's light, portable, and is fast becoming the new standard. Hard-drive filmmaking was pioneered, of course, by the great Aleksandr Sokúrov in his 2002 film *Russian Ark*, a 97-minute single-take film recorded entirely on the hard drive of a handheld digital camera. At the time, the film was seen as something of a revolution (not only for its endlessly tracking Ophulsian style but also for the methods used to produce it); now, the practice of hard-drive production is an industry commonplace.

Coupled with the new industry habit of letting the camera run while rehearsing a scene—no need for a clapper board to maintain synchronization or any push to conserve film because none is used—the new question becomes what to save and what to throw out since the meaning of the word *outtakes* has become almost immeasurably expanded. You may want some extras on the DVDs of the films you see, but how much is too much? The AMPAS report suggests that, for the

present, all digital films will probably have to be recopied to a newer, perhaps more stable electronic medium every 7 to 10 years, or else they will cease to exist altogether. This is a new kind of ephemerality for the moving image to deal with; it seems the future is much less stable in this regard than the past.

Still, one can confidently predict that this latest digital logjam is another obstacle that will eventually be overcome by new methods of image storage and retrieval that only a few of us have even given the slightest bit of consideration to—methods, no doubt, that will make newly minted billionaires of yet another group of young innovators. If the 20th century combined machine technology and electronic invention to create radio, television, talking pictures, and other mediums of image dissemination, the 21st century is surely the digital era in which all earlier image capture and retrieval systems will eventually be superseded or, in some cases, supplanted.

As video imaging increases in ease, portability, and quality, the already blurred line between cinema and video will vanish altogether. Now, with more films, videos, television programs, and viral videos being produced than ever before, and with international image boundaries crumbling, we will see in the coming years an explosion of voices from around the globe, in a more democratic process that allows even the most marginalized factions of society to have a voice.

In addition, many new art films are now available immediately on cable or television as on-demand items, such as "IFC on demand," which opens films theatrically and on pay-per-view television on the same day. With the ease and low cost of the digital age of production, distribution is still the most important, if not the deciding, factor in who will see precisely what films, and where, and how. As Carl Rosendahl of Pacific Digital Imaging comments, "for independent filmmakers, that fact remains that if you want your film in broad distribution, you still have to partner with a studio. You can make a great film but you can't get it into 3,000 theaters without being able to back the film with millions of dollars of advertising. Most filmmakers can't do that, so they need the studios" (Willis 16).

Yet one can also argue that mainstream cinema, while still controlled as a commercial medium by a few conglomerate organizations,

has become with the use of inexpensive flip video cameras and the like a truly democratic medium. It is impossible to hold back the flood of images created by these technologies, as recent events in Iran in 2009 have demonstrated; and in the 21st century, these images will both inform and enlighten our social discourse, along with tweets, texts, and other communicative iterations. While the big-screen spectacle will continue to flourish, a plethora of image constructs now compete for our attention, often with a significant measure of success.

The monopoly of the television networks is a thing of the past; who is to say that theatrical distribution as we know it will not also be transformed into a different sort of experience altogether? IMAX films and 3-D systems mimic reality; but in the future, as previously noted, holographic laser displays, in which seemingly 3-dimensional characters hold forth from a phantom staging area, may well become the preferred medium of presentation, signaling a return to the proscenium arch but, in this case, a staging space with infinite possibilities for transformation. The dead could come alive again; Michael Jackson would be an obvious candidate for holographic revivals. Powered by high-intensity lasers, this technology could also present performances by artists who no longer wish to physically tour to present their faces and voices to the public.

Movie theaters could also become even more aggressively commercial than they are now, with the usual array of commercials, promos, and trailers before the main feature. As Hoag Levins reports,

> Finding ways to turn movie theaters into interactive social-media venues is a major project at New York's Brand Experience Lab. . . . [L]ab chairman David Polinchock [is conducting] experiments that turned 300 solitary moviegoers into coherent teams using body movements in unison to control digital elements on the big screen. This new field of "audience games" hopes to provide marketers with an entirely new way of engaging consumers in *brand-oriented digital play* [emphasis added] prior to the start of the main feature.

Anything to sell more product, during both the main feature and the surrounding programming. And in Brazil,

Fiat [the car manufacturer] in Brazil has created an interactive movie theater experience to promote a new light off-road vehicle. Moviegoers will see a short film that plays before their feature movie. Using an SMS Text message from their cell phones, people will . . . choose how the film unfolds and create one of 16 different versions as well as how it ends. The short film plays in segments between the previews and was directed by Fernando Meirelles, who directed [with Kátia Lund] the movie *City of God* [2002]. (Bajwa)

The possibilities for commercialization are literally endless.

Although Hollywood will seek to retain its dominance over the global presentation of fictive entertainment constructs, we argue that a vision of international access, a democracy of images, will finally inform the future structure of the moving image in the 21st century. Many of the stories told will remain familiar; genres are most comfortable when they are repeated with minor variations. But as the production and exhibition of the moving image moves resolutely into the digital age, audiences have even greater access to a plethora of visual constructs from every corner of the earth. The center will not hold, as Yeats well knew; too many forces are tearing it apart from the margins. Cinema incorporates all known distribution methods and extends beyond it into the net, the web, cell phones, and other methods/mediums we can now only hazard a guess at.

As scholars, or even casual viewers, we are still the custodians of the past of cinema, but we are also the heralds of the future of the moving image, whether on film, or video, or a chip, or a digital CD. The digital technologies we are seeing now will only accelerate their hold on the public consciousness in the decades to come, and, in the end, the practice and reception of cinema will become more democratic because of it. The past of the moving image belonged to the few; the future, it seems, will belong to almost everyone with a cell phone and access to the web. More people than ever before will have a platform from which to present their vision of the world. The end of 20th-century cinema, when, as Andrew Sarris put it, films were constructed like Gothic cathedrals, brings with it the dawn of the individual as image maker. People interact with each other more on a global scale, and

the dissemination and transmission of images shift beyond all known boundaries into the unknowable zone of the world as the simultaneous creator, and consumer, of the future of the moving image.

For the most part, Hollywood's embrace of digital cinema is in the service of spectacle—the bigger and louder, the better. Director Michael Bay is one of the foremost proponents of this barrage of sound and light, and his films, especially *Transformers: Revenge of the Fallen* (2009), are nothing more or less than hyperkinetic, hyperviolent spectacles that audiences apparently devour with unbridled abandon. As critic John Horn noted,

> Bay has never been a critic's favorite, but the thrashing he received for *Transformers: Revenge of the Fallen* was the worst of his eight-film career. Reviews ridiculed the new sequel about battling robots as "beyond bad" (*Rolling Stone*), "bewildering" and "sloppy" (the *Village Voice*) and "a great grinding garbage disposal of a movie" (the *Detroit News*). The early notices were so uniformly disapproving that after Bay's traditional opening-night dinner party at Beverly Hills' Mr. Chow, the 44-year-old director wondered aloud to executives at distributor Paramount Pictures about the possible impact of the drubbing. He needn't have worried. . . . [I]n its first five days [the film made] an estimated $201.2 million—[more] than any other movie in Hollywood history except one: last year's *The Dark Knight* (which grossed $203.8 million in its first five days and went on to earn $533.3 million at the domestic box office). . . . Although [audience member] 27-year-old Diana Salazar didn't know that Bay had directed the movie, she praised its execution. "It had a lot of action. It was really interesting to see the good fight scenes," she said. "Either I like the plot or I don't. It makes absolutely no difference who the director is."

For Bay, *Transformers: Revenge of the Fallen* succeeds because it appeals to "the kid in all of us—it's a wish-fulfillment movie. This one is just a big, epic adventure. It's got scope beyond belief and it's got more heart," while also noting that his long apprenticeship as a director of television commercials helped him immeasurably in capturing the audience's attention. "The one thing commercials teach you is how

to convey a message in 30 seconds," he said. "And this I know for a fact: I shoot actors—even young actors—as if they were movie stars. And that's something a lot of other directors don't do" (see Horn). But where will this lead? And what sorts of films are coming next? Surely there must be something beyond mega-blockbusters and genre retreads.

It is an inescapable fact that we will soon experience a complete changeover to digital formatting, eschewing film entirely. Many audience members have been deeply disturbed by the thought, as if, in losing the platform of film, they are losing some essential essence of the medium. But a moving image is just that, as Jean-Luc Godard demonstrated with his revolutionary *mixages* of film and video in *Histoires du Cinéma* (an epic project begun in 1989 and completed in 1998), and what was once conjecture on our part has now become an accomplished fact. Film has vanished, but the image remains, albeit in a new, sleeker format. It isn't a question as to whether this is good or bad; it's just a fact. The movies have changed, and we are changing with them.

CHAPTER TWO

Constructing an Audience

In the 21st century, filmgoers use the movies as a means of escape. Films that challenge the viewer or are hard to decode are often unsuccessful. *The Hurt Locker*, for example, won the 2010 Academy Award for best picture, and its director, Kathryn Bigelow, won for best director (a first for a woman); but the film did only a fraction of the business of James Cameron's *Avatar*, which is now, amazingly, the most successful film of all time from a financial viewpoint. In *Avatar*, the viewer is invited to escape his or her body and become immersed in a role-playing world of complete fantasy, albeit with a slight eco-friendly subtext, which can easily be ignored by most viewers, who are intent only on following the narrative line to the exclusion of all else. Most of all, the film has a happy ending, the most important prerequisite for contemporary Hollywood mainstream success. As Michael Cieply and Brooks Barnes note, during this recessionary period,

> While much of the economy is teetering between bust and bailout, the movie industry has been startled by a box-office surge that has little precedent in the modern era. Suddenly it seems as if everyone is going to the movies, with ticket sales this year up 17.5 percent, to $1.7 billion, according to Media by Numbers, a box-office tracking company. And it is not just because ticket prices are higher. Attendance has also jumped, by nearly 16 percent. If that pace continues through the

year, it would amount to the biggest box-office surge in at least two decades. Americans, for the moment, just want to hide in a very dark place, said Martin Kaplan, the director of the Norman Lear Center for the study of entertainment and society at the University of Southern California. "It's not rocket science," he said. "People want to forget their troubles, and they want to be with other people." (Cieply and Barnes 1)

The contemporary film audience is young, uncertain about the future, and suspicious of authority figures; and viewers are looking for an easy way to escape their increasingly mundane lives. Is it any wonder, then, that Michael Bay, director of *The Transformers: Revenge of the Fallen* (2009), took home an estimated $125 million in personal salary in 2009; $75 million in back-end profit participation on the film itself, which grossed $835 million worldwide; $28 million as his share of DVD sales; $12.5 million for toy and other merchandising royalties; plus an additional $9.5 million for producing the latest incarnations of *Friday the 13th* (2009) and *A Nightmare on Elm Street* (2010) (Newcomb 273)? Escapism, of course, comes in many flavors, and feel-good films account for only a middling percentage of the theatrical viewing audience. Horror films are reliable box-office performers, cheap to produce, and almost guaranteed to make money, especially if they're part of a franchise that's been rolling on for more than 3 decades.

Other heavy hitters in contemporary Hollywood (directors, actors, and producers) include Roland Emmerich, Steven Spielberg, James Cameron, Ben Stiller, Tom Hanks, Jerry Bruckheimer, Tyler Perry (one of the few African Americans in the group), Adam Sandler, Denzel Washington, and *Daily Show* alum Steve Carell. Even with the current austerity crunch in the film capital, Carell earned $12.5 million for starring in Shawn Levy's *Date Night* (2010), an intermittently amusing action comedy about a romantic evening on the town gone disastrously wrong. Because Levy, however, favors a blunt approach to his material, the film soon degenerates into a series of routine car chases and spectacular crashes, all of which add nothing to the film's narrative but easily entertain a jaded audience that is accustomed to unceasing violence, whether comedic or serious (Newcomb 274).

Star salaries, in general, are one of the key factors in creating an audience and audience buzz for a film; and as a result, stars who can "open a picture" on their own are handsomely rewarded with a lavish salary up front and back-end percentage points of the film's income (net, sometimes gross, depending on a particular star's wattage). For starring in the final two *Harry Potter* movies, *Harry Potter and the Deathly Hallows*, parts 1 and 2, the series star, Daniel Radcliffe, took home a cool $40 million, while co-star Emma Watson was paid $30 million for her participation (Newcomb 273–74). Russell Crowe received $20 million for appearing in Ridley Scott's latest incarnation of *Robin Hood* (2010), and Robert Downey, Jr., was paid a relatively modest $10 million for starring in Jon Favreau's *Iron Man 2* (2010) (Newcomb 274).

But perhaps the most intriguing figure is that received by producer Jason Blum and novice director Oren Peli, whose 2009 hit *Paranormal Activity* cost a mere $15,000 to produce and racked up a worldwide gross of $141 million. For their efforts, the two split an estimated $22.5 million for *Paranormal Activity*, as well as an up-front payment of $5 million for their forthcoming film *Area 51*, in which they use a cinema verité approach to tell a tale of flying saucer cover-ups by the government (Newcomb 275). Other, more established figures, such as George Clooney, received a low-key $10 million for starring in Jason Reitman's *Up in the Air* (2009) and racked up an additional $5 million in fees for appearing in international television commercials, royalties from older films, and endorsement deals (Newcomb 275).

In contrast, Clint Eastwood earned a mere $6 million for directing and producing *Invictus* (2009), another $6 million for directing and producing *Hereafter* (2009), $4 million in DVD royalties for *Gran Torino* (2009), plus a paltry $1 million in royalties from earlier projects: a total salary of $17 million that pales in comparison to what others are earning (Newcomb 275)—for instance, a youngster such as Robert Pattinson, who took home $18 million for his various projects in 2009, including his work in the ongoing *Twilight* series. All of this money is pegged on how much these stars can command at the box office, who will come to see their films, and how much brand loyalty viewers will give to both the stars and the films they appear in.

As Malcolm Gladwell has suggested, however, the magic formula for making a hit film has yet to be distilled. As he notes,

> The most famous dictum about Hollywood belongs to the screenwriter William Goldman. "Nobody knows anything," Goldman wrote in *Adventures in the Screen Trade* a couple of decades ago. "Not one person in the entire motion picture field *knows* for a certainty what's going to work. Every time out it's a guess." One of the highest-grossing movies in history, *Raiders of the Lost Ark*, was offered to every studio in Hollywood, Goldman writes, and every one of them turned it down except Paramount: "Why did Paramount say yes? Because nobody knows anything. And why did all the other studios say no? Because nobody knows anything. And why did Universal, the mightiest studio of all, pass on *Star Wars*? . . . Because nobody, *nobody*—not now, not ever—knows the least goddamn thing about what is or isn't going to work at the box office."

And yet, naturally, people keep trying. Sequels are usually a safe bet, although they can either surpass or fall far below the gross of the first film. Sequels become exhausted after a while and eventually give way to parody. Then, as with the new *Batman* films directed by Christopher Nolan, it becomes necessary to reboot the franchise, as Nolan did with *Batman Begins* and *The Dark Knight*, perhaps the finest comic-book movie ever made.

Comic-book movies are big business; Iron Man, Batman, the X-Men, Spiderman, and other comic-book heroes and heroines—the darker the better, for the present moment, although Zack Snyder's *Watchmen* (2009), based on the comic book by Alan Moore and Dave Gibbons, disappointed at the box office despite a ferocious media campaign after the spectacular success of Snyder's ultra-stylized epic of the Battle of Thermopylae, *300* (2006), itself a remake of a CinemaScope epic, Rudolph Maté's *The 300 Spartans* (1962). *Watchmen*, the movie, simply wasn't faithful to the original work's intent. Even before it was released, Alan Moore, the key force behind the original comic-book version, viewed the then-upcoming film with complete disdain, telling Geoff Boucher that

I find film [as a whole] in its modern form to be quite bullying. It spoon-feeds us, which has the effect of watering down our collective cultural imagination. It is as if we are freshly hatched birds looking up with our mouths open waiting for Hollywood to feed us more regurgitated worms. . . . They take an idea, bowdlerize it, blow it up, make it infantile and spend $100 million to give people a brief escape from their boring and often demeaning lives at work. It's obscene and it's offensive. ("Alan Moore")

And indeed, when *Watchmen* came out, it did only a fraction of the business that it could have and was generally seen as being overly violent, overly loud, and overly long, containing nothing of the essence of the original work.

On the other hand, *300*'s visual design was defined by the source material for the film, a graphic novel of the same name by the prolific artist Frank Miller; and Snyder followed the line of the original material more faithfully. Graphic novels, or high-end comic books, are becoming potent source material for big-budget blockbusters inasmuch as they are already storyboarded in comic-book form and thus heavily previsualized. For example, Frank Miller, Robert Rodriguez, and Quentin Tarantino's *Sin City* (2005) pushed stylization of imagery to the limits, creating a seemingly black-and-white noir world in a color film that was based on the narratives of three of Miller's graphic novels, which were shoehorned into one film. The nonstop violence of *Sin City* is very 21st century, as is the hyperprocessing of its visuals; indeed, *Sin City* was screened to considerable critical acclaim at the Cannes Film Festival in 2005 and won a major technical award for its innovative manipulation of live-action raw material.

But the *Superman* franchise seems, for the moment, to be out of tune with the times. Too clear-cut for our alienated age, the Man of Steel was a reliable franchise through the 1970s and 1980s in the person of Christopher Reeve; but with his tragic demise, the series seems to have come to a dead end, although there are periodic attempts to revive it. Perhaps Reeve's death is too ingrained in viewers' minds; perhaps Brandon Routh, in Bryan Singer's *Superman Returns* (2006), the latest installment of the series, was too much of a carbon copy of Reeve's iconic

interpretation. But others have a different argument. In its embrace of star salaries and pre-sold commodities, Lynn Hirschberg, for one, feels that the industry has lost its way. As she notes,

> Blockbusters, based largely on toys and comic books, which can be turned into hugely lucrative franchises for the studios, have all but replaced movies aimed at a smaller and perhaps more discerning audience. [Because of this,] Warner Brothers decided not to release [director Danny Boyle and Loveleen Tandan's] *Slumdog Millionaire* [2008] because it felt no one in America wanted to see a movie set in Mumbai, particularly in another language. Despite the film's low budget, the Warner execs decided that the considerable cost of distribution and promotion would far surpass the estimated profits. Instead . . . they preferred to spend their money on hugely expensive movies like [Andy and Lana Wachowski's] *Speed Racer* [2008] (which lost tens of millions of dollars) [. . . and even] when *Slumdog* was scooped up by Fox Searchlight, where it made more than $140 million and won the Academy Award for Best Picture, Warner said it did not regret its decision. The thinking seemed to be: better a loud, super-expensive popcorn extravaganza than a quieter, smaller (and riskier) film. ("Core Values")

And with budgets so grossly inflated, who can blame them? Every film now is a large, corporate bet, in which hundreds of millions of dollars are usually at stake, a far cry from the days when the average cost of a film was in the several-million-dollar range, with a million or two more for prints and advertising. Now, a bad bet can sink a company, and so only the safest projects win studio backing. More adventurous films are made, but lacking advertising, promotion, and distribution outlets, they wind up on IFC at three in the morning, often only months after their initial release. And even when a film does get the full publicity rollout, studios are increasingly finding ways to lure patrons to the theaters without the massive ad campaign that used to define the industry. As Brooks Barnes notes,

> Hobbled by a depressed DVD market and drooping sales of movies to foreign television networks, Hollywood studios are finally reining in

runaway marketing budgets. Lionsgate, already one of the leaner opera-
tions, boasted that it cut marketing expenses by 66 percent in the second
quarter from a year ago, while Disney dismissed about a dozen market-
ing executives early this month in an effort to shrink spending. . . .
As studios cut "paid media" (newspaper ads, television spots and bill-
boards) they are leaning more heavily on armies of publicists generating
what they call "earned media," free coverage in magazines, newspapers,
TV outlets and blogs. ("Ad Budget Tight?" 7)

Facebook, Twitter, and instant messaging can get the word out
much faster and more efficiently than a full-page ad in a conventional
newspaper can. Thus, even the biggest companies are constantly search-
ing for a new way to separate their product from the rest of the other
offerings, whether it is a television program or a theatrical feature. A
30-second interview on such TV shows as *Access Hollywood, Entertain-
ment Tonight*, or *The Daily 10* can be worth as much as, if not more than,
a paid commercial, particularly if the interview is hyped in bumpers
and wraparounds for the show, teasing the viewer with brief snippets
of the "exclusive interview" numerous times before the segment finally
appears. In addition, as Barnes notes, the fact that the segment is edito-
rial content rather than a paid spot gives the material added cachet and
validity.

At least with publicity—placed stories—there is a feeling that the mes-
sage has gone through a filter, said Paul Pflug, the co-owner of Principal
Communications, a public relations firm that specializes in entertain-
ment. Journalists and their editors had to consider the pitch worthy of
space. The message has been vetted in some way. [According to Pflug,]
an article [is] more valuable to the studios because it is more credible to
viewers than an ad. ("Ad Budget Tight?" 7)

Of course, when all else fails, you can always arrange a lavish press
junket to Bora Bora to promote your latest comedy, as Universal did with
Couples Retreat in 2009, and then milk the attendant publicity for all it's
worth, as a "news item" that stands out on blogs, in newspapers, and

even in the entertainment section of the Google news homepage. As Michael Moses, Universal's executive vice president of publicity, summed it up, "You've got to remain responsible with your resources while continually finding new ways for your campaigns to stand out" (Barnes, "Ad Budget Tight?" 7). Anything to put bodies in the seats, in short.

Which is something that theaters are more concerned about than ever in the current economic climate, especially since there are so many other entertainment options competing for the consumer's time, attention, and money. In 1946, the peak year of motion-picture theater attendance, right after the end of World War II, more than 80 percent of the entire American populace went to the movies once a week, just to "see a show." It really didn't matter, to a large extent, what was playing. Home was radio, books, the telephone, and a record player; if you wanted to see a moving image (unless you were wealthy enough to afford a 16mm movie projector, to say nothing of the copies of the films themselves), you had to go out to a movie.

Besides, going to the movies was a social event; people would meet for dinner or cocktails, see a show, and then amble home in the dusk to their homes, sure that nothing would ever change. Amazingly, this was only about 60 years ago; and for all intents and purposes, although weekly theatrical attendance declined precipitously in the 1950s and 1960s, the average home was a sanctuary rather than a media hub until the late 1980s, when home computers and VCRs were first introduced. That puts the entire digital revolution into the past 25 years or so; now people are so "wired" (or "wireless") that, instead of living "in the moment," the contemporary young adult is bombarded with media on all sides in a manner that was hitherto inconceivable.

In such an atmosphere, it takes a good deal of persuasion to motivate a potential viewer to see a first-run feature in a theater when cable, on-demand movies, torrent downloads, and Netflix (to name just a few sources) are so readily available. As one young woman told James P. Yates in September 2009, "sometimes, it's nice to have a wider screen, but I don't think I gain that much by going to a movie theater anymore. Now, it's more about convenience." Or as another post-millennial moviegoer told Yates, "I watch movies the way many people listen

to music—anytime, anywhere, any way." So theaters are fighting back, as they always have to any new threat, with spectacle, luxury, and a desire to make the movie-going experience an event outside the boundaries of daily life. As Jeffrey Klenotic, an associate professor of communication arts at the University of New Hampshire, told Yates, "Cinema-going has as much to do today with the hospitality industry as it does with the film industry, per se." To achieve this effect, Yates notes,

> These upgraded theaters' offerings begin with the super-comfortable seating, even lounge chairs and beanbags in some auditoriums. Add 3-D effects and larger-than-life IMAX blockbusters, made possible by new digital projectors. And then come the midnight movie premieres and opening-night parties.
>
> To boost revenue and appeal, many theaters also are broadcasting live sporting events, operas and symphony performances and hosting in-theater video game competitions on the big screen. Still others are opening in-house restaurants and bars for those old enough to drink alcohol. . . . In Europe, cinemas are taking it a step further by remaking themselves as entertainment destinations—with bowling alleys, karaoke bars, comedy clubs and children's play areas. . . . [The] interior design schemes . . . appeal to the 18-to-24 set . . . with a few splashes of color, flashing lights and loud music. Video games, often tucked away in theaters of old, also are scattered around in plain view.

Another aspect of this goes beyond presentation and into the heart of film structure itself. In a groundbreaking study, James E. Cutting of Cornell University and his staff "analyzed 150 popular movies released from 1935 through 2005 [counting and measuring] all the separate shots, the bits of [film] that are taken from different camera angles and were spliced together by cuts, fades or wipes" (Angier D2). Their conclusion? Aside from the obvious one—that, since 1960, shot structures have grown increasingly complex, with increasingly rapid cutting as the years progress—Cutting and his colleagues found that the shot structure of contemporary films, according to Natalie Angier,

has greater coherence, a comparatively firmer grouping together of similarly sized units that ends up lending them a frequency distribution ever more in line with the lab results of human reaction and attention times. "Roughly since 1960," Dr. Cutting said, "filmmakers have been converging on a pattern of shot length that forces the reorientation of attention in the same way we do it naturally." (D2)

In short, cinematic "vision" has fallen in line with human vision; and as we become increasingly accustomed to visual multitasking and our surroundings become increasingly complex, cinematic shot structure has grown ever more hyperkinetic and fragmented, just as an actual observer might confront such a scene in real life, by flitting from one detail to the next with almost stroboscopic intensity in an attempt to take everything in.

The recent James Bond film, A Quantum of Solace (2008), for example, had an average shot length of a mere 1.7 seconds, or roughly 40 frames per shot, which is astonishing when one considers the meditational gaze of such films as John Ford's The Grapes of Wrath (1940) (also analyzed in the study), in which the director would allow the camera to hold on a person's face or a scene for minutes at a clip (Angier D2). Cutting's study concluded that eventually shot structure will grow even more complex and splintered, reflecting contemporary visual overload and our need to adapt to it. Long takes bore us; we need something new, nearly every second.

Contemporary cinema can only oblige us, that is, if it wants to compete with the minuscule attention span required by most YouTube offerings, with an average running time of 2 to 3 minutes. Shortly before his death, director Ronald Neame observed that this trend to keep up audience interest at all costs ultimately paid limited dividends, commenting that contemporary cinema had in general "become too frenetic, partly because the stories are not good enough . . . so they try to make up for their lack of . . . characterization and storytelling by quick cutting and frenetic use of the camera" ("Director Ronald Neame Dies"). Such a strategy can only work for a while, until audiences finally realize that at the center of all the rapidly swirling images there's really no content at all.

To keep up with this shift in cinematic values, the media surrounding the film industry has changed as well. For many decades, *Variety* and the *Hollywood Reporter* were the true bibles of show business, the "trades" that no one in the business could afford to be without. Now, as newspaper readership declines across the board, both publications, but especially *Variety*, have become increasingly out of touch with the second-by-second rhythm of the film industry. In their place, numerous showbiz blogs have appeared, but none is more influential, or more feared, than *Deadline Hollywood Daily*, founded, edited, and largely written by Nikki Finke. To give you an example of how fast things are moving right now, consider the fact that *Deadline Hollywood Daily* didn't even exist until 2006 but since then has become arguably the dominant source of information and gossip for the industry, displacing print media with an around-the-clock barrage of updates, exclusives, and withering criticism.

A former correspondent for the Associated Press in Moscow and for *Newsweek* in Washington, D.C., Finke began her blog in March 2006 when she was running short on cash and career opportunities; like many prescient bloggers, she realized that print journalism couldn't keep pace with the digital era and began hammering away at her computer from her home in Westwood, California. As David Carr, one of the few people to garner an interview with her, commented,

> In a place built on appearances, she is never seen at the right premiere, the right lunch spot, the right address. Her presence in Hollywood is spectral—she had a single photo taken in 2006 that runs everywhere. "I just don't go out to industry events, in part because it puts my sources in an awkward situation," she said, adding that "the other thing about going out with these people is that when it comes time to cover something involving them, they say, 'But, Nikki, we're friends.' I don't want those kind of friends." "It is not a great mystery how all of this happened," said Joe Donnelly, who edited her column at *LA Weekly*. "It happened because Nikki willed it to happen through a lot of hard work. She is not afraid of new technology and new ideas. She saw this coming." (A3)

As always, Hollywood is a place of continual reinvention, only now it is literally happening at the speed of light. Nikki Finke's site is uninterested in film criticism, theory, or even most star gossip; what interests her are the everyday nuts and bolts of the industry, or what *Variety* used to call the "executive shuffle." As Carr notes, her site really exploded in 2007–2008, when her coverage of the Writers Guild of America strike—minute by minute, painstakingly accurate, absolutely thorough—made *Deadline Hollywood Daily* a must-view destination. Though her site has recently been purchased by Mail.com Media, Ms. Finke retains sole editorial control, still writes a majority of the site's content, and provides the most penetrating and incisive coverage that one could ask for in an industry where secrecy is at a premium. With *Deadline Hollywood Daily*, the story always gets out—at lightning speed.

Another issue is the perpetual shibboleth that film audiences are predominantly male, ages 18 to 24, and that this is the reason why comic-book movies drive the theatrical market. But a good deal of recent research casts considerable doubt on this line of reasoning. As Melissa Silverstein reported,

> Younger people in general go to the movies more, but based on the MPAA [Motion Picture Association of America] numbers of frequent moviegoers (ones who go more than once a month) in the coveted demographic of 18–24, women make up 3.4 million filmgoers while men make up 3.1 million.
> . . . In 2009 there were 217 million moviegoers. The total admissions was 1.4 billion dollars. Women are 113 million of the moviegoers and bought 55 percent of the tickets. Men are 104 million of the moviegoers and 45 percent of the tickets. [As the MPAA summarized,] a higher percentage of women than men are moviegoers in all categories of frequency. [In short,] women make up 9 million more filmgoers than men. ("Guess What?")

And while Kathryn Bigelow is the hot name of the moment, with two Oscar wins for *The Hurt Locker*, other, more commercial filmmakers are tapping into this burgeoning female audience. Nancy Meyers,

for example, is one of the top power players in Hollywood, and her films are designed to appeal to a wide-ranging audience but one that is skewed toward younger women. Her first film as a director, the remake of Disney's *The Parent Trap*, was released in 1998 and grossed $92 million worldwide; her film *What Women Want* (2000) made $374 million in worldwide rentals; *Something's Gotta Give* (2003) took in $267 million internationally; and *The Holiday* (2006) grossed $205 million throughout the world (Merkin 34–35). While frankly admitting that her films are mainstream, escapist entertainment, Meyers is clearly adept at creating films that audiences want to see and that, more importantly for Hollywood, make money. And yet, paradoxically, and perhaps heretically, she claims the French cineaste François Truffaut as one of her idols, a man who often said, as Meyers is fond of noting, that "making movies is an accumulation of details" (33).

As Daphne Merkin commented after watching Meyers at work on *It's Complicated* (2009), her fifth film as a director and one of her most successful ($214,886,000 worldwide gross on a total budget of $85,000,000),

> Meyers has directed and produced four movies (three of them under her own production company, Waverly Films, which is named after the theater where she saw virtually every movie of her childhood)—and is now paid upward of $12 million for each. This amount doesn't include her earnings as what is known in Hollywood as a "gross player"— someone who takes home a percentage of the film's profit over and above his or her salary.
>
> It typically takes Meyers two years from start to finish to do a movie—a year for the writing, then six months for the shooting and another six for the editing. She is known for her obsessive, micromanagerial attention to detail. . . . "I don't shoot movies quickly," she says, "because I get a lot of coverage and a lot of angles, so we have all the pieces in the edition. I do a lot of takes, but it's because I'm looking for something." John Burnham, [her] I.C.M. agent, has a simpler, X-versus-Y-chromosome view of the whole thing. "If Mike Nichols said to do another take," he crisply notes, "there would never be any issue." (32–33)

This X-versus-Y factor of incipient sexism is something that still, perhaps not unsurprisingly, permeates the industry, despite the numerous women who successfully work in the business as studio heads, producers, writers, and directors. Indeed, when James Cameron was going head to head with his former wife, Kathryn Bigelow, for best director honors at the 2009 Oscars, he suggested in an interview that Bigelow might win the prize *because* she was a woman. As he told an interviewer on MTV, "I would say that it's an irresistible opportunity for the Academy to anoint a female director for the first time. I would say that that's, you know, a very strong probability and I will be cheering when that happens" (as quoted in Nolte). As John Nolte observed about this comment,

> Cameron's been running around practically begging the Academy to split the difference and award Bigelow with the director Oscar and *Avatar* with best picture. At first he sounded gracious, but now I'm not so sure. You get the impression that he wants to position himself as the man who bestowed the award on Bigelow, or at least volunteered to get out of her way, as opposed to losing to her fair and square—and the. . . . interview with MTV appears to back that up.

And yet, according to a study conducted by the Center for Study of Women in TV and Film, "in 2008, women made up 25 percent of creators, executive producers, directors, writers, editors, and directors of photography working on situation comedies, dramas, and reality programs, [and] 23 percent of executive producers" for television (Silverstein, "What Is This?"). The figures within the industry as a whole are comparable; yet advertisers, reviewers, media pundits, and other supposedly knowledgeable sources continually play down the influence of women as both creators and consumers of programming content, whether it be for television, theatrical motion pictures, or even the web.

Nonetheless, as the New Media Strategies study group recently pointed out, "women control slightly more than half of all personal wealth in the U.S.; women make 83 percent of family purchasing

decisions; and unmarried women delivered a stunning 70 to 29 percent margin to Barack Obama during [the 2008] election. . . . [A]t the end of the day it is important to realize that women are the target audience, not a niche audience" ("Why Women Are the Target Market"). This is something that Abbe Raven, CEO of A&E Television Networks, knows very well. The group owns the A&E Channel, the History Channel, Lifetime Movie Network, and the Lifetime Channel itself; and Raven became CEO in 2005. A former high school teacher who joined A&E as a secretary in 1982, she rose to the top through a series of savvy media decisions.

By January 2010, Lifetime Movie Network was reaching 75 million households, up 11 percent in 2009 alone, demonstrating once again that, while not touted in the media, women are a dominant force in the construction of the modern media landscape, albeit one that often goes underreported in numerous audience surveys. Even in emerging media, women are the leaders in using and creating content for Twitter, Facebook, and Flickr: 57 percent of all Twitter and Facebook users are female, and 55 percent of all Flicker users are women. Digg is the only network whose users are predominately male, at 64 percent (see Thornton). With statistics like these, why is there a public disconnect between audience perception and the reality of the marketplace? Patrick Thornton of Beat Blogging.org has one possible explanation:

> I have a lot of theories as to why there are more females on social media than men, but nothing concrete. It's clearly important, however, to understand the demographics of each social network, *and news organizations—especially newspapers—have struggled for years to attract as many female readers/users as they do with males* [emphasis added].

We argue that is the *interactivity* that drives women to use these sites more than men, to create a sense of community, and thus to build an audience different from the one that is presented by the mainstream, read-only media. Newspapers, radio, and television broadcasts are all one-way propositions: information, of a sort, comes out, but feedback opportunities are limited. With Flickr, Twitter, Facebook, Ning, and MySpace, users have the opportunity to engage in a dialogue, contrib-

ute content, and help shape the discussion of the flow of news, programming content, and distribution patterns.

Conventional broadcast and print media speak from a seemingly unassailable pulpit; but as many studies have shown, audiences are tiring of getting their news and entertainment programming from an unresponsive, closed-circuit system. Newspaper and magazine readership continues to plummet, and we posit that this is not a question of print versus electronic media but the difference between a passive spectator and a responsive one. This interactivity, then, will continue to be the benchmark of new forms of media—both entertainment and information—in the decades to come.

Similarly, African American directors are creating a new audience for their films, as pioneers Oscar Micheaux and Spencer Williams carved out their own territory in a series of groundbreaking all-black-cast films in the 1930s and 1940s. The most famous exponent of the black renaissance in American cinema is unquestionably Spike Lee; but a host of other directors, such as Hollywood veteran Michael Schultz, Robert Townsend, Gina Prince-Bythewood, Darnell Martin, Tyler Perry, John Singleton, Albert and Allen Hughes, F. Gary Gray, Kasi Lemmons, and Matty Rich, to name just a few, are making their mark on the contemporary cinematic landscape. Darnell Martin, for instance, started her career with her debut feature *I Like It Like That* (1994), a raucous sex comedy, but soon fell afoul of studio stereotyping. As she told Gene Seymour,

> They insisted on making me the poster child for the film, the "female Spike Lee," and I said, "Look, I don't mind that. I'm proud to be a black woman director, and I want that out there." But we'd gotten some great reviews, and I felt that was what they should be leading with. If it had been a white director, they would have emphasized the reviews, but instead they were trying to get people to see it only because I was black. (11)

As Seymour notes of Martin's experience, "momentum for African-American cinema is stalled by conceptions about its audience" (11). When feature work dried up, Martin went into television, directing

many episodes of the prison series OZ before moving on to her film *Cadillac Records* (2008), a fictionalized history of Chess Records starring Adrien Brody, Mos Def, Beyoncé Knowles, and Jeffrey Wright. Beyoncé's performance as R&B pioneer Etta James was particularly praised, and Beyoncé sang James's signature number, "At Last," at Barack Obama's inaugural ball as the newly appointed president and his wife, Michelle, danced together for the first time as first lady and president.

Still, although the film received generally positive reviews (David Edelstein, the film critic for *New York* magazine, placed the film at the number 4 slot in his 10 best for the year, A. O. Scott of the *New York Times* ranked it 10th out of 10, and the film picked up best-picture honors at the prestigious Black Reel Awards), *Cadillac Records* still struggled, surprisingly, to find an audience. Shot for a mere $12 million, it grossed only $8,288,710 during its worldwide theatrical run but then sold an additional $7,847,772 in DVDs after release, putting the film firmly on the profit side of the ledger.

However, prospects for the creation of a cohesive African American audience continue to improve, especially when one considers the box-office clout of such crossover stars as Denzel Washington and Will Smith, who appear in a wide variety of projects in every imaginable genre and appeal to a wide international audience. As Zola Mashariki, senior vice president for production at Fox Searchlight, notes,

> Twenty, even 10 years ago, the only way you could see actors like Denzel Washington or Cuba Gooding or even Will Smith was in an African-American movie. Now you find that almost every mainstream movie has a black presence, whether in a big-budget action movie or even a comedy geared towards mass audiences.
>
> . . . What this means for movies whose core target audience is black is that we have to give them something that they're not getting in the mainstream, which are stories that reflect back their own direct experience, and I think that's something Tyler Perry has done. This doesn't mean you're not hoping for some crossover success. You always want that. But you don't want that core audience to feel left out, that the movie's not speaking to their own lives. (as quoted in Seymour 15)

Will Smith, in particular, is one of busiest actors in Hollywood, with a long string of credits in every possible aspect of the medium, from rapper to television sitcom actor to movie star to producer and screenwriter. While starring in the TV series *The Fresh Prince of Bel-Air* from 1994 to 1996, on which he also served as executive producer, Smith segued into an extremely successful career as a major film star, beginning with a role in Fred Schepisi's *Six Degrees of Separation* (1993). He then smoothly moved on to leading roles in such films as Roland Emmerich's science-fiction epic *Independence Day* (1996), Barry Sonnenfeld's equally sci-fi themed *Men in Black* (1997), Alex Proyas's *I, Robot* (2004), nominally based on Isaac Asimov's classic novel, and Francis Lawrence's *I Am Legend* (2007), based on Richard Matheson's novel. All these projects were enormously successful commercially, and Smith soon became a completely bankable star, one who could "open" a movie all by himself.

Indeed, in *I Am Legend*, as the last man on earth, he *had* to: for most of the film, Smith's character, Robert Neville, wanders through the streets of a post-apocalyptic Manhattan, with all other human beings apparently dead, if they've not been transformed into flesh-eating zombies who attack in waves by night. (The film, incidentally, is the third version of Matheson's source work; Ubaldo Ragona and Sidney Salkow directed an Italian American co-production of the novel as *The Last Man on Earth* in 1964, starring Vincent Price; and Charlton Heston starred as Robert Neville in Boris Sagal's *The Omega Man* in 1971.) Through all these projects, Smith moves with ease and assurance, and everything he touches seems to turn to gold. As a result, his services are much in demand; as of July 10, 2010, he had no fewer than 30—that's right, 30—films in various stages of preproduction.

Unless Smith clones himself, there's no possible way that he can fulfill all these commitments, but the sheer volume and range of the projects Smith is tackling demonstrates conclusively that he may be the first truly post-racial star; his appeal transcends all national, social, and racial boundaries, yet he retains close ties to the black community, as evidenced by his star turn in Gabriele Muccino's *The Pursuit of Happyness* (2006), based on a true story, in which young entrepreneur Christopher Gardner (Smith) struggles to keep himself and his son

afloat as he reaches for his piece of the American dream against seemingly insurmountable odds. Smith's future in films is only expanding; able to tackle commercial as well as personal projects with equal assurance, he has a seemingly limitless future as a major A-list star.

Gina Prince-Bythewood's *The Secret Life of Bees* (2008) was also a commercial and critical success, with worldwide box-office receipts of more than $40 million and a multiracial cast anchored by Queen Latifah in the leading role. With this success comes greater commercial clout, just as with Will Smith, though certainly to a lesser degree of influence. Nevertheless, Prince-Bythewood notes that "I know now that I can get [the script for my new project] read by everybody, and the doors will be opened wider" (as quoted in Seymour 11). And Michael Schultz, who has the longest-running career of all contemporary African American directors, displays a similarly wide range of interests in his work, which ranges all the way from 1970s blaxploitation films such as *Cooley High* (1975) and *Car Wash* (1976) to the Richard Pryor comedy *Greased Lightning* (1977) and the musical *Sgt. Pepper's Lonely Hearts Club Band* (1978)—which was largely trounced by the critics and suffered fatally from the casting of the Bee Gees as Beatlesque clones in the title roles of the film—before he moved into television and began directing episodes of everything from *The Rockford Files* to *Ally McBeal* to *Brothers and Sisters*, one of the most popular network hour-long dramas of recent vintage.

Still, it was the rather spectacular failure of *Sgt. Pepper* that forced Schultz into television and away from theatrical films. Despite the success of his previous ventures, the project's disastrous reception caused his Hollywood bankability to plummet. As Schultz himself said, "White directors can have big failures, like Francis Ford Coppola, and they'll get another chance. But black directors have one failure and they're finished. The projects from then on didn't come like they did for white directors who failed" (as quoted in Wankoff). And yet Schultz has persevered in an often-inhospitable industry, carving out a path for himself and others by example and paving the way for the current generation of black filmmakers.

Tyler Perry is another exponent of the new African American cinema; but to some observers, his work is more problematic. Perry is a

largely self-taught filmmaker, and he certainly is an entrepreneur: born into relative poverty and an unstable family background, he dropped out of high school at age 16 and drifted through a variety of minimum-wage jobs until, inspired by an *Oprah Winfrey Show* in 1991, he began writing in earnest and soon completed his first play, *I Know I've Been Changed*, in 1992. When an attempt to mount the production in a conventional theater failed, and cost him his life savings of $12,000, Perry decamped to lick his wounds, once again supporting himself with subsistence labor until 1998, when he figured out what had gone wrong with his first attempt to produce *I Know I've Been Changed*, a deeply personal work dealing with rape and child abuse. (As a youth, Perry was abused by his father.) As Hilton Als writes,

> The audience that he wanted to attract—poor and lower-middle-class Christian blacks like him—thought of theatergoing as a luxury. Churchgoing, on the other hand, was a necessity. Perry resolved to turn his performances into an extension of their faith. He did the rounds of Atlanta's black churches, becoming a spokesman for his play and the values it stood for. He was personable, presentable, and religious; and his play, he made clear, delivered a Christian message—Jesus forgives everything, even poverty and blackness—through characters and situations that audience members would recognize from their own social, cultural and economic worlds. (68)

Having found an audience, the play was a hit, and Perry soon began crunching out one new production after another, including *I Can Do Bad All by Myself* (1999) and *Why Did I Get Married?* (2004). He toured with the productions, doing between 200 and 300 shows each year, which he wrote, produced, directed, and starred in. This gave him the money for his next big leap: movies. In 2005, he wrote, produced, and starred in director Darren Grant's *Diary of a Mad Black Woman* (2005) and in 2006 directed, produced, and starred in *Medea's Family Reunion* (2006). Both were enormously successful at the box office.

But what makes Perry's work problematic for Als and other cultural critics is its tendency toward repetitive (and often recycled) plots relying on "melodrama" (Als's word) and the syrupy righteousness of

his "faith will conquer all" scenarios. But like Steven Spielberg, who proudly noted in a 1999 interview that "I've never made a movie that I consider immoral. . . . [T]he majority of my films, I have made to please people" (as quoted in Dubner), Perry never wants to leave his audience behind. While Spike Lee tackles complex projects like *Jungle Fever* (1991), *Malcolm X* (1992), *Four Little Girls* (1992), *Bamboozled* (2002), and other films that examine racial stereotypes, racism itself, and the history and impact of the civil rights movement in American society, Perry offers them something else: safety. Notes Als, Perry's films show "what the audience wants to see, rather than what actually is." He continues: "Perry has been, for some time, virtually critic-proof. No white critic wants to tell a black man what he can or cannot say about his own society. As for black audiences and critics, Perry is just about the only director who actually makes an effort to reach and entertain them; why wouldn't they appreciate that attention?" (72).

Why not, indeed? For if Tyler Perry knows one thing, it is how to construct an audience and give them something simple, reassuring, and familiar. This, of course, is what Hollywood appreciates most: a winning formula, ceaselessly repeated, that always makes money and leaves viewers hungry for more, as a fast-food hamburger does. It's not surprising, then, that of all the African American filmmakers discussed here, Perry has had the greatest commercial success. His films and plays are feel-good, moralistic entertainment ladled out with large dollops of slapstick comedy, which includes the figure of Perry himself in drag as Medea, his signature on-screen alter ego. There's nothing at risk in a Tyler Perry film, and that's just the way he wants it.

That's the way Hollywood likes it, too. For a long time, the studios have been "running on empty" in the content department, recycling not only plots but characters, situations, and sometimes the entire screenplays of previously made films because, as Jack L. Warner, the production head of Warner Brothers, once observed, "great films aren't made—they're *remade*." As the film capital moves into the 2nd century of cinema, this seems truer than ever before, with a plethora of films awaiting resurrection with new casts, vamped-up special effects, and, in many cases, actual or reprocessed 3-D, the flavor of the month for most studios, as a way to enhance box-office returns by tack-

ing an extra $2 or so onto each admission ticket. As Simon Brew astutely notes, "It's far cheaper for Hollywood to avoid original ideas and thinking altogether wherever possible, and instead attempt to breathe fresh life into an old film or dormant franchise. Throw in US versions of world cinema hits, and the increasing trend to revisit old TV shows too, and you come up with a scary list of projects in varying stages of production."

As proof, Brew offers no fewer than 75 examples of films soon to be released or in various stages of production or preproduction, including *Alien* (since the series has clearly run its course, this would have to be a complete reboot); *American Pie* (as Brew acidly comments, "after plundering as much blood out of the franchise as it could via straight to DVD sequels, Universal is now looking to reboot the cinematic *American Pie* franchise. It'd pick up the story of the key characters ten years later, and the likes of Jason Biggs and Seann William Scott would be set to return"). There is also the 2011 remake of *Arthur*, centering on an alcoholic multimillionaire and his tirelessly attentive butler, played respectively by Dudley Moore and Sir John Gielgud in the original 1981 version, directed by Steve Gordon.

With Jason Winer directing and Russell Brand [star of Nicholas Stoller's comedy *Get Him to the Greek* (2010)] stepping into the role that Dudley Moore made famous, the film was supposed to be an instant hit, but was a critical and commercial failure. Another target is *The Birds*, based on Alfred Hitchcock's classic 1963 thriller. (There already has been, believe it or not, a sequel to the film, *The Birds II: Land's End* [1994], a TV movie so abysmally poor that the film's director, Rick Rosenthal, had his name removed from the credits, and replaced with the infamous *nom de désastre* "Alan Smithee.")

Tippi Hedren, the star of the original 1963 version, offered this opinion about a remake of *The Birds*: "A couple of years ago, when they were first thinking about it, they called and asked what I thought about a remake. . . . I thought 'Why would you do that? Why?' I mean, can't we find new stories, new things to do? They tried to make *Psycho* over [in 1998, in an updated version by director Gus Van Sant] and it didn't work. Must you be so insecure [that] you have to take a film that's become a classic and a great success and then try to do it over?"

(as quoted in Adler, "Original Screen Queen"). The new version was expected to star Naomi Watts, with Martin Campbell slated to direct. After years of preproduction, a screenplay is reportedly complete; Universal has now pushed the film back to 2012 or even 2013 (see Brew).

Other remakes in the works include *The Best Little Whorehouse in Texas*; *Creature from the Black Lagoon* (no doubt in 3-D, as was the original 1954 version directed by Jack Arnold); *Death Wish* (another reboot of a moribund franchise, perhaps with Sylvester Stallone in the Charles Bronson role); *Dune*; *Escape from New York*; *Flash Gordon* (also in 3-D and directed by Breck Eisner, who ironically made his reputation on a 2010 remake of George Romero's 1973 film *The Crazies*); *Ghostbusters*, with Bill Murray and Harold Ramis reportedly set to appear as if they are passing the torch to a new generation of ectoplasmic warriors; *Gilligan's Island* (TV adaptations always have a healthy pre-sold audience); *Footloose*; *Hawaii Five-O* (as a rebooted TV series); *Honey, I Shrunk the Kids*; *Jurassic Park* (another "from the top" reboot); *Police Academy*; *Porky's*; *Superman* (with *Dark Knight* director Christopher Nolan "supervising" production, to give the film a grittier look); *Teen Wolf* (as a television series for MTV; the pilot is already in the can, directed by Russell Mulcahy); *The Thing*, a prequel to John Carpenter's 1982 remake of Howard Hawks and Christian Nyby's 1951 original, helmed by Matthijs van Heijningen, Jr.; yet another offering in the *Lara Croft: Tomb Raider* franchise; *The Warriors* (based on Walter Hill's 1979 original, directed this time by *Top Gun* helmer Tony Scott). Robert Zemeckis's remake of *Yellow Submarine*, however, was thankfully scrapped in early 2011 after the failure of *Mars Needs Moms* (see Brew).

Is there a spark of originality in *any* of these projects? Of course not, but that's the point. They're pre-sold, and they'll probably sell. Younger audiences haven't seen the originals, and older viewers might just be curious enough to buy a ticket to see what the updated version looks like. In any event, it seems relatively assured that these films will at least make back their negative cost and are (at least to Hollywood's corporate mindset) safer bets than something new, untried, and untested. An original concept? Risky. A sequel, reboot, or remake? Usually money in the bank. This ultra-commercial approach to narra-

tive material has been with us since the dawn of the cinema, of course; even cinematic pioneer Alice Guy Blaché remade her 1896 hit *La Feé aux Choux* (*The Cabbage Patch Fairy*) in 1900, when the original negative wore out, in response to public demand.

But given the ever-rising cost of filmmaking, the saturation booking philosophy (in which a film opens everywhere at once, worldwide, on the same day to ensure complete penetration of the market and to forestall piracy and potential negative word-of-mouth) has become entrenched as the sole way of opening a film for maximum payoff, which makes only the most pre-sold projects attractive to major Hollywood studios. When a moderately budgeted original film becomes a surprise success, big-budget sequels immediately follow, often to deleterious effect. And if a foreign film, in its original language, is a surprise hit, it almost always gets remade as a big-budget Hollywood film, in English, with American stars replacing the original actors for marquee value alone.

Consider George Sluizer's *The Vanishing* (1988), a Dutch-French co-production that was a modest, efficient, and eerily unforgettable thriller. In 1993, Sluizer accepted an offer to direct a Hollywood re-make of his film, starring Jeff Bridges, Kiefer Sutherland, and Sandra Bullock; in doing so, he was forced to rewrite the shocking, deeply nihilistic ending of the original to create a forced happy ending, ruin-ing both the film and his career as a director. More recently, Georgian filmmaker Géla Babluani created a stir with his first film, an equally uncompromising thriller, *13 Tzameti* (2005), shot in France, about a young man forced into a ritualistic tournament involving progressively dangerous rounds of Russian roulette. The film was an instant hit with audiences and critics, and Babluani was seduced by the prospect of a Hollywood version of his gritty black-and-white original. For the 2010 remake, however, he rewrote much of the narrative to make the film more acceptable to an American audience; and rather than using a cast of talented unknowns (including his own brother, Georges Babluani, a complete novice, in the leading role of the original), Bab-luani shot the film in color (seldom a good idea for a film noir) and cast Mickey Rourke, 50 Cent, and Jason Statham in the principal roles. Why bother to do this? Because black-and-white films, especially with subtitles, may win critical plaudits and perform respectably at the box

office, but an English-language color remake—*now* you're talking real box-office potential. But the remake was a misfire, failing both critically and commercially.

Similarly, Tomas Alfredson's inventive Swedish vampire tale, *Let the Right One In* (*Låt den rätte komma in*, 2008), a substantial audience and box-office success, was remade as a glossy, big-budget Hollywood film by director Matt Reeves (who broke through with the monster film *Cloverfield* [2008]), using his own script, based on (but not entirely faithful to) the original novel and screenplay, which is a period piece set in 1982. Again, there were two major factors propelling this remake: (1) a lack of original ideas, and (2) the profit potential for an English-language version with recognizable stars in the leading roles. But the new version, entitled *Let Me In*, failed at the box office despite the artificial gloss of A-level production values and star power involved in the project. Chloë Moretz, the teen star of Matthew Vaughn's comic-book film *Kick-Ass* (2010), appeared in the pivotal role of Abby, a 12-year-old vampire constantly on the lookout for new victims, but even she couldn't save the film.

Just as a starting point, consider the significant changes that will arise in moving the film from the frigid precincts of Stockholm to the fictional town of Los Alamos, New Mexico (the film was actually shot in and around Albuquerque). Surprisingly, *Let Me In* was one of the first projects of the newly revived Hammer Films, which in the 1950s and 1960s pioneered a new approach to gothic horror with such classic films as Terence Fisher's *Horror of Dracula* (1958). But that was under Hammer's original management; now, new Hammer chief Simon Oakes says of the remake,

> I think [the remake] takes it out into a more accessible setting. I think perhaps there is a little more characterization in terms of the two central characters. To be perfectly frank with you, this is making an astonishing story—*which however hard you might try or I might try to get people to go see the original, they're never going to do it* [emphasis added]—more accessible to a much larger audience. I think perhaps, again, the roughness of the original is great . . . but I think [the remake will] just have perhaps a little sheen to it that makes it a little more accessible. (as quoted in McCabe)

For his part, Tomas Alfredson, the film's original director, wasn't particularly thrilled by the prospect of an English-language remake of his film, commenting that, "if one should remake a film, it's because the original is bad, and I don't think mine is" (see Triches). However, John Ajvide Lindqvist, the author of the novel on which Alfredson's film is based, disagreed, opining that Reeves would "make a new film based on the book, and not remake the Swedish film. . . . It'll be something completely different, but it's going to be really interesting to see" (see The Northlander). For his part, director Matt Reeves was well aware of the potential pitfalls of the entire enterprise, telling Mark Olsen that

> There's definitely people who have a real bull's-eye on the film, and I can understand because of people's love of the [original] film that there's this cynicism that I'll come in and trash it, when in fact I have nothing but respect for the film. I'm so drawn to it for personal and not merce-nary reasons, my feeling about it is if I didn't feel a personal connection and feel it could be its own film, I wouldn't be doing it. I hope people give us a chance.

Reeve's respect for the original film was genuine enough, but that's not what's driving Let Me In. Rather, it is producer Simon Oakes's previ-ously quoted assertion that "however hard you might try or I might try to get people to go see the original, they're never going to do it" (see McCabe).

But why is this true? We argue that it's because of distribution pat-terns: the conditioning of audiences to expect elaborate spectacles with computer-generated imagery, instantly recognizable characters, and predictable plot arcs and to shun films that make them work for their pleasure, that ask them, in a sense, to be the co-creators of the film. Subtitles, foreign languages—both are seen as audience barri-ers. In the 1960s, when all feature-film distribution was theatrical, even small towns in America had an art-house theater that played for-eign imports—films by Bergman, Fellini, Varda, Godard, Truffaut, Kurosawa, Bertolucci, and others—to packed houses and respect-able grosses, at least enough to keep the theaters and distributors afloat, because audiences had been *trained* to differentiate between

modestly budgeted, thoughtful independent films and glossier Hollywood productions, and to appreciate both groups of films on their own terms and turf.

Today, with the ubiquity of streaming video, on-demand movies, and pay channels, the entire art-house circuit has collapsed. No longer does a distributor need to release a "difficult" foreign film in a theater. There are cheaper, simpler ways to exploit it. At the same time, even if a brave distributor wanted to open a small, foreign language, subtitled film on a wide basis, it would be nearly impossible to do so, inasmuch as the overwhelming majority of U.S. theater screens are dedicated to mainstream product. Thus, there's really no place to exhibit smaller films, and they are relegated to the margins of a nominal "selected cities" release (New York, Los Angeles, Chicago, Boston, and the like) and then a fast playoff to DVD format or "on demand."

But even a DVD release is becoming problematic as the market for home video becomes saturated and fewer people purchase DVDs, preferring to rent them from Netflix or Blockbuster or, even more easily, stream films live from various online sites, watching as the images download onto their computer screens. Today, the moving image, once discrete and sacrosanct, has become something like water, gas, or electricity: a utility that one turns on and off at will, consuming bits and pieces of a film at one's leisure rather than experiencing the film as it was meant to be seen, on a large theater screen as part of a communal shared experience.

Much of this diminishing audience tolerance for anything other than the ordinary can be traced to the popular films of the 1970s, when the modern blockbuster appeared in the shape of Steven Spielberg's *Jaws* (1975) and George Lucas's *Star Wars* (1977). As Stephen Dubner noted in a profile of Spielberg in 1999, the director, a former Boy Scout, describes himself as the embodiment of the values set forth in the Boy Scout code, ticking them off rapidly as life lessons he learned long ago: "I'm trustworthy, I'm loyal, I'm sometimes helpful, I'm sometimes friendly, I'm always courteous, not always kind, not always obedient, not always cheerful, mostly thrifty as a producer, not brave at all, always clean and very reverent." Spielberg also owns a solid collection

of Norman Rockwell originals, which certainly mirror these values. Dubner adds,

> Spielberg is driven by a need for approval—from his family, from his peers and especially from his ticket buyers. When I ask him who he thinks his core audience is, he says, "At this point, it's pretty much everybody, which I think is great, because every comic wants to fill up the house with laughing, stomping people, and I'm a whore like any other stand-up who wants big laughs." This is the kind of talk that makes his friends smile and his critics cringe. Spielberg's desire for approval, the critics say, is what breathes sentimentality into his films, or inspires him to substitute moral simplicity for nuance. They chafe at his do-good instincts and argue that his cinema of accommodation has taught the entire world to view history as he sees it: in black and white, with musical accompaniment.

Of course, the world isn't that simple, and Spielberg knows it. As an action filmmaker, he is without peer, the logical successor to such kinetic directors as William Witney, who directed numerous non-stop slugfests as Saturday morning serials for Republic Pictures in the 1930s and 1940s; but when Spielberg moves into deeper material, this simplicity of vision seems to be a handicap. Spielberg's approach to the cinema has become a template for others to follow. His films make a fortune, they place no real demands on viewers, and he can churn them out like cereal boxes. There's nothing wrong with this, but a steady diet of Spielbergian cinema would make it difficult for a contemporary audience to appreciate the subtlety of a more demanding auteur. Spielberg's films do all the work for the viewer, just as Rockwell's paintings focus on the sweet spot of faux nostalgia in their celebration of an America that never really existed, except in the artist's memories.

But while there's nothing wrong with escaping, per se, the problem is that Hollywood keeps selling the same dream over and over again; in the end, the "escape" becomes as mundane as the most quotidian daily existence. The powerless will triumph, good will overcome evil, couples will live happily ever after, children will enter magical realms in

which all their dreams are satisfied, and all villains will be vanquished (until the sequel, of course). But the problem comes when we lose the ability to distinguish between reality and virtual experience, as Jacob Shafer argues:

> Many people call films like *Avatar*—and *Star Wars* and *Lord of the Rings* before it—modern myths. In a way they are. They contain universal themes, most notably what writer Joseph Campbell called the "hero's journey." We connect with these stories because we see pieces of ourselves—simplified, aggrandized pieces—in them. Yet what comes out of these modern myths is almost always a cartoonishly overblown affirmation of the Great Man; the power of the hero to swoop down and save the day. It's repeated in video games, in TV shows, in superhero comics and the films spun from them. We have become a nation of hero-worshippers. Waiting for the messiah to arrive and solve our problems with a wave of his hand or a swing of his lightsaber. . . . [But] every hour we spend watching fictional heroes solve fictional problems is an hour we aren't spending solving the problems that await us when we take off the 3-D glasses and emerge, blinking and dazed, into the bright glare of a very real world. (Gilsdorf and Shafer)

In short, virtual communities aren't "real" communities, except to those who control them, and those who have spent so much time staring at their flat-screen monitors that the actual word has ceased to exist. In 1956, Charles Eric Maine (born David McIlwain in 1921) published a superb, often overlooked science fiction novel, *Escapement*, which posited just such a future. In Maine's novel, tech mogul Paul Zakon, head of the "3-D Cinesphere organization," builds a worldwide network of "Dream Palaces," in which millions of "dreamers" lie immobile in isolation chambers, hooked up to electrodes and put into a semi-comatose state through a combination of IV drugs and liquid protein. These "dreamers" spend most of their lives existing only in a fantasy world, from which they emerge only when they've run out of money, and are taken out of the system. Then, like the addicts they are, the erstwhile "dreamers" desperately work at whatever menial job they can find until they can scrape together enough cash for another

6 months or so in one of Zakon's "Dream Palaces," and then the process repeats all over again. His unwilling associate in all of this is Dr. Philip Maxwell, whose research has created the "Dream Palaces," where millions of men and women are electronically fed dream scenarios more real than life, in which they experience lives of power, wealth, and sexual abandon.

As Maine prophetically writes, describing the vise of Zakon's "Dream Palaces"—and remember, this is more than half a century ago—

> at first the thing had been a novelty, an expensive novelty, demonstrated in a handful of specially adapted theatres in the major cities of the States. But the novelty had also been an enormous success. The Cinesphere studios converted their sound stages into psycho-recording sets, and ambitious productions were recorded on miles of brown plastic tape. Lavish, spectacular and sensational productions, loaded with romance and glamour and an aphrodisiac innuendo of sex. . . . In the space of four years psycho theatres—later to be called Dream Palaces—were installed in their thousands throughout North America. . . . Dreamplays were produced that ran continuously for days, and then weeks, and finally, years. (Maine 182, 184)

As Maxwell becomes increasingly uneasy with the growth of Zakon's empire, he starts to move against his employer but finds that Zakon's hold on both the populace and the law is too tight. People *want* what the novel terms "unlife"; otherwise, why would it be so popular? Eventually, a quarter of the world's population is sequestered in isolation tanks; and as they increase the length of their dream escapes, they gradually default on mortgage payments and other responsibilities. Then the Cinesphere corporation acquires their property and cash savings, exponentially increasing Zakon's empire with each passing day. As he tours the facility with Zakon, Maxwell stops to examine the isolation tank of one Paula Mullen, age 27, who has signed up for a dream entitled "woman of the world"—length, eight years of uninterrupted synthetic fantasy—in which she imagines herself alive, awake, and the center of worldwide media attention. In reality, of course,

she is an immobile, corpse-like husk in an oversized filing cabinet, but Zakon sees nothing wrong with this. As he tells Maxwell,

> There's nothing anti-social about unlife, Maxwell. In fact, it acts as a scavenger of society, and removes the more anti-social types from active circulation. Take this Miss Mullen . . . and try to imagine her as a useful member of society. She chose to escape from society for eight years. That proves she was one of the many millions of maladjusted people living out their lives in dull unending routine. The kind of people who find no creative pleasure in work. Who seek their fun in furtive sex relations and objective entertainment. She's better off here. She's happier than she ever knew and she's no longer a burden to society. (Maine 207)

By the end of *Escapement*, Maxwell successfully revolts against Zakon and brutally murders him with a jack handle, while recording Zakon's experience of death on one of Cinesphere's dream machines. Then, to awaken the millions of dreamers, Maxwell forces his way into the central control room of Cinesphere and orders the technicians to play the psycho tape of Zakon's murder throughout the entire Cinesphere system, in the hope of awakening the millions of dreamers from their narcoleptic slumber. But the tape of Zakon's death is too realistic: 100 million dreamers, ensconced in Cinesphere's isolation tanks, die along with Zakon, unable to support the horror of being beaten to death, and Maxwell is put on trial. As the prosecution intones, summing up the charges against him,

> Ninety-eight million, four hundred and thirty-two thousand, eight hundred and twelve people, men and women, old and young, died suddenly one evening nine months ago. They were voluntary dreamers seeking relaxation in the many Dream Palaces of the Zakon organization. This man, Philip Maxwell, coldly and brutally murdered Paul Zakon, and made a psycho-recording of his death agonies which he then played back over the world unlife network. The result you all know. Psycho dreams are realistic. Psycho nightmares are equally realistic. And psycho death is indistinguishable from ordinary death. (Maine 221)

The book ends with Maxwell sitting alone in his prison cell, awaiting the final verdict. While the conclusion of Maine's novel is undeniably melodramatic, one can't help comparing the operations of the fictional Cinesphere corporation to the real-life virtual worlds offered on the web, to which hundreds of millions of people subscribe and spend countless hours and real (as opposed to virtual) money to "exist" in a more attractive, alternative universe. While technological advances have long superseded the mechanics of Cinesphere's fictitious operations, the fact remains that, for many, online virtual life has become an addiction, more "real" than the physical existence they so desperately hope to escape. *World of Warcraft*, for example, currently boasts 10 million users and counting, and its advertising motto is "10 million people can't be wrong." But they can—and often are.

As Steve Mollman writes of the virtual reality phenomenon,

> consider Zach Elliott . . . [who] plays *Fantasy XI*, an online role-playing game. About three years ago, he says, "there were people in my real life that sort of vanished into this game, and I followed them into it." Now he spends . . . hours a day playing the game on a computer in his basement. "I could have never anticipated the sort of draw the game has had for me, and how involved I would get," he says. "It still surprises me." . . . For Elliott, an occasional reminder of how absorbed he is in the game comes when his Internet service is disrupted. "I get pretty upset," he says. Were he to be permanently cut off from the game, "I think I would feel that very acutely." At the same time, though, he knows that the game has to end eventually. "It's funny because when I think of not playing anymore . . . I think about it as almost kind of a death," he says. "I know that sounds very dramatic, but I mean it is a sort of a life, and so it is a sort of a death to have it end."

This sounds a great deal like the real-life death inflicted on the dreamers in Maine's *Escapement*, nor is Elliot's an isolated case. In New Delhi, virtual reality addiction is nearly pandemic, and more and more people seem to be forsaking the real world to live almost exclusively online. As Dr. Samir Parikh, a New Delhi psychiatrist, notes, young people are particularly susceptible to the allure of virtual reality

because it takes them out of their everyday problems into a completely immersive experience:

> The dazzling splendor of the virtual world makes the youth succumb easily. Websites like *secondlife*.com, *gojiyo*.com, *Farmville*, where they are introduced into a panorama of the animated world affects their mental health to a great extent. . . . [Players tend to cut themselves off] from the real world and get engrossed into the virtual gaming websites. Eventually they tend to lose interest in their daily normal activities, start losing interest in curricular and co-curricular activities. . . . [S]tudies appear secondary to them, and winning these games becomes of primary importance. . . . [P]eople [use] these websites . . . to keep away the stress of the existing world and enjoy gratification in the non-existent world. They are hence used as an escape from the social, professional and academic problems of life. (as quoted in Sharma)

For some, however, role-playing games offer a more positive experience. Ethan Gilsdorf, a popular writer on cyberspace and web gaming, is a proponent of alternative virtual realities and stresses the therapeutic values of the online community in his work. In one of his articles, Gilsdorf documents the case of Max Delaney, a young man who moved with his family to rural Maine in 1997 at the age of 8 and soon experienced a sense of crushing isolation both at school and in the community at large. Frequent family moves from one small town to another didn't help. As Gilsdorf reports, Delaney told him that "It was hard for me to find people." Now age 21, he says, "I was searching for a community." His academic performance suffered, and he didn't get along with his teachers. "I did not do well with authority in school" (as quoted in Gilsdorf).

But all of that changed when his family moved to Belfast, Maine, a town of roughly 6,300 inhabitants, and Max found a home at the Game Loft, a community outreach center founded by Ray and Patricia Estabrook. The Estabrooks ran a video game shop, All About Games, and had sensed a need for a space where teens could meet and play together rather than remaining isolated at their home consoles, cut off from the rest of the world. For Max Delaney, the Game Loft was a

lifeline. It is also unique: founded in 1998 in the attic of the building that housed the Estabrooks' shop, it remains, in Gilsdorf's words, "the only gaming-focused youth center in the country."

Delaney rapidly progressed from being a casual drop-in to a volunteer staff member and ultimately to an employee, and he feels that the center's impact can only be described as positive. As he told Gilsdorf, "I was [at the Game Loft] to socialize with kids who had mutual interest not only in games but conversation." Delaney says, "It was a place to channel a lot of curiosity." Moreover, he was able to interact with kids of all ages, as well as adults, who treated him as an equal. "The level of respect we got at The Game Loft was different than [at] school." Working together in a group, the denizens of the Game Loft have created a community based on gaming but not obsessed with it.

And for those who prefer more traditional entertainments—that is, movies with a fixed narrative line, without the possibility of mutable interactivity—there are a plethora of websites offering films, both feature and shorter length, for ready audience consumption. For instance, Snag Films.com specializes in documentaries; Babelgum.com, according to the IP video curator website, "combines the full-screen video quality of traditional television with the interactive capabilities of the Internet and offers professionally produced programming on-demand to a global audience"; IndieMoviesOnline.com offers bleeding-edge independent films as free, legal downloads without subscription fees or charges of any kind, thus becoming an international clearinghouse for a multitude of alternative visions; OpenFilm.com, Joost.com, IFC.com, Current.com, and numerous other locations present a refreshing change from the canned reality shows and heavily commercialized news reporting available through conventional broadcast mediums.

And then there's the potential for creating a YouTube video that not only goes viral but can be used as a stepping stone to a career in the mainstream media. Fede Álvarez, a young filmmaker in Uruguay, spent thousands of hours of his own time but only $300 to $1,000 (accounts vary) in cash to create *Ataque de Pánico* (*Panic Attack*, 2009), a 5-minute film in which a band of giant robots attacks Montevideo without warning or provocation (which makes the film both more mysterious and more economical in its narrative structure) and proceed to blast the

metropolis to smithereens, step by step. As the enormous robots con-verge on the center of the capital, they link together to form a gigantic thermonuclear bomb and simultaneously detonate, turning the city into a post-apocalyptic wasteland.

Álvarez began working on the short in 2006 but then scrapped all of the existing footage and re-created the film from the ground up in 2008, using a wide variety of digital special-effects software to create a gallery of remarkably professional and spectacular images, simultane-ously terrifying and fantastic but also resolutely convincing. The com-pleted film was posted on YouTube on a Thursday in November 2009, "and on Monday my inbox was totally full of emails from Hollywood studios" Álvarez recalled. "It was amazing, we were all shocked" (as quoted in Kelly). After sifting through the potential offers, Álvarez, age 31, finally made a deal with Sam Raimi's Ghost House Pictures to create a completely new film—*not* a remake of his short film—with a budget of $30 million, working with Hollywood screenwriter John Hlavin, whose credits include the TV series *Shield* and Len Wiseman's feature film *Underworld 4* (2003).

As Álvarez told reporter Cathal Kelly, "If some director from some country can achieve this just uploading a video to YouTube, it obvi-ously means that anyone could do it." Kelly continues, "Álvarez is now drawing comparisons to Vancouver resident Neill Blomkamp. The South African–born Blomkamp directed the critical and commercial success *District 9* [2009]. The feature was based on Blomkamp's six-minute short film *Alive in Jo'Burg* [2009], which first earned plaudits as a viral video," a parallel Álvarez concedes but insists is not accurate. To his credit, Álvarez realizes that the nonexistent plot line of *Panic Attack* is too flimsy to support a 90-minute film, and assured interviewer Bill Desowitz that "this movie is not going to be a long feature version of *Panic Attack!* I read that somewhere—and it's not. So there are no big robots this time, but it's a new take on an alien invasion movie. . . . It's impossible to deny that this is following *District 9* in some way, but it wasn't our intention." Álvarez will be working with Raimi, a specialist in action, fantasy, and horror films, as his mentor; and it will be interesting to see what he comes up with. A "new take on an alien invasion movie" sounds like a tall order; but if he's able to pull it off,

it should be a compelling piece of work, as was Blomkamp's *District 9*, one of 2009's most interesting and innovative science fiction films.

Yet in more mainstream filmmaking of the 21st century, conventionality is the most sought after quality. This applies not only to theatrical films but also to television shows of the most mundane variety. *Wheel of Fortune*, for example, debuting in 1975, is now the longest-running game show in television syndication history; but starting in late 2010 or early 2011, *Wheel of Fortune*, which, like any other franchise inevitably shows signs of age, will be broadcast in 3-D for that added "kick." Predictably, industry types are all jumping on the 3-D bandwagon with lockstep alacrity, such as Steven Poster, ASC, the national president of the International Cinematographers Guild, who, in a recent column in *ICG* magazine, compared the experience of watching *Wheel of Fortune* in 3-D in a trial run at Sony Broadcast Center to that of watching *Avatar*:

> I recently had the opportunity to see *Wheel of Fortune* in 3D and I was blown away. . . . Watching the show in 3D, I was stunned by how dynamic camera movement created an entirely new experience. . . . The feeling was similar (only more so) the first time I saw a 3D screening of *Avatar*, a production at the opposite end of the spectrum from *Wheel of Fortune*. And yet seeing both works in three dimensions helps to confirm what Sony Pictures Entertainment Technologies President Chris Cookson told me when I asked how many hours a day the average person can watch 3D. "Based on how human beings perceive the world," Chris said, "from the time we wake up until the time we go to bed!" . . . Movies, TV, concerts will all co-exist in this new 3D universe. . . . Repeat after me: 3D is not a marketing gimmick. It's not a fad or trend created merely to make audiences spend more money (although that will certainly be the byproduct of its success at the box office and in the home). Think of the 3D medium as a brand new way of telling stories. (6)

Adds producer Jon Landau, "Why would you do a movie today with mono sound? Stereo . . . enhances the audience's enjoyment of the film . . . and it's the same with 3-D" (as quoted in Kaufman, "Landau" 20). He continues,

I think it's great for us producers. We need to rely on ancillary markets. As 3D becomes more ubiquitous in the home, it'll force more 3D films to be made. If you look at the history of films in black and white and in color, you'll see that there were films shot in color in the 1930s, but color didn't become ubiquitous in films until the 1960s, when color TVs came out. As 3D TVs come into the home it'll *force* [emphasis added] more and more people to make 3D content. Right now, it's hard for art house theatres to justify playing 3D films. They're not yet even digital and 3D compatible. . . . Ultimately, however, all the theatres will be digital. (as quoted in Kaufman, "Landau" 20)

And yet, as director Tim Burton noted of his 2010 version of *Alice in Wonderland*, Burton and his cinematographer, Dariuz Wolski, decided not to shoot the film in 3-D because "shooting tradition-ally gave us more freedom to get into depth [an ironic statement, to say the least], the layers that we wanted in the time we were deal-ing with" (Kaufman, "One Wild Tea Party" 41). Added cinema-tographer Wolski, shooting in 3-D would have been "prohibitively expensive. . . . [A]nytime I wanted to change the lens, I'd have to reca-librate. . . . [W]e were afraid the whole thing would slow down our process" (41). The film was converted to 3-D after shooting as Burton had done with his earlier film *The Nightmare Before Christmas* (released in 1993 and directed by Harry Selick). "After seeing that conversion job, I found no reason to do it any other way," he noted before the film's re-lease. But as many critics have argued, was the conversion really neces-sary at all, especially since "shooting traditionally," in his own words, gave Burton "more freedom," both aesthetically and thematically, to tell the tale he wanted?

Disney's animated 3-D feature *How to Train Your Dragon* (2010), di-rected by Chris Sanders and Dean De Blois, was a huge box-office hit that blended familiar fantasy elements in a bright, shiny, 3-D pack-age. Director Alex Aja resurrected the *Piranha* horror film franchise with the predictably titled *Piranha 3-D* (2010). We've had yet an-other franchise reboot with Jim Johnston's (and an uncredited Mark Romanek's) *The Wolfman* (2010), which failed both critically and com-mercially after Universal decided to incorporate an increased number

of computer-generated effects and, feeling that the script needed more "bite," made the Wolfman's (Larry Talbot, played by Benecio Del Toro) father (Sir John Talbot, played by Sir Anthony Hopkins), a werewolf, too, so that father and son can engage in a WWF smackdown in the final reel of the film, with no discernable improvement in the finished project.

A number of the major studios see 3-D as the savior of the industry, in one form or another. In the area of 3-D TV, experts at the 2010 Consumer Electronics Show (CES) in Las Vegas have predicted that roughly 3.4 million 3-D TV sets will be sold in 2010 in the United States alone. Said Panasonic's Elsuke Tsuyuzaki, "it's a challenging market. We need something to kick us out of this. To me, the thing that's going to get us there is 3-D. Once you see it, you get it. It will take off a lot more quickly than a lot of people expect" (Shiels, "3D TV"). And Jeffrey Katzenberg, head of Dreamworks Animation, is one of 3-D's biggest boosters and the maker of films such as *Shrek* (2001), *Antz* (1998), and *Monsters vs. Aliens* (2009). Enthused Katzenberg,

> 3-D is the single greatest innovation for both the making and, maybe even more importantly, the presenting of movies to movie-goers. There have been three revolutionary movements in the film world. The introduction of sound, color and now 3-D. . . . There are going to be 20 3-D movies in 2010 and those were all committed to before these had their success. . . . The first few years will be driven by sports and gaming, and that is for a specific demographic. It's not for everyone. I don't know how many people want to rush out and watch *The View* or *Oprah Winfrey* in 3-D. I can tell you watching a football game on a 3-D monitor is breathtaking. Watching soccer or playing *Call of Duty*, which is already a 3-D experience, is really really fantastic. (Shiels, "Mr. Hollywood")

The CES served as a platform for this emerging technology, with announcements that the Discovery Channel is forming a joint venture with Sony and IMAX to create 3-D TV channels, that British satellite TV operator BskyB will launch a 3-D service in late 2010, and that ESPN will broadcast "at least" 85 sporting events on its new ESPN 3-D channel. But price seems to be a major factor in rolling out the new

technology. Research analyst Van Gartner noted that "the TV industry is desperate, and they are latching on to 3-D as hard as they can. They have done the flat panel upgrade. It will be a hard sell to get people to spend big bucks again on 3-D TV so soon after paying out for an HDTV." Ahman Ouri, of Technicolor, agrees, noting that "I think all the consumer electronics companies are waiting to see what the others do. It can't be double the price tag, or it's a non-starter" (Shiels, "3D TV").

And the upgrade factor is considerable: a 3-D TV, special glasses costing about $70 a pair (glasses need changing all the time, at least at this point, to keep them operational), and the intense desire to watch a *lot* of 3-D TV. As John Biggs astutely observes,

> To watch 3-D TV, you have to have a 3-D-capable home entertainment center (for example, a 3-D TV and a 3-D Blu-ray player). The process of sending 3-D video to the TV involves decoding and sending two separate pictures, a left and a right view of every frame in the movie or broadcast, to the TV every $1/120$th of a second. To do this, the refresh rate of the television has to be fast enough to keep up with the image. The ordinary TV has a refresh rate of 120 hertz while newer "3-D-capable" TVs have a refresh rate of 200 hertz or more. A "3-D capable" TV, by the way, still requires an infrared transmitter to tell the active glasses when to polarize, so there's an extra cost. Want to know a dirty secret? Most older 120-hertz televisions can display 3-D content just fine. However, television makers are requiring a complete upgrade because of various improvements to Blu-ray technology, as well as built-in infrared emitters necessary to drive their proprietary active shutter glasses. More important, they want you to go out and buy a new TV. (Biggs B9)

The whole setup will set you back roughly $4,000 right now, although the price will certainly go down as more 3-D TV sets are produced. But by then a newer 3-D system may well be in use, requiring another upgrade. As Biggs concludes, "Remember the consumer electronics motto: A.B.O.—always be obsolescing" (B9).

And then there's the boredom factor, when what one might call the "wow" aesthetic wears off. As Thomas Leupp of Hollywood.com

argues, "When handed a golden goose, the instinct of the typical Hollywood studio exec is to not only kill the precious creature, but to repeatedly gang-rape its lifeless corpse. Consumer backlash over the recent spate of overpriced ersatz-3D offerings has led some to wonder if the enhanced format is already endangered."

But the global financial meltdown of 2008 means less money to upgrade theaters to digital 3-D projection, which is why *Avatar* was released in both 3-D and 2-D versions. The film opened in 3,500 digital theaters in the United States, but director James Cameron had hoped for as many as 5,000 screens. Digital projection systems can cost as much as $100,000 per screen, and someone has to pay the cost. Higher ticket prices help, but the studios also agreed to foot much of the bill in many cases, correctly figuring that the cost of distributing a film on a hard drive, as opposed to conventional 35mm celluloid format, would save them an enormous amount of money on prints, shipping, insurance, and storage (Lieberman). And so far, the 3-D films continue to roll out.

Then there's this cheerful little nugget of information: as researchers led by Dr. David Dunstan at the Baker Heart and Diabetes Institute in Melbourne, Australia, have noted, watching a great deal of television is directly linked to a higher rate of death. In a study that tracked 8,800 people over a 6-year period, Dunstan and his staff discovered that people who watch more than 4 hours of television a day were 46 percent more likely to die at a younger age and 80 percent more likely to die of some form of cardiovascular disease than were those who watched television for fewer than 2 hours a day (Winslow).

"It's not the sweaty type of exercise we're losing," says Dunstan. "It's the incidental moving around, walking around, standing up and utilizing muscles that [doesn't happen] when we're plunked on a couch in front of a television" (Winslow). And when one considers that 4 percent of video gamers play for almost 50 *hours per week*, Dunstan's research gives one definite pause (Martin, "Four Percent"). Even more alarmingly, according to a similar 2009 survey from the NPD Group, players ages 2 and up are playing video games for roughly 13 hours a week, up from 12.3 hours (Martin, "Four Percent"). So it doesn't look as if Americans are going to get off the couch any time soon; in fact, they seem to be sinking deeper into it.

Finally, there are aesthetic objections, which have been most passionately argued by Roger Ebert, who noted in an article bluntly titled "Why I Hate 3-D (And You Should Too)" that "many directors, editors, and cinematographers agree with me about the shortcomings of 3-D. So do many movie lovers—even executives who feel stampeded by another Hollywood infatuation with a technology that was already pointless when their grandfathers played with stereoscopes." He tellingly cites Alfred Hitchcock's *Dial M for Murder* (1954) as a classic example of an excellent director decisively rejecting the 3-D process. The film was shot in 3-D but released in 2-D; for as Hitchcock noted in an interview with François Truffaut, "there isn't very much we can say about that one, is there? . . . I found that Warner's had bought the rights to the Broadway stage hit *Dial M for Murder*. I immediately said I'd take it because that was coasting, playing it safe" (Truffaut 209). Hitchcock was so unimpressed with the results that he famously remarked that 3-D "was a nine-day wonder, and I came in on the ninth day" (as quoted in Brooks). Ebert concludes his attack by noting that "I cannot imagine a serious drama . . . in 3-D," declaring that "whenever Hollywood feels threatened, it has turned to technology: sound, color, widescreen, Cinerama, 3-D, stereophonic sound, and now 3-D again."

Indeed, the original 3-D craze of the 1950s lasted only a few years before audiences grew weary of both the technology and the material being presented. But at the time, the first 3-D films were hailed as the advance wave of a coming revolution, and those who were skeptical were dismissed as both short-sighted and out of touch with then-contemporary technology. As one reporter wrote in the *Los Angeles Daily News* on October 4, 1952, "The 'depthies' are coming and they may be the depth charge that will unseat you from that living room television set and send you crowding back into the Bijous and Jewels. The 'talkies' did it 26 years ago and now the long-time dream of three-dimensional motion pictures . . . may come true" (as quoted in Handy WK5). Meanwhile, the *Motion Picture Herald*, an industry paper, asserted on January 3, 1953, that

this may well be it! Many within the industry misjudged the future of both sound and color films. Some prophets asserted that both were

passing novelties, or at best only suited to a minority of attractions. The three-dimensional revolution could be just as embracing as that of sound and far greater than that of color. . . . The public will decide, if it has not already decided! There is little doubt that the verdict will be for the best and truest recreation. The best and truest picture is the one that will have *motion, color, length, breadth—and depth.* (as quoted in Handy WK5)

Producer Sol Lesser opined in *Daily Variety* on January 27, 1953, that the "third-dimensional revolution has actually taken place and that it is no longer a question of how many 3-D pix will be produced within the next year, but rather, 'how many two-dimensional films will the various studios be stuck with?'" (as quoted in Handy WK5).

And yet by July 26, 1953, the fad was already wearing off. As *Daily Variety* noted on September 30, 1953, only 9 months after the initial wave of 3-D films hit theaters nationwide, "Showmen now admit that the decline of stereopix is due in part to technically faulty, quickly made B pix rushed on the market to make a 'quick buck'" (as quoted in Handy WK5), and the *New York Times* editorialized on October 18, 1953, that "there appears to be more general appreciation that technical innovations alone are not the only answer to winning larger audiences. Once again the rallying cry around Hollywood is, 'the play's the thing'" (as quoted in Handy WK5).

Louis Leterrier, director of the 2010 remake of *Clash of the Titans*, shot the film in 2-D but was forced by the film's producers to process it into 3-D. In an interview with Borys Kit, Leterrier admitted that that he was underwhelmed by *Clash of the Titans*'s 3-D conversion. When Kit told Leterrier that the resultant film was like "watching a View-Master" (a 1950s stereoscopic still process that mimicked a 3-D effect by placing one object in the foreground and the balance of the frame's composition in the distance), the director laughingly agreed, telling Kit that

It's funny, that is one of the things I was saying to them. Don't make it so much like a ViewMaster—so puffed up. Listen, it was not my intention to do it in 3-D, it was not my decision to convert it in 3-D. Now,

people love 3-D. People will go see it in 3-D, and it will play in 3-D; it's like a ride. If you love 3-D and the studio is giving you the opportunity to see it in 3-D, go see it in 3-D. If you don't like 3-D, don't go see it in 3-D. Conversions, they all look like this. *Alice in Wonderland* looks like this. Remember the technology was not ready, so it's Warner Bros. saying we are giving you the best of what we can do.

Other writers, producers, and directors are also starting to voice objections about working in 3-D or having their films reprocessed for 3-D after the fact. As of late 2010, a popular joke making the rounds in Hollywood was the cynical statement, "if you can't make it good, make it 3-D." J. J. Abrams, director of the reboot of *Star Trek* in 2009 that earned more than $385 million in traditional two-dimensional format, noted at the influential 2010 Comic-Con in San Diego that he's inherently unhappy with the format because, as he puts it, "when you put those glasses on, everything gets dim." Fellow filmmaker Joss Whedon, co-writer and -producer of Drew Goddard's film *The Cabin in the Woods* (2011), appearing on same Comic-Con panel with Abrams, concurred: "what we're hoping to do is to be the only horror movie coming out that is *not* [emphasis added] in 3-D." *The Cabin in the Woods* was shot in 2-D; but at press time, MGM, the production company behind the film, was still pushing for 3-D conversion in post-production. Said Whedon, "[3-D] hasn't changed anything, except it's going to make it harder to shoot" (as quoted in Cieply, "Resistance").

Similarly, Christopher Nolan has refused, thus far, to allow a 3-D conversion of his vastly successful film *Inception* (2010); and Jon Favreau, director of the *Iron Man* films, also speaking at Comic-Con, noted that, for his new project, *Cowboys & Aliens* (2011), he wouldn't even consider using 3-D, saying somewhat categorically that "westerns should only be shot on film" while true 3-D production process requires digital cameras from the start. Greg Foster, the president of IMAX Filmed Entertainment, has long felt that some films were meant to be seen in 2-D, even on IMAX screens. "We've always said it's all about balance," Foster commented. "The world is catching up to that approach" (Cieply, "Resistance"). But who knows what technological refinements lurk around the corner? As the cinematic visionary Erich von Stroheim

proclaimed in the 1950s, "the cinema of the future will be in color and three dimensions, since life is in color and three dimensions" (as quoted in Cairns). Perhaps he was right. Only time will tell.

What else does the future hold? Blu-ray continues its inroads into America's living room, and Warner Brothers recently announced that, as of January 2010, all of the Blu-ray releases will also include a conventional DVD disc, thus appealing to users of both home video formats (see Yoskowitz); Disney and other studios are doing the same with their new releases. 3-D high-definition movies are also on the foreseeable horizon, with the added bonus of being compatible with the regular Blu-ray format, so that a 3-D Blu-ray disc will play on a conventional Blu-ray player, albeit in 2-D format. To get the full 3-D effect, a special player, 3-D glasses (of course), and other hardware will be necessary; and there are, at the moment, a variety of competing 3-D formats, with the winner still to be decided (see Foresman). However, despite what seems to be a limited market for 3-D now, there is apparently a substantial audience for 3-D television—the 2010 Masters golf tournament, for example, was broadcast in 3-D—and the 3-D home experience may well gain widespread acceptance in the not-too-distant future.

In fact, as this book goes to press, an even newer development has appeared in 3-D technology: true 3-D without glasses. The new system, which is understandably in its trial stages, is Nintendo's 3DS and is meant primarily for video games, although it can also be used for conventional 3-D films. As Seth Schiesel enthused after watching a trial demonstration at the Electronic Entertainment Expo in Los Angeles in late June 2010, "the 3DS displays true 3-D images without the use of glasses. It actually works. Unlike many 3-D movies with objects that might appear to come whizzing out at you, the 3DS images appear to have depth that recedes into the screen" ("New in Gadgetry," C1). While the system will probably be expensive and may take years to develop, it's out there, and further refinements will surely follow. Even if the 3DS system itself proves to be just a prototype, the technology behind it makes the process a real breakthrough.

But as always, whatever the platform, all contemporary and/or future cinematic constructs will need to find an audience in order to be

successful commercially; and as everyone knows, film and digital video are enormously expensive mediums to work in, unless one is a master of homebrew special effects, as Fede Alvarez is. Film, of course, is for all intents and purposes an obsolete medium, and HD production should theoretically put the moving image within reach of even the most impoverished filmmaker. But even if digital video cuts costs to the bone, a film needs a compelling story, solid acting, and a theme that resonates with audiences if it will be able to stand out among the avalanche of images that now compete for our collective attention. Nonetheless, the image-capture system used to create the next generation of Hollywood films will certainly play a role in how these films look, with portability, ease of operation, and image quality all key factors in choosing production equipment.

Although there are any number of digital video systems that producers and directors can use in creating new digital works, the RED One camera, weighing in at a relatively light 10 pounds, has emerged as the camera of choice for a number of significant mainstream and independent theatrical projects. The camera costs $30,000, which puts it out of the range of the most renegade independent artists; but compared to a conventional 35mm camera or other competing HD cameras, the RED One clearly stands out. Already, it has been used on a wide variety of projects, including Lars von Trier's *Antichrist* (2009), Peter Jackson's *The Lovely Bones* (2009), the aforementioned *District 9*, Steven Soderbergh's epic *Che* (2008), Shawn Levy's resolutely mainstream *Night at the Museum: Battle of the Smithsonian* (2009), and even Patrick Lussier's 3-D splatter film *My Bloody Valentine* (2009). As befits its out-of-the-box reputation, the RED One remains something of an outlaw camera with a rapidly expanding reputation and a certain amount of anti-establishment attitude, both of which are clearly reflected in the RED One website, which repeatedly states that "specifications, prices and delivery dates are subject to change. Count on it. We reserve the right to refuse service to anyone with a bad attitude." As conventional 35mm film fades into the mist of memory, the RED One and other portable lightweight cameras will clearly emerge as the workhorses of a new generation of cineastes.

Still, it is the audience who ultimately shapes the reception and

long-range reputation of any film, and theorists and researchers alike continue to speculate about how one can most effectively create an audience. Constructing such an audience remains as elusive a goal as it always has been. George Papadopoulos, the manager of finance and acquisitions for the Australian distributor Newvision, succinctly summarizes the problem:

> In the end, I don't think any Hollywood studio, distributor or market researcher knows what the audience wants. The audience itself does not even know what it wants. . . . Moviegoers will know what they like after they have seen it and not before. . . . What does hold true is the financial risks involved in releasing a film theatrically in print and advertising costs and that is the gamble that all distributors face when dealing with an art form such as film. . . . While Hollywood likes to think it knows what audiences want by giving them endless remakes and mind-numbing sequels ad nauseam, they often discover after a $100 million loss that they were wrong.

To that, one must also add the theatrical experience itself, which has to be tailored in the 21st century to an entirely new set of audience expectations, to say nothing of tearing down existing projection facilities and replacing them with digital, 3-D–adaptable systems. In addition, as Marke Andrews observes, "the changes [also] include age and ethnicity" in the makeup of audiences as well as concerns about movie piracy and the entire theatrical experience for patrons. For seniors in a rapidly graying worldwide population, "smaller food and drink portions, better lighting, lower sound levels, and more elevators are changes movie theatres need to implement to keep an aging clientele coming back to the movie house. . . . Seniors do not want to walk 10 minutes from parking lot to theatre seat [or] drink from a pop container the size of an industrial barrel, and they may well choose big-screen concerts, operas or sporting events over the latest *Hannah Montana* screen romance," Andrews argues.

These comments reflect Andrews's findings at the 2010 Conference of the Motion Picture Theatre Associations of Canada (MPTAC), which, as he notes, hold true for U.S. theaters as well. At the same

conference, John Fithian, the CEO of the U.S. trade group the National Association of Theatre Owners (NATO), told the assembled exhibitors that, while the American box office remains "robust," continual adaptation to meet audience needs and expectations is essential. The North American box office rose 10.7 percent in 2009 (from $9.63 billion to $10.6 billion), while admission rose 5.4 percent (from 1,341 billion to 1,414 billion), which, if you stop to think about it for a second, is a rather spectacular performance. As relatively cheap entertainment, movies generally do well in a recession; nevertheless, 1,414 billion tickets sold in a continent of roughly 300 million inhabitants is a remarkable figure.

But most important, as Fab Stanghieri, the head of MPTAC, asserted, is the question "who is your community? You need to understand your market. Understand what they get out of movie going" (as quoted in Andrews). This is, indeed, the central question of cinema exhibition—in the past, now, and in the future. In the 20th century, theaters had little competition, as we've seen. Now there are a host of competing options for the consumer of movies, from iPads to iPhones, from laptops to flat-screen TVs. One upside to all of this is that, with the explosion of platforms, the appetite for content has become voracious: while the rest of the world's economy remains unstable and very much in recovery mode, film and television production, as well as production for the web, remains a growth industry. Indeed, more theatrical films, television programs, made-for-TV movies, web series, and other programming formats are being created now than at any time in the history of the medium. And around the world, global audiences are demanding films that reflect the concerns and demands of today's social and political climate and are constructed in an entirely different fashion from 20th-century cinema.

CHAPTER THREE

The Globalization
of the Moving Image

While Hollywood, with its vast technical resources and its perceived dominance of commercial cinema continues on a global scale, the massive effort to shift to digital ultimately opens the way for significant changes in global distribution and creates new platforms and methods that question global Hollywood in exciting and unprecedented ways. One would think that the success, on a global scale, of an international blockbuster such as *Avatar* would assure Hollywood's continued dominance. Mark Lynch doesn't think so. His essay, "What If Hollywood Doesn't Survive as a Global Player?," demonstrates that Hollywood's supremacy is far from a sure thing. Interestingly, Lynch argues that Hollywood's increased dependence on global markets actually undermines its sustainability in the domestic box office.

In the past, American moviemakers were not as dependent on international success; as Lynch comments, "forty years ago, give or take, Hollywood was transformed by Altman, Coppola, Polanski and others at their commercial and critical peak." But that success was not predicated on the international market. Amazing as it sounds today, those filmmakers and many others "were largely sustained by the domestic box office alone" (see Lynch). Granted, there was some success in foreign markets, but Hollywood didn't depend upon it. These days, blockbuster success is often indebted entirely to foreign markets. Indeed, many Hollywood films that don't do well domestically only

break even because of international bookings. Films are now routinely pushed decisively into the black by global playoff as well as by ancillary marketing on DVD and other platforms.

Hollywood's old model of success, as Lynch argues, may actually lead to its downfall. In a world where $100 million "has been the yardstick of box-office success," Lynch predicts that Hollywood will have to radically alter a business model in which "profligacy [has] gone mad" and film-production costs have been driven to stratospheric levels by "squadrons of producers, executives, agents, managers, lawyers, PR handlers, etc." Hollywood has been slow to adapt to, much less notice, the fact that its "grasp on the global popular imagination has definitely waned. The American way as the definitive way is a dead idea."

Hollywood's global dominance of filmic consumption is no sure thing. In many ways, Lynch argues, Hollywood is not keeping up with global changes. It does not, for example, routinely take advantage of social media networking websites; and as Lynch sees it, "rather than exploiting its information sensibly, Hollywood subsidizes TV and print media" instead being subsidized by them, as it sometimes appears. People outside the United States increasingly want to see their own stars and their own cultures, and they want to hear their own languages spoken in films. They will turn out for proven franchises such as *Iron Man*; but interestingly, there seem to be trends in international filmmaking that point away from the model of Hollywood's hegemonic dominance in production and exhibition patterns.

China is a good case in point. There has been an unprecedented increase in the success of Chinese films made for Chinese audiences. Due to a variety of reasons, Chinese films have "topped foreign films at the local box office for five years running" (see Hendrix). Revenue growth has increased by 25 percent each year; and as Grady Hendrix notes in an article in *Slate*, "China has nurtured a new generation of directors who make Chinese hits for Chinese audiences," a groundbreaking and revolutionary trend that has hardly registered with American executives or journalists. The Chinese government and SARFT (the Chinese censorship authority) have completely reinvigorated the landscape of Chinese cinema toward nurturing local talent and local film distribution and ensuring domestic fiscal success. The government now limits

foreign imports to "22 films per year, encouraging the expansion of the number of screens . . . yanking successful American movies from theaters in the middle of their runs, promoting blackout dates when only local productions can be distributed, and generally making life hell for foreign producers and distributors" (see Hendrix).

The new Chinese hitmakers are not dependent on international global distribution, nor are they making dumbed-down films fashioned after the Hollywood genre blockbuster. Chinese blockbuster film hits are, according to Hendrix, "complicated, fascinating films . . . and they're all far better than Zhang Yimou's recent string of ancient Chinese epics." Hendrix singles out two Chinese films for Chinese audiences that illustrate his point. Fenx Xiaogang's *If You Are the One* (*Fei Cheng Wu Rao*, 2008) is a romantic comedy that is the "highest grossing movie ever released in China," displacing James Cameron's *Titanic*, the previous record holder. *If You Are the One* is about an online romance; but as Hendrix notes, it "takes place in a China that's sophisticated, urban and cosmopolitan." Fittingly, the jokes in the film are at the expense of Obama, the weakness of the American economy, and the American economic recession. According to Hendrix, *If You Are the One* "puts to shame anything Hollywood has recently turned out under the rom-com banner."

Feng Xiaogang's *Cell Phone* (*Shou ji*, 2003) also found considerable success in China, Taiwan, and Hong Kong. *Cell Phone* is about a married TV talk-show host who has a series of extramarital affairs. His world comes crashing down when his wife accidentally answers a cell phone call from one of his mistresses. The success of the film supposedly led to a rise in the divorce rate when wives began checking up on husbands through that method. Cell phone stories (called "shouji") are now prevalent in all media, including newspapers and tabloids, underscoring the popularity and widespread success of a homegrown Chinese film all but unknown to Europeans and other westerners.

The chasm between Chinese films for Chinese audiences and Chinese films packaged as art-house films for foreign consumption is markedly important. In the past, China exported its top directors. The best path to international success was via the international film-festival circuit and to have your film packaged as "banned in China." As Hendrix

points out, the "banned in China" label often really meant that a film might have had insurance or other legal problems that had prevented or delayed its domestic release; but the truth is that "banned in China" made a perfect marketing tool:

American distributors like to import movies that toe a certain political line, depicting modern-day China as an environmentally degraded hellhole where human life has little to no value, where most people live in poverty and women have no rights. (See [Li Yu's] *Lost in Beijing* [2007], [Yang Li's] *Blind Shaft* [2003], [Jia Zhangke's] *Still Life* [2006], [Lou Ye's] *Summer Palace* [2006], [Zhang Yimou's] *Raise the Red Lantern* [1991], [Yimou's] *The Story of Qiu Ju* [1992], etc.) The best marketing tool for selling a Chinese film in America is to plaster "Banned in China!" across the poster. American audiences love the idea of the little guy with the shopping bags blocking the tank at Tiananmen Square; we're schooled to think any officially approved movie out of China is going to be propaganda and the only way to "really see" China is through the eyes of filmmakers out of favor with SARFT, China's official film censorship body. (see Hendrix)

Due in large part, therefore, to western Orientalist ideas about China, many Chinese directors such as Zhang Yimou and Jia Zhangke made their way to Hollywood via the art-house circuit. Most people assume that well-known American import directors are also celebrated in China, but Hendrix writes that "few Chinese are interested in the shopworn Orientalism and miserablist worldview they're selling." Hendrix is prescient in noting the widespread cultural shift in China toward domestically produced films as a sign of immense importance, concluding that, "with enough government support, and with enough directors making movies, pretty soon they may rival us at our own game." The same is true in other countries around the world.

One of the most explosive film movements in recent memory, rivaling the prodigious output of Iranian films in the 1990s, is the Nigerian feature film industry, which, working almost entirely in video (both digital and analog) racked up an astounding 9,000 full-length feature productions between 1992 and 2007. In 2006 alone, Nolly-

wood (the nickname for the Nigerian film industry) produced roughly 1,600 feature-length productions, all shot rapidly on 3- to 10-day shooting schedules. The entire cost of these 1,600 films was less than $60 million in U.S. currency; or, as Pierre Barrot points out, roughly the cost of one medium-budget Hollywood movie, minus prints and advertising (xi).

Nollywood films are cheaply made, but they give a voice to African filmmakers that traditional film production often denied them. The difficulty and expense of working in 16mm or 35mm film as opposed to digital video means that, as in other countries, film is rapidly being phased out as the preferred medium. Video is cheap and easily edited, offers speed and portability, and doesn't require processing. Once completed, the films are immediately distributed to recoup their meager investment, and remakes and outright imitations proliferate. Many of these films are of poor quality, lacking both artistic ambition and technical polish; but even the weaker films in the Nollywood movement offer escapism, as well as political and social engagement, for audiences throughout Africa.

The films conform to what audiences have come to expect from a feature film: they're narrative; they run from 70 minutes to 2 hours in length; they rely on the Nollywood star system, which has many devoted followers; and, for the most part, they are designed to please certain target audiences, depending upon the genre (action films, romance films, dramas, and the like). But Nollywood's frank commercialism and its embrace of video have made it a vanguard film movement for other developing nations to follow. Nollywood has grabbed video filmmaking with a ferocious intensity and created a national cinema that allows Nigerian viewers to see themselves on the screen rather than being limited to movies colonized exclusively by Hollywood imports. American films are still big box office in Nigeria but mostly by way of DVDs, many of which are pirated. Nonetheless, for the nation to have such a lively and progressive cinema culture of its own is a testament to the vision and artistry of its many indigenous practitioners.

Before Nollywood, all Nigerian cinema was colonial. Jean Rouch's classic ethnographic short film *Les maitres fous* (*The Mad Masters*, 1955) is

a good example. (Rouch, one of the last of the colonialist documentary filmmakers, was himself the subject of a fascinating video documentary by African cinema specialist Manthia Diawara, *Rouch in Reverse* [1995], in which Diawara examined Rouch's daily life in France with the same cold, clinical, somewhat condescending gaze that Rouch used in his own films on African culture.) In his final years, Rouch commented that video production had taken precedence over film production and had almost wiped it out; but in the process, video had given a voice to millions who, until now, had been denied access to the basic tools of visual communication. Rouch wasn't sure whether or not this pleased him. Once, others had spoken for Nigerians. Now they were speaking for themselves.

The Nollywood movement has also proven influential in neighboring African nations, which embrace Nollywood films as a model for feature video productions in their own countries. The Nollywood cinema is a *people's* cinema, unmediated by government agencies or corporate purse strings; no matter how stark and Spartan the production methods are, Nollywood's productions mirror the birth of cinema in any country in which the fever for self-representation first takes hold. In Nollywood, Nigeria has found its image, an image that it continually builds on and refines.

For the most part, Nollywood films are genre enterprises: comedies, romances, gangster films, domestic dramas, musicals, and action pictures. But a handful are serious, sustained dramas that interrogate contemporary Nigerian society. Many of these films are extremely violent and downbeat. Lancelot Oduwa Imasuen's *The Apple* (2000) is typical: it deals with Uju, a 15-year-old girl in love with a much older man. Uju's father intervenes, but after the girl attempts suicide, he relents, and the couple is married. Yet this is just the start of the film; rather than living happily ever after, Uju and her husband, Ariuze, have terrific battles over domestic matters, which result in Uju's returning to her unsympathetic family. When Uju finally has a child with Ariuze, it is stillborn, and Uju is injured in the delivery. Ariuze rejects her; and though her parents try to help her, Uju again attempts suicide, this time successfully. Imasuen, who is in his mid-30s, has more than 70 films to his credit; and in getting his work to the outside world, he

is luckier than most: one of his films was screened at the 2004 African Film Festival in New York (Barrot, 10–11).

Kingsley Ogor's *Osuofia in London*, a 2-part comedy shot and released in 2003 and 2004, is a picturesque narrative in which Osuofia, a farmer known for his dishonesty, suddenly comes into a fortune and travels to London to claim it, a situation that leads to a series of cross-cultural plot twists that critique both Nigerian society and British colonialism. As Barrot reports,

> The film is probably the most successful of all Nigerian video films. Its first public screening in front of 2,000 people in Lagos brought in more money than *The Lord of the Rings* on the day of its simultaneous release in the cinemas of Nairobi. Following the screening, some 300,000 to 400,000 VHS-cassettes and [DVDs] were in circulation. . . . The success of *Osuofia in London* is rooted not only in the quality of the directing, . . . but also it is one of the rare Nigerian films . . . popular with both adults and children. (22, 23)

Chico Ejiro's *Hit the Street* (2004) is a complicated thriller, rife with violence, death, and deceit; one of the most prolific Nollywood directors, Ejiro has directed more than 100 films (Barrot 30–31). *Dangerous Twins*, a 3-part film directed by Tade Ogidan in 2004, is a brutal domestic drama, which moves from a rather carefully choreographed beginning to scenes of horrific carnage. As Barrot notes,

> *Dangerous Twins* is a surprising film. It is rare to see such a switch from light drama to horror. One scene (suggested but not filmed), of the children's murder, introduces a bitter edge. Some aspects of Nigerian life-style, seen from the perspective of London, may look comic, but some of the realities of the country are also portrayed. Tade Ogidan was criticized for the shocking scene in which the children are executed by armed bandits while their father runs away under the pretext of fetching help. He justified his decision by saying that the scene was not gratuitous, and because he understood the extent of criminality in his country, having worked closely with the Nigerian police on a television series. (41)

Despite the Nollywood cinema's insistent use of violence, there is one taboo: nudity. As far as censorship goes, you can get away with pretty much anything, just so long as there is no nudity of any kind. Violence and more violence are the staple ingredients of many Nollywood films; but any bodily display at all, even a glimpse of a nipple, is apparently enough to bring down the wrath of the National Film and Video Censors Board, which classifies many of the more popular Nollywood films and has become unnecessarily strict in recent years.

Surprisingly, most Nollywood films are shot in English, with Yoruban and Hausu language films coming in closely behind. Nollywood also has a star system; and as in Hollywood, the most popular players can command relatively high salaries, which often make up the bulk of a film's production cost. As of 2003, 65 percent of Nigeria's inhabitants had access to a video player (VHS was still the dominant format); and top stars, such as Geneviève Nriagi, Chinedu Ikedieze, Nkem Owoh, and Emeka Ike were making as much as $23,000 per film in U.S. currency (Barrot 38–39). As of 2010, DVD technology has replaced VHS tape, purely as a matter of progress, but the output of Nollywood cinema remains torrential.

While bootlegs of the films also attract a sizable audience share, homegrown Nollywood films are a potent force in the nation's box office. And with the use of digital technology, the moving image in Nigeria is everywhere—in schools, churches, and makeshift open-air theaters that can consist of as little as a playback desk and a large-screen TV. Indeed, in many towns, theaters are traveling affairs: equipment is hauled from one screening location to the next in a panel truck; and after the show ends, the proprietors offer a wide range of DVDs to their customers to take home and view—a theatrical screening and home-video outfit combined. With this continual saturation of movies, the Nigerian cinema is prolific and raw, dealing directly with the concerns of its viewers. Indeed, it is proving to be a model that other African nations can follow.

But in other countries, the indigenous cinema is not nearly as robust. In the same time period (April 1–4, 2010) as the other samples cited in this chapter, nearly all of Argentina's top hits were U.S. imports; indeed, one has to go down the list to number 19 to find a non-U.S.

title—Niels Ardey Opleu's *Män som hatar Kvinnor* (*The Girl with the Dragon Tattoo*, 2009), which is an import as well, from Denmark. The first Argentinean film in the list, Juan José Campanella's *El Secreto de sus ojos* (*The Secret in Their Eyes*, 2009), a crime drama with Argentinean star Ricardo Darin that won a 2010 Academy Award for best foreign film, clocks in at number 22. *El Secreto de sus ojos*, however, in many ways resembles a conventional Hollywood product, sort of a 2-hour-plus episode of the U.S. TV series *Law and Order*. Indeed, Campanella directed several episodes of the various *Law and Order* franchises while honing his craft.

Similarly, in Colombia, the major box-office hits are all Hollywood products; and the same holds true in Peru, the United Arab Emirates, Australia, and Egypt. As an ironic example of visual colonization, in all these countries Tim Burton's 3-D remastered *Alice in Wonderland* topped the charts during this period, followed by such predictable hits as Dean DeBlois and Chris Sanders's *How to Train Your Dragon* (2010), James Cameron's *Avatar* (2009), Martin Scorsese's *Shutter Island* (2010), Andy Tennant's *The Bounty Hunter* (2010), and Steve Purcell's *When in Rome* (2010). Looking around the world in the same period, only Brazil, the Czech Republic, Italy, and Japan, on a list of 35 international markets, have domestic product in the top-grossing box-office films.

But while worldwide box-office grosses continue to be dominated by Hollywood product such as *Avatar*, *Titanic*, and *The Dark Knight*, a look at the top box-office blockbusters in individual countries around the world suggests surprising cracks, fissures, and upsets in the model of Hollywood dominance. In Japan for the weekend of April 1–4, 2010, for example, *Avatar* was beaten out for the number 1 box-office position by Kôzô Kusuba's *Eiga Doraemon: Nobita no ningyo daikaisen* (*Doraemon the Movie: Nobita's Great Battle of the Mermaid King*, 2010), the 13th film in a long-running animated series, despite the fact that it was running on fewer screens than *Avatar* and was not a 3-D film.

Quite a few homegrown films dominated the Japanese box office; and though *Avatar* and Guy Ritchie's *Sherlock Holmes* (2009) held the number 2 and 3 slots for the weekend, a number of American films that performed poorly in the United States appear on the list, evidence of the construction of a very different audience. *The Hurt Locker*, for

example, did sluggish business in the States despite winning Academy awards for both Best Director (Kathryn Bigelow) and Best Picture in addition to receiving overwhelmingly positive reviews and the widespread publicity that comes with Academy Award nomination and success. Yet it showed up at number 9 in the same list in Japan and was also a substantial hit in Peru, the United Arab Emirates, Colombia, Australia, and Argentina. Despite Hollywood's undeniable expertise in distribution, publicity, and perception of its product, a healthy number of Japanese titles appear in the top-grossing position, such as Hiroaki Matsuyama's *Precure All Stars DX2* (2010), a feminist animé film from Toei Studios; Matsuyama's *Raiâ gêmu: Za fainaru sutêji* (*Liar Game: The Final Stage*, 2010), a psychological thriller involving swindles, double-crosses, and vast sums of money; and Takahiro Miki's *Solanin* (2010), a pop-music drama about young people trying to find their place in contemporary Japanese society.

All three films are based on manga, or comic books, and have a strong fantasy element; at the same time, with the exception of *Precure All Stars DX2*, the only animated film of the group, there is an element of almost *Saw*-like grittiness in their execution. All of these films were homegrown products, and landed in 4th, 5th, and 6th place, respectively. Thus, out of the top 5 films for the weekend, 3 out of 5 were local efforts. Yet even though native cinema is seemingly alive and well in Japan, we in the United States will probably never get a chance to see these films, even on DVD. They're designed for home consumption only, and no major U.S. distributor is likely to take a chance on them; besides, they're clearly direct competition (as their box-office placing shows) to Hollywood's own films.

Russia is another country that is well represented with homegrown product. While the top 3 spots for the weekend of April 1–4, 2010 were occupied by the American films *How to Train Your Dragon*, Jim Fieldsmith's *She's Out of My League*, and Miguel Sapochnik's *Repo Men* (all 2010, although *Repo Men* sat on the shelf for some time before its eventual release), not far behind were Aleksandr Chernyaev's *Ironiya lyubvi* (2010), a romantic comedy shot in Russia and Kazakhstan, and Inna Evlannikova and Svyatoslav Ushakov's *Belka i Strelka. Zvezdnye sobaki* (*Space Dogs 3D*, 2010), based on the early days of Soviet space explora-

tion and centering on two dogs who were shot into space in 1960 as part of the program.

Rounding out Russian top 10 list for the week were Dmitriy Dyachenko's *O chyom govoryat muzhchiny* (*What Men Talk About*, 2010), a comedy based on theater pieces in which men talk about their innermost feelings, and Aleksei Popogrebsky's *Kak ya provyol etim letom* (*How I Ended This Summer*, 2010), an existential drama centering on two men stuck in a weather station on a desolate Arctic island. This last film is hardly conventional Hollywood fare; indeed, Kirk Honeycutt's review of *How I Ended This Summer* in the trade paper the *Hollywood Reporter* was so relentlessly downbeat that it all but ensured that the film will never be released in the United States. Yet *What Men Talk About* grossed more than $11,000,000 in Russia alone as of April 4, 2010; and while it was a more modest success, *How I Ended This Summer* still racked up acceptable numbers for such a demanding film.

As in Japan, a surprising number of films that Americans avoided seem to appeal to Russian audiences. Despite widespread Hollywood colonization, international audiences can behave unpredictably; and though Hollywood decidedly hates unpredictability, it takes advantage of it to the best of its ability. *Chloe* (2009), Atom Egoyan's edgy romantic drama, which did poorly in America, seemed to attract Russian audiences, as did *The Bounty Hunter*, a quirky action comedy thriller with Jennifer Aniston and Gerard Butler. Regardless, such mainstream titles as *Alice in Wonderland*, *Avatar*, and *How to Train Your Dragon* clearly benefit immensely from lengthier and more profitable international runs, fueled by their status as pre-sold entities.

Though there is obviously an appetite for homegrown product in countries abroad, a snapshot of the number 1 film by territory for the weekend of April 1–4, 2010, for example, is dominated with such American product as Louis Leterrier's *Clash of the Titans, Shutter Island,* and Matthew Vaughn's *Kick-Ass* (2010). A few non-U.S. films appear, however, such as Brazil's *Chico Xavier* (2010), director Daniel Filho's biopic about author and spiritual medium Francisco Candido Xavier; the Czech Republic's *Zeny v pokuseni* (2010), a comedy directed by Jiri Vejdelek that centers around the exploits of a marriage expert; the aforementioned Japanese film *Eiga Doraemon: Nobita no ningyo daikaisen*; and

Italy's *La vita è una cosa meravigliosa* (2010), a romantic comedy directed by Carlo Vanzina that topped Italy's theatrical box office. Considering the massive effort on the part of Hollywood to suppress the box-office potential of non-Hollywood films, it's heartening to see that international films still find their core audiences sometimes, even if viewers in the United States never get to see them here.

Interestingly, all these titles appear on many websites as easy and sometimes free (often semilegal) downloads, which naturally limits their potential as commercial imports in the United States. If a film is already available in a variety of digital forms, it's considerably unlikely that it will find U.S. theatrical distribution on the large screen or DVD distribution and marketing. Meanwhile, foreign-film theatrical distribution and DVD sales continue to decline. While we export our films internationally to great success, it is seemingly a 1-way market of exchange, and many critics have noticed that it is becoming less likely for a foreign film to make it in the United States.

Unless you live in New York, Chicago, Los Angeles, or another major American metropolis or regularly attend international film festivals, you are shut out of viewing foreign films on the big screen. Even if you religiously keep track of foreign releases through festival round-ups in *Film Comment*, the *New York Times*, and elsewhere, you will need to make foreign-film following your full-time job if you're going to be able to track down worthwhile international films. Some of these films make it to cable on-demand services, and a precious few play a ragtag number of art houses; but your best bet is to get a region-free DVD player and hope that the film comes out in Europe, with English subtitles, and you can buy a copy through the Internet. You're not going to find any of these titles on Netflix.

Underscoring this, Anthony Kaufman paints a gloomy picture of the future of international cinema in his *New York Times* piece "Is Foreign Film the New Endangered Species?" Attendance is down, the number of screens playing foreign films is down, and there is a significant drop in media attention. Mark Urman, head of the distributor Think-Film, summarizes the problem succinctly: "nobody's writing about them, because nobody cares, and nobody cares because they don't

penetrate the culture. It's a vicious cycle" (as quoted in Kaufman, "Is Foreign Film?"). Marie Therese Guirgis, head of the distributor Wellspring Media, notes the lack of marketing of notable foreign directors. Sadly, Guirgis feels that "there's no auteur anymore. As opposed to 20 years ago, you were marketing the movies around the filmmaker—Fassbinder's new film, Godard's new film[, for example]. We still do it, but the honest truth is that the filmmaker matters increasingly little today" (as quoted in Kaufman, "Is Foreign Film?"). Increasingly, foreign films are being replaced by English-language documentaries at the remaining art houses in the United States, which are even cheaper for exhibitors to screen. The DVD medium is accurately described by Anthony Kaufman as a "mixed blessing" in that it takes away a large portion of the theatrical audience and a film's impact is considerably diluted on the small screen.

Exacerbating the situation, in 2009 and 2010 we have seen some of the top luminaries in film criticism fired from their positions. How do foreign films get on the radar in the first place? Through reviews by knowledgeable film critics, who seek them out at international festivals around the globe. But the days of the globe-hopping film critic seem to be over. For example, Todd McCarthy, who wrote for *Variety* for 31 years, was fired along with the rest of *Variety*'s remaining staff; from now on, the trade paper will rely on freelancers. As McCarthy ruefully told Sharon Waxman, *Variety* editor Tim Gray

> said that they're restructuring, and let go . . . all the full-time reviewers. He said we're . . . doing it all freelance. . . . I've been fiercely and proudly reviewing at full speed since all the cutbacks. I made sure we had no slippage in our festival coverage and film reviewing, I've worked hard in recent times to make sure nothing slipped. The reviews have been the most unchanged part of *Variety*, period. Forever. I've always made a point of running the film review operation—we never slacked off. We tightened our belts—took cheaper airlines, rental cars. We were tight with expenses. It's sad. It's the end of something. You can say it's the end–the end, or you can say it's the end of the way it's always been done. It's the end of me. ("McCarthy Fired")

Indeed, *Variety*'s key value in recent years has been the fact it reviewed nearly every film in existence, using a knowledgeable staff. Who will these freelancers be? They can't possibly have the same credentials as McCarthy, who has been reviewing films since the 1970s and knows the entire international film industry inside out, or his colleague at *Variety*, Derek Elley, who has been a critical force since the late 1960s, or David Rooney, who was *Variety*'s longtime and highly respected theater reviewer. Reaction, predictably, was swift. As Daniel Frankel and Sharon Waxman reported,

> Roger Ebert tweet[ed], "*Variety* fired Todd McCarthy and I cancel my subscription. He was my reason to read the paper. RIP, schmucks." Still, in his memo [regarding the firings, *Variety* editor Tim] Gray insisted, "Today's changes won't be noticed by readers. Our goal is the same: To maintain, or improve, our quality coverage. We are not changing our review policy," he added. "Last year we ran more than 1,200 film reviews. No other news outlet comes even close, and we will continue to be the leader in numbers and quality. It doesn't make economic sense to have full-time reviewers, but Todd, Derek and Rooney have been asked to continue as freelancers."

For *Variety*'s editors to insist that "today's changes won't be noticed by readers" is risible. The freelancers will be people who work cheaply or are willing to blog for minimal pay; people who can crank out reviews quickly and inexpensively, no matter what their credentials might be. Critics such as McCarthy often acted as the champions of both foreign film and smaller American independent cinema. When these people are gone, the credibility of *Variety* as a critical source will vanish.

Thomas Doherty, writing in the *Chronicle of Higher Education*, summarizes the swift and violent rupture in film criticism: "The ballast of traditional credentials—whereby film critics earned their bones through university degrees or years at metropolitan dailies—has been thrown overboard by the judgment calls of anonymous upstarts without portfolio but very much with a DSL hotline to Hollywood's prime

movie going demographic. In film criticism, the blogosphere is the true sphere of influence."

Online, the most popular route to film critical opinion is *Rotten To-matoes*, an aggregator site that numerically adds together points on films from various online site "critics" and comes up with a number that supposedly represents a sort of survey of online criticism. But individual reviews seem to have dropped off in importance. It's so much easier to look at a number and use that to see what a majority of critics— some with credentials, and some without—have to say about the film in question. Do 77 percent of the critics surveyed like a film? Good enough. Do 60 percent dislike another film? That's all today's audiences want to know. Who has time to read anymore? Let's just follow the statistics.

Many viewers grew up with names we knew, critics we could follow, especially in journals such as the *Village Voice*. Yet in a cutback similar to *Variety's*, the *Voice* fired longtime film critics Dennis Lim and Nathan Lee in 2008; only longtime avant-garde champion Jim Hoberman remains (as of now) on staff. As Ebert put it, "the age of film critics has come and gone. . . . [T]he death blow came when the Associated Press imposed a 500 word limit on all entertainment writers. The 500 word count limit applies to reviews, interviews, news stories, trend pieces and 'thinkers'" ("Death to the Film Critics"). Ebert dubs the problem the "CelebCult virus," in which AP writers are asked to focus more on celebrity gossip than on any meaningful thought, news, or critical debate. In such an atmosphere, small, foreign, independent, and challenging films are almost guaranteed to be marginalized.

Sadly, Doherty's prediction of fan-based criticism without any real knowledge of the medium seems to be well justified. In an article on the saturation booking rollout of *Iron Man 2*, which opened in 2,500 screens on Friday, May 7, 2010, and then expanded to a record-shattering 4,380 screens for the weekend, Eric Ditzian of *MTV Movie News* seemed content to cite those distribution statistics and then leave the critical work to his readers. Said one, "I thought it a worthy sequel. The other characters were more developed without killing the popcorn fun of this movie. It is worth going to the theater to see on

a big screen. I will go again soon, and will add [it] to my Blu-ray collection when it hits stores," while another wrote that "I thought it was pretty good. Better than the first? I'd say close. The drone thing didn't appeal to me though. And as for Whiplash [one of the villains of the film, played by veteran actor Mickey Rourke], I thought he was pretty badass. And of course it was CGI-heavy. How could you possibly expect to make a movie like this without the CGI being abundant? I would definitely see it again" (Ditzian, "Iron Man 2").

Content, insight, context, and any sort of critical work are almost completely absent in these brief comments. "Pretty good," "pretty badass": these are vague generalizations that tell the reader nothing. The only concrete piece of analysis is the comment that the film is "CGI-heavy," which is hardly a startling observation. This is consumer criticism, created to drive an audience into the theaters. Do you think these readers have ever seen, or will ever see, an Eric Rohmer movie, or an Ingmar Bergman or Agnès Varda film, or even The Hurt Locker? Or know, or have seen, the works of more mainstream Hollywood directors of the past, such as Howard Hawks, John Ford, Michael Curtiz, Henry Hathaway, and many others? When McCarthy, Elley, Lee, and their colleagues were summarily sacked from their posts, they took a lifetime of knowledge with them. Now all we have to look forward to is boosterism or critical mauling without any credentials or, in many cases, even reviewer identification. Everyone uses an Internet handle now, which protects the critic's identity.

As far as Matt Atchity, head of the Rotten Tomatoes website is concerned, this is just a fact of the digital revolution in all its manifestations; and he is, not surprisingly, totally comfortable with it:

> I think there's a growth in the awareness and the interest in a movie fan. When you first start watching movies, you just want to see what the cool movie is. When you're younger, probably critics don't matter as much . . . but as you get older, [and] you start to think "my time is a little more important" or you're just getting more sophisticated in your film tastes . . . you at least can get some education on what you're watching. (as quoted in Leopold, "Are Social Media?")

Another person who is utterly at home with the new era of film criticism, if it can be called that, is Austin, Texas–based Harry Knowles, founder of *Ain't It Cool News*, a website that specializes in horror, action, and exploitation films. Knowles started the website in February 1996 and by 2000 was being sought out by the major studios for "pull quotes," or blurbs, which Knowles seemed only too happy to provide. With his incessant blogging and his enthusiastic embrace of fan-boy culture, Knowles has become a force to be reckoned with in the blogosphere, even hosting an event called "Butt-numb-a-thon" each December, a 24-hour marathon of pop films, as well as serving as co-programmer of Austin's Fantastic Fest, an 8-day film festival centering on science fiction, horror, and fantasy films. He is also a member of the Austin Film Critics Association, which certainly doesn't say much for that organization ("Harry Knowles"). But when it comes to action and exploitation movies, Knowles is ready to provide a user-friendly blurb. And Hollywood loves it.

Harry Knowles is, of course, one of the key bloggers in the success of such a film. As Paula Parisi reported more than a decade ago, even in the early days of the web, many studio executives believed that the *Ain't It Cool* site could actually "make or break a film":

"Harry is very powerful," concedes one studio Internet czar, who like many interviewed for this piece, would speak only on condition of anonymity. "It's become so insider," the executive continues, characterizing the site a must-read for those working in the film world. "I'll bet 80 percent of his hits come from Los Angeles. Half his readers want to see how their projects are doing and the other half are posting under aliases to create their own spin." . . . Agents send him scripts by the ton, hoping his good word will build momentum for their clients' projects. Studios fly him to film sets, though that doesn't guarantee a glowing review, as the makers of [Stephen Sommers's] *The Mummy* [1999] will tell you. Privately, however, some of his professional contacts diss him, maddened that the buzz is beyond their control. "I don't want to legitimize what he does by commenting on it," says one marketing source who regularly seeks exposure on the site. "I consider him a credible *outlet* [emphasis

added], but let's face it, he doesn't have fact checkers. He is not a credible journalist."

And Knowles's taste in films is strictly popcornland, as some of the headlines of the May 13, 2010, issue of *Ain't It Cool News* readily attest. A few samples:

Do You Like Limber Girls?? Then Check Out THE LAST EXORCISM Poster!!; Wait . . . UNIVERSAL SOLDIER IV? More Van Damme vs. Lundgren? IN 3-D?!?; The Greatest Artist of the 20th Century is Dead. Long Live [fantasy poster artist] Frank Frazetta!; Updated! Fox wants a Kick-Ass director for X-MEN: First Class, but does a Kick-Ass director want Fox?; Harry says IRON MAN 2 hits the sweet spot over and over again!; Harry says SERBIAN FILM will be the best film you won't likely see in Theaters this year! (Front page)

Ah yes. *Serbian Film.* In his review of *Serbian Film,* Knowles calls it "a brilliant movie. The very best film that I saw at SXSW [South by Southwest] 2010. I say that not with a tongue in my cheek, some wicked friendly relationship with the filmmakers . . . none of that." OK, so what is *Serbian Film's* narrative? As Alison Willmore reported in the *Indie Eye* blog, Srdjan Spasojevic's *Serbian Film* (2010) centers around "Milos (Srdjan Todorovic), a retired porn star who's lured in for one last (inevitably ill-advised) gig, is shown a tape in which a man attends a nude pregnant woman through labor, and then . . . rapes the still-bloody infant." As Willmore notes, *Serbian Film* gives "new meaning to the term 'torture porn'"; but she adds that, while "it's impossible to imagine *Serbian Film* getting a theatrical release, . . . I'm sure it'll be a major cult item on DVD someday."

It apparently has already found an enthusiastic audience in *Ain't It Cool News* and its followers, and many observers seem perfectly content with this. As Aaron Weiss approvingly notes on the *Cinema Funk* website, "film criticism is not dead. Primitive media outlets are dying," by which he means traditional reviewing platforms are passé. For Weiss, "user reviews are product reviews. Most films released, often times considered art, are still products." While one can hardly argue against

the proposition that film is an increasingly commercial medium, there is an enormous gap between *Iron Man 2* and Jean-Luc Godard's latest effort, *Film Socialisme* (2010), one that most bloggers seem loath to acknowledge or even investigate. As Clarence Page commented in the *Chicago Tribune*,

> A disturbing Internet-age trend is revealed in the fall of professional critics and the rise of what author Andrew Keen warned is "The Cult of the Amateur" in a book with that title. The rise of amateurs in various walks of life, empowered by the Internet, can slide to "idiocracy." Actually, *Idiocracy* was the title of [director Mike Judge's 2006] futuristic [film] comedy: An average guy from 2005 wakes up 500 years later and finds, to his horror, that everything has been so dumbed-down and commercial that he's the smartest guy on the planet. . . . In a world without reliably good culture critics, I fear, "dumbed-down and commercial" would describe popular entertainment even more than it already does. But it is the small-but-earnest effort like *The Hurt Locker*, the little, low-budget movie about a bomb-disposal team in Iraq, for which critics can make a big difference.

As always, small, smart, and original films need all the help they can get in a hypercommercial marketplace. While *Avatar*, as of May 22, 2010, in addition to being the highest-grossing film of all time theatrically, had sold an astounding 19.7 million Blu-ray and DVD discs in the first 3 weeks of its release, *The Hurt Locker* did only a fraction of that business. One film offers escape, the other engagement. As with the 1982 box-office battle between John Carpenter's nihilist masterpiece *The Thing* and Steven Spielberg's *E.T.: The Extraterrestrial*, the public chose the easier route: escape from the everyday world to a fantasyland of fairytale enchantment. In an interview with Gilles Boulenger, Carpenter eloquently recalled the resulting debacle:

> Just before *The Thing* was going to be released, *E.T.* came out . . . and its message was the exact opposite of *The Thing*. As Steven said at the time, "I thought that the audience needed an uplifting cry." . . . On the other hand, our film was just absolutely the end of the world and was

centered on the loss of humanity. [Before the film's release] the studio showed [The Thing] to a focus group [and] . . . one telling moment happened. I was talking to all these kids when this young lady who was about sixteen or seventeen years old said, "What happened in the end? Who was 'the thing?' What happened up there?" And I answered, "Well, that's the whole point! You never find out. You have to use your imagination." Then she replied, "Oh, God! I hate that." That's when I realized we were doomed because I had forgotten one of the obvious rules: The audience hates uncertainty. (Boulenger 171–73)

And yet, as Ebert points out, there is an upside to all of this. Some of it is a tectonic shift in formats; for example, almost immediately after he was fired from *Variety*, Todd McCarthy found a job with the online journal *Indiewire* writing a column titled "Deep Focus" and also got a consulting job with the New York Film Festival (Hernandez). But as Ebert notes, while "film criticism is still a profession, . . . it's no longer an occupation. You can't make any money at it. . . . Anyone with access to a computer need only use free blogware and set up in business" (Ebert, "The Golden Age"). And sadly, many established critics have failed to find a home in this new world, including Kevin Thomas, formerly of the *Los Angeles Times*; Jami Bernard, formerly of the *New York Daily News*; Philip Wuntch, formerly of the *Dallas Morning News*; Dennis Lim, formerly of the *Village Voice*; Jack Mathews, formerly of the *New York Daily News*; Nathan Lee, formerly of the *Village Voice*; David Ansen, formerly of *Newsweek* (though he still contributes reviews to it as a freelancer and in November 2009 was named artistic director of the Los Angeles Film Festival); and Mike Clark, formerly of *USA Today* (Means).

But the general film-going public, as a whole, remains unaware of this wholesale bloodletting. Have you noticed lately that the superlatives used in both print and web film advertisements, as well as in trailers, have gotten larger and larger in font size while the source of attribution has shrunk to microscopic size? It doesn't matter to the studios *who* is praising their product, only that words of praise, from some source, exist.

As Daniel Frankel comments, "with the youthful, movie going audience watching less TV than ever, studio marketers have begun to

aggressively mine what has quickly become their preferred media platform—the web. These days pretty much every major release now has promotional ties to Facebook, MySpace, Twitter or the other online watering holes where movie-watchers congregate" ("Friends of Facebook"). Not surprisingly, Hollywood is only interested in the good reviews for their product; they're interested in promotion, not criticism. Indeed, as Armond White puts it, "over recent years, film journalism has—perhaps unconsciously—been considered a part of the film industry and expected to be a partner in Hollywood's commercial system." He continues, citing Pauline Kael's famed comment, made in 1974, that film "criticism is all that stands between the public and advertising" and then adds that, in the current climate of cinematic commerce,

> Critics are no longer respected as individual thinkers, only as adjuncts to advertising. We are not. And we should not be. Criticism needs to be reassessed with this clear understanding: We judge movies because we know movies, and our knowledge is based on learning and experience. . . . [Fan-boy] Internet criticism . . . has unleashed a torrent of deceptive knowledge—a form of idiot savantry—usually based in the unquantifiable "love of movies" (thus corrupting the French academic's notion of cinephilia).

Viewers could certainly use some guidance in the current cinematic marketplace: while overall viewership has dropped, the number of films released continues to rise. As Tad Friend reported in 2009,

> Even as movie attendance has dropped nineteen per cent from its peak of 1.6 billion theatergoers, in 2002, the number of films released each year since then has increased by thirty per cent. A dozen new films—three of them big studio releases—now vie for attention on any given weekend. To cut through the ambient noise, major studios spend an average of *thirty-six million dollars* [emphasis added] to market one of their films. "Most of a movie's opening gross is about marketing," Clint Culpepper, the president of Sony Screen Gems, says. "You can have the most terrific movie in the world, and if you can't convey that fact in fifteen- and thirty-second TV ads it's like having bad speakers on a great stereo."

At Sony, executives ask, "Can we make this seem 'babysitter-worthy'?
Will it get them out of the house?" (41)

Tim Palen, a veteran moviemaker, uses social media, among other
tools, to get viewers out of their houses and into theater seats. He is
one of a new breed of advertising entrepreneurs who know how to
deliver a 21st-century audience, whether it be to Paul Haggis's *Crash*
(2004), any of the *Saw* films, or James Mangold's 2007 remake of Del-
mer Daves's 1957 classic *3:10 to Yuma*, which despite middling re-
views still did excellent business. Whatever the film, Palen has to find
a hook.

Classic Hollywood exploitation producer William Castle, direc-
tor of such exploitation horror hits as *House on Haunted Hill* and *The
Tingler* (both 1959), succinctly observed in 1973, near the end of his
career, that "I say an audience doesn't know what they want to see,
but they know what they *don't* want to see," and his words hold true
today (Strawn 287). Castle, the all-time king of carnivalesque bally-
hoo, knew that, no matter how exploitable a film was, if you didn't
put in the effort, the film would ultimately fail to fully capitalize on its
potential. As he put it, "You've got to have some little hook, whether
it's perfume, whether it's incense, or whether it's a flamethrower. But
you've got to have something" (298).

Today, the stakes are considerably higher. In 2009, the *average* studio
film cost a staggering $107 million to produce and promote, making
the business increasingly risky and producers increasingly risk-adverse
(Friend 43). As Friend further notes, in this highly charged financial
environment, "films [in 2009] no longer have time to find their audi-
ence; that audience has to be identified and solicited well in advance"
(44). And that, of course, is where Facebook and its brethren come
in. Getting the word out to audiences well before the film opens in
theaters is the new name of the game, building brand awareness with
jarring images, brief spots on the web (some as short as 5 seconds), and
sequences of (as the case may be) violence, action, romance, or comedy.
The audience usually wants more of the same, just slightly modified for
this particular generic installment.

Palen works for Lionsgate, a medium-sized production company that

specializes in niche films—horror, comedy, and action—and the studio's unofficial motto when it comes to promotion is straightforward and simple: "Do Fucking Everything" (Friend 41). And while you're at it, appeal to the widest possible audience. You can't afford to leave anyone out. At Lionsgate, as elsewhere in Hollywood, films are expected to reach at least 2 audience groups to be worthy of a green light for production:

[Y]oung males like explosions, blood, cars flying through the air, pratfalls, poop jokes, "you're so gay" banter, and sex—but not romance. Young women like friendship, pop music, fashion, sarcasm, sensitive boys who think with their hearts, and romance—but not sex (though they like to hear the naughty girl telling her friends about it). They go to horror films as much as young men, but they hate gore; you lure them by having the ingénue take her time walking down the dark hall. Older women like feel-good films and Nicholas Sparks–style weepies: they are the core audience for stories of doomed love and triumphs of the human spirit. They enjoy seeing an older woman having her pick of men; they hate seeing a child in danger. Particularly once they reach thirty, these women are the most "review-sensitive": a chorus of critical praise for a movie aimed at older women can increase the opening weekend's gross by five million dollars. In other words, older women are discriminating, which is why so few films are made for them. Older men like darker films, classic genres such as Westerns and war movies, men protecting their homes, and men behaving like idiots. Older men are easy to please, particularly if a film stars Clint Eastwood and is about guys just like them, but they're hard to motivate. "Guys only get off their couches twice a year, to go to *Wild Hogs* or *3:10 to Yuma*," the marketing consultant Terry Press says. "If all you have is older males, it's time to take a pill." (44–45)

So you've got know your audience and how to reach it. For the *Saw* franchise, that audience is young men seeking ever increasing doses of gore and mayhem; thus, to market one of these films, Palen designed ads for the Internet featuring a scene of extremely graphic violence, with the matter-of-fact tag line, "How Fucked Up Is That?" As John

Shea puts it, "Tim [Palen] recognized that you want the core of the audience to feel, for a while, that the film is theirs. So he gives them content that feels bloggy and street—like they're behind the curtain. Then they become barkers for your film" (Friend 47).

In short, "the advertising advantage that studios have over other industries is that they can give out free samples of a movie as advertising—promotional material that feels like content" (46). The other major advantage is that, since audience tastes are subjective, the film industry is one of the few production entities that can get away with *not* offering refunds to dissatisfied customers. Once you've paid your money at the box office, or rented the DVD, or purchased an on-demand or online movie, if you're unhappy with what you see, tough luck. It has to be this way. As trailer (or preview) editor David Schneiderman notes, "How many great movies are there each year? We're in the business of cheating, let's face it. We fix voice-overs, create dialogue to clear up a story, use stock footage. We give pushup bras to flat-chested girls, take people's eyes and put them where we want them. And sometimes it works" (46–47). And with all the ways that one can reach an audience in the digital era, if the film is marketed properly, when one factors in overseas theatrical rentals, DVDs, ancillary rights, and other revenue streams, most of the time it does work.

Yet if one goes "off the grid" of popular movie culture, the results can still be hard to market. Fede Álvarez's short film *Panic Attack*, as we've seen, delivered precisely what the target audience wanted: gigantic robots and epic scenes of destruction. It got Álvarez a production deal, and no doubt he will create some highly commercial films. More recently, Gareth Edwards created an even more impressive project— the simply titled *Monsters* (2010). Using a crew of 2 people (Edwards shot, edited, directed, produced, and created the special effects for the film; his only assistant was a sound recordist with a boom microphone) and a budget of a mere $15,000, he successfully conjured up a futuristic nightmare in which most of Mexico has been infected with alien life forms that threaten to destroy mankind and are gradually spreading north to the U.S. border. Part social allegory, part romance, and part thriller, *Monsters* follows a freelance news photographer, Andrew

Kaulder (Scoot McNairy), and Samantha Wynden (Whitney Able) as they make their way through the infected zone and attempt to return to the supposed safety of the United States.

The film was shot entirely on location, with no permits, using by-standers as extras and even in speaking parts and depending on semi-professional video equipment. While shooting, Edwards used a series of pages that suggested sequences but had no formal script, and much of the dialogue and action were improvised. As Edwards told David Harley,

> It was a really organic process and even during the shoot, ideas changed; we were very open-minded during the shoot. Like, we had this scene-by-scene outline where we had a paragraph for each scene instead of a script. So what happened was we'd be driving along in the bus in Central America and if we saw anything interesting, that looked really freaky or weird, we'd jump out and just pick a scene from the film to do there. There would be these instances where we'd say, "Well, this looks appropriate. Let's give this a go and do this scene," and the ac-tors would quickly get into their headspace. We'd have a little motiva-tional conversation and just go for it. Sometimes they'd stay in character and people we met wouldn't know it was a film. They would think it was probably a documentary as we would shoot a lot of naturalistic behavior of people as we would bump into them or meet on the street or wherever we were on the journey. As soon as it was over, my line producer went up to them with a release form and explained what was really going on and got them to sign it to have their permission to be in the film. I'd say that it wasn't like, "OK, I want to tell this story." It was more like I just wanted to create a very believable world where there [could] be people behaving [as if] . . . there really were monsters.

With his expertise in special effects, Edwards would shoot the scenes in a semi-documentary manner, panning to nearby signs or placards, which he would then digitally alter into warning notices or supposed maps of the infected zone.

But *Monsters* is far from the traditional science-fiction movie. As Edwards told Chris Ullrich,

Everyone always says this when they come out of a big Hollywood film these days: "I didn't really care about the characters but I really loved the effects." That happens. I wanted to make a movie where you do care about the characters. You have to see things in the characters that you can relate to the more you are pulled into them. I wanted to go with something like [Sofia Coppola's 2003 film] *Lost in Translation* meets [Byron Haskins's 1953 film] *War of the Worlds* or pick your favorite Sci-Fi film. Part romance, part monster movie. I think we achieved that.

And for some viewers, that's a problem. Although the completed film has won a plethora of awards at various festivals around the globe, those in the audience who expect a nonstop gorefest will be sorely disappointed. The monsters of the title appear only briefly; and in the film's final, evocative moment, two of the giant squidlike aliens are seen mating outside a deserted gas station in the desert, a scene that is played more for its wondrous aspect than for any shock value. A quick scan of customer reviews on Amazon, where the film premiered as a streaming download (as well as on TV as an on-demand offering), shows a sharp divide in viewer response. More thoughtful viewers discern the film's undeniable social subtext; thrill seekers feel cheated. But as Edwards told Cole Abaius,

I just think, the more money you have, the more you have to appeal to a broader audience to get that money back, and the more compromise you have to make, and the less unique the film will be. I was just saying something earlier to someone that there are a lot of examples of people who made unique films that made a lot of money, but it's far less common than the people who made films with very little money because there wasn't so much at risk to jump off the cliff.

So I'd like to jump off the cliff again.

But for most people, it seems, live-streaming "reality" video and YouTube clips are the preferred forms of entertainment, and the web eagerly obliges, offering an endless smorgasbord of chaotic, unrelenting images. So the flow of visual information continues unabated, and it seems that most people want more visual input rather than less. How

else to explain the fact that 1 in 10 Americans under the age of 50 would like to have a direct-line Internet implant inserted directly into their brains, if such a thing were possible, so that they could have 24-hour access to the web? Or that 37 percent of all Americans "would rather spend time on the Internet than with co-workers, while 49 *per-cent* [emphasis added] would choose the Internet over their in-laws" (see Evangelista). In addition, 41 percent of Americans said that, if they had access to a time machine, they would go back in time and create Google rather than seek a new spouse or bet on "the known outcome" of a sporting event (see Evangelista). And, oddly enough, 10 percent of all web users say that the experience of being online makes them feel closer to God; among born-again Christians, that fig-ure jumps to 20 percent (see Kirkpatrick). In addition, 24 percent of all respondents "said that the Internet could serve as a replacement for a significant other, including 31 percent of single people, 31 percent of self-described political 'progressives' and 18 percent of those who consider themselves 'very conservative'" (see Kirkpatrick).

But given the shift in attitudes toward others in our lives, perhaps this isn't all that surprising. As Jeanna Bryner reports of a large-scale sampling "based on a review of 72 studies of 14,000 American col-lege students overall conducted between 1979 and 2009," students in 2010 "scored 40 percent lower on a measure of empathy than their elders did." Perhaps this is because, without the web as a "mediator of human interaction," people dealt with each other directly on a daily basis or through conventional mail letters, which are far more labor-intensive than the web is. Said Sara Konrath, a researcher at the Uni-versity of Michigan Institute for Social Research and also a member of the psychiatry department at the University of Rochester,

> We found the biggest drop in empathy after the year 2000. Many peo-ple see the current group of college students—sometimes called "Gener-ation Me"—as one of the most self-centered, narcissistic, competitive, confident and individualistic in recent history. The increase in expo-sure to media during this time period could be one factor. Compared to 30 years ago, the average American now is exposed to three times as much nonwork-related information. In terms of media content, this

generation of college students grew up with video games. And a growing body of research, including work done by my colleagues at Michigan, is establishing that exposure to violent media numbs people to the pain of others. (as quoted in Bryner, "Today's College Kids")

When, as a child, if you were playing with another child and a fight broke out, there were immediately identifiable consequences; and through social behavior, people learned how to respond to overtures of friendship, or bullying, or threats, or praise and rewards. Now, with the web's distance between us, those consequences are diminished; and the ability to hide behind aliases further compounds the problem. Cyberbullying is rampant, driven for the most part by page-view hits as a result of controversial or inflammatory content. Who has the larger audience: the *PBS Newshour* or Fox News? Fox wins, hands down, because it courts and endorses controversy. The *PBS Newshour* is more balanced and nuanced in its presentation of the day's events, but it seeks to enlighten, not enflame. The same thing is true on the web. With the lack of face-to-face content, people feel that there are no consequences for even their cruelest actions and behave with relative impunity.

Thus, it's not surprising that centers to treat web addicts have lately been springing up around the United States. Ben Alexander, a 19-year-old student at the University of Iowa, spent nearly all of his waking hours playing *World of Warcraft* and, as a result, flunked out of school. He subsequently entered an Internet addiction center in Fall City, Washington, called Re START, a 45-day boot camp designed to break the cycle of addiction. As the Associated Press reported on September 6, 2009, the United States is behind the curve on Internet dependency, compared to other countries around the world:

Internet addiction is not recognized as a separate disorder by the American Psychiatric Association, and treatment is not generally covered by insurance. But there are many such treatment centers in China, South Korea and Taiwan, where Internet addiction is taken very seriously, and many psychiatric experts say it is clear that Internet addiction is real and harmful. . . . The center uses a "cold turkey" approach. Alexander spends his days in counseling, doing household chores, working

on the grounds, going on outings, exercising and baking cookies. . . . Alexander said he started playing *World of Warcraft*, a multiplayer, role-playing game, about a year ago and became hooked. He tried a traditional substance abuse program, which was not a good fit, he said. He sought out a specialized program and arrived in Fall City in July. He thinks it was a good choice. "I don't think I'll go back to *World of Warcraft* anytime soon," Alexander said. ("Center Tries" 17)

Fantasy violence is becoming literally indistinguishable from real conflict, and the shift from video-game warfare to actual warfare seems now just a jump away from conventional game playing. Soldiers in Iraq and Afghanistan are now busily crafting their own online videos of the war as they experience it, uncensored by conventional media and disseminated over the web. As Noam Cohen reports,

If you want to see the horror of war, you do not need to look far. There are sites aplenty showing the carnage, and much of the material is filmed, edited and uploaded by soldiers recording their own experiences. "There are many more types of recording devices, mounted in different ways," said Jennifer Terry, an associate professor at the University of California, Irvine, who produced a study of military videos from Iraq and Afghanistan for the multimedia journal *Vectors*. "The way these videos circulate on the Internet is unprecedented, in all these different leaky ways. That is why I like to say this is the first YouTube war." . . . [T]he violent material posted by soldiers usually comes in highly packaged form . . . resembling nothing so much as a music video. Certain songs have become established scene-setters, particularly the heavy-metal song "Bodies" by Drowning Pool, with its mantra: "Let the bodies hit the floor, let the bodies hit the floor." . . . "These videos will have a strong impact, but it is hard to tell what it will be," [Don] Hewitt [the co-founder of LiveLeak.com] said. "Some people watch it and think, 'That is grotesque, how can we do it?' Others will say, 'Hell yeah, go team'" (B3)

In short, war has become a spectator sport, both in the virtual and actual worlds, a spectacle designed for handy Flip-camera recording

and used for personal or global consumption. All it takes is the push of a button to upload the image for the entire world to see. YouTube now handles a staggering 1 *billion* requests for video uploads per day, according to CEO Chad Hurley, who adds that "clip culture [is] here to stay"; while YouTube's content manager, Dave King, estimates that 20 hours of video are uploaded to YouTube every minute, every day, 365 days a year, 24 hours day, creating a bewildering labyrinth of images in which the self can easily be lost.

Indeed, point-and-shoot video has become even easier with two new camcorders that allow hands-free recording. The Looxcie, a small video recorder introduced in late 2010, costs $199 retail and, as Anne Eisenberg notes, is "a small wearable camcorder [that] loops over the ear":

> The camera is built into a Bluetooth headset that streams digital images wirelessly to Android phones that use a free Looxcie app. From there, the clips can go directly to e-mail. . . . [Each] camera weighs about an ounce and stores up to five hours of video . . .
>
> The cameras are likely to be very popular for both business and recreational use, said Jonathan Zittrain, a law professor at Harvard Law School and a co-founder of the Berkman Center for Internet and Society. "People will put them on and wear them everywhere."
>
> [But] as wearable cameras gain popularity, and as some amateur auteurs capture candid images of people with no wish to star on the Internet, the devices are sure to raise privacy and other issues, said Professor Zittrain. . . . "What will we do then?" he asked. "Ban them at basketball games and recitals?" ("When")

For some people, however, even wearing a video camera constantly isn't enough. Wafaa Bilal, a photography professor at New York University's Tisch School of the Arts, has decided to take matters one step further: by surgically implanting a video camera in the back of his head, which will record his every action for a year and will stream the images to a museum in Qatar for public exhibition. As Erica Orden described it,

For one year, Mr. Bilal's camera will take still pictures at one-minute intervals, then feed the photos to monitors at the museum. The thumbnail-sized camera will be affixed to his head through a piercing-like attachment, his NYU colleagues say. . . . The artwork, titled "The 3rd I," is intended as "a comment on the inaccessibility of time, and the inability to capture memory and experience," according to press materials from the museum, known as Mathaf: Arab Museum of Modern Art. Mr. Bilal's work would be among the inaugural exhibits of Mathaf, scheduled to open next month. (A23)

Because Bilal is teaching a regular course load at NYU, such constant surveillance might come as something of an unwelcome surprise to his students, particularly since, as a teacher, he will presumably spend at least some of his time in the classroom writing on the blackboard, thus affording his built-in camera an excellent view of what transpires behind his back. Deborah Willis, chair of the university's photography department, was less than sanguine about the idea, asking, "What if students are upset? What if you're documenting what they don't want you to see?" Meanwhile, NYU spokesperson John Beckman somewhat laconically noted that "it's fair to say that a good deal of discussion ensued" when Bilal first came up with the project (Orden A23).

Nevertheless, "The 3rd I" seems to be moving forward, and really, is it any different from the Looxcie? It's just part of your body now, another eye that constantly records your daily activities as well as the actions of everyone around you. In many ways, the project seems to be the logical extension of numerous science fiction films, especially Vittorio Sala's Italian thriller *Spy in Your Eye* (1965), in which spymaster Colonel Lancaster (Dana Andrews) has a continuously broadcasting miniature television camera surgically implanted in place of his left eye. Then it was fantasy. Now it can be fact.

In short, when Alvin Toffler coined the terms *future shock* and *information overload* in 1970, he had no idea what was coming with the dawn of the digital age. Here is a device, no bigger than a lipstick case, capable of recording and storing up to 5 hours of video for future storage and playback. In addition, the Looxcie can isolate 30-second clips of

video at the touch of a button and send them as email attachments to anyone at all. Soon, it seems, everyone will be recording everyone else, and we will become, in every sense of the word, a panopticon society. Yet Jonathan Zittrain seems remarkably sanguine about the end result of this avalanche of images. As he told Anne Eisenberg, "we have painstakingly reconstructed ancient civilizations based on pottery and a few tablets. . . . I would love to leave this legacy instead" ("When").

Perhaps. But the sheer volume of images involved staggers the imagination. And given that the camera costs less than $200—a price that will soon be almost certainly reduced—everyone will want one.

Thus, the globalization of the moving image is an accomplished fact; for better or worse, we now have access to an almost infinitely indexed web of images that chart our entire history since the birth of the moving image with Augustine le Prince in 1888 (see Van Buskirk). In the 1970s, for example, Europeans had access to a very limited choice of television channels; in Britain, there were only 3 television networks. Now Europeans have a choice of 8,600 TV channels. As Tim Adler comments,

> The number of television channels in Europe continued to nudge upwards in 2009 despite the global recession. There are 7,200 television channels based in Europe. If you take into account U.S. channels being beamed into the EU, the number of channels available to European viewers reaches a staggering 8,600. Movie channels and television drama continue to dominate in terms of channel genre. There were 496 movie and drama channels in the 27 European Union member states last year. Sports were in second place with 419 channels followed by light entertainment (318 channels).

This is just a partial list of televisual offerings; the number of channels changes by the minute as new venues emerge to compete with existing programming, in a never-ending battle for ratings and audience. It's all driven by advertising, subscriptions, satellite delivery, and the seemingly insatiable demand of an already media-saturated society that still wants more, more, more.

Hollywood, with its vast technical resources and its dominance

Bruce Willis in Frank Miller, Robert Rodriguez, and Quentin Tarantino's *Sin City* (2005): the comic book world come to life. Courtesy Jerry Ohlinger Archive.

Christopher Nolan directs on the set of his film *The Dark Knight* (2008). Courtesy Jerry Ohlinger Archive.

Heath Ledger and Ang Lee on the set of Lee's film *Brokeback Mountain* (2005). Courtesy Jerry Ohlinger Archive.

OPPOSITE: Heath Ledger as the Joker in Christopher Nolan's *The Dark Knight* (2008). Courtesy Jerry Ohlinger Archive.

Jake Gyllenhall and Heath Ledger as the tormented lovers in Ang Lee's *Brokeback Mountain* (2005). Courtesy Jerry Ohlinger Archive.

Johnny Depp as the Mad Hatter in Tim Burton's *Alice in Wonderland* (2010).
Courtesy Jerry Ohlinger Archive.

One of the more peaceful scenes from Zack Snyder's violent war film *300* (2006).
Courtesy Jerry Ohlinger Archive.

Will Smith as the last man on earth in Francis Lawrence's *I Am Legend* (2007). Courtesy Jerry Ohlinger Archive.

Sam Worthington in James Cameron's 3-D extravaganza *Avatar* (2009), the most commercially successful film in cinema history. Courtesy Jerry Ohlinger Archive.

One of the "prawns," or aliens, in Neill Blomkamp's sci-fi parable *District 9* (2009).
Courtesy Jerry Ohlinger Archive.

Matt Damon as title character Jason
Bourne in Paul Greengrass's *The Bourne
Ultimatum* (2007). Courtesy Jerry
Ohlinger Archive.

Louis Leterrier (on right) directs Sam Worthington on the set of *Clash of the Titans* (2010). Courtesy Jerry Ohlinger Archive.

The menacing figure of Medusa (Natalia Vodianova) in Louis Leterrier's *Clash of the Titans* (2010). Courtesy Jerry Ohlinger Archive.

Robert Downey suited up as industrialist/superhero Tony Stark in Jon Favreau's *Iron Man 2* (2010). Courtesy Jerry Ohlinger Archive.

Denzel Washington as the title character, Eli, in Albert and Allen Hughes's *The Book of Eli* (2010). Courtesy Jerry Ohlinger Archive.

OPPOSITE: Benicio Del Toro as Lawrence Talbot, transformed into a werewolf by the full moon in Joe Johnston's 2010 version of *The Wolfman*. Courtesy Jerry Ohlinger Archive.

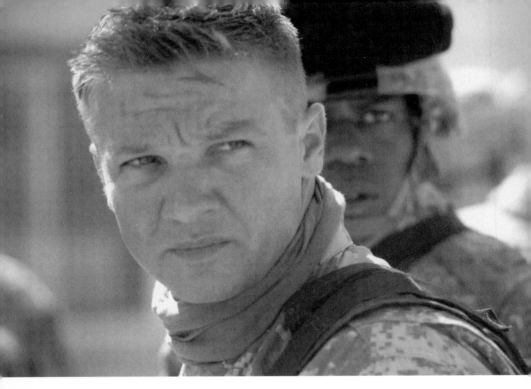

Jeremy Renner as Sergeant First Class William James in Kathryn Bigelow's searing drama of war, *The Hurt Locker* (2008). Courtesy Jerry Ohlinger Archive.

Kathryn Bigelow directs *The Hurt Locker* (2008) on location in Amman, Jordan. Courtesy Jerry Ohlinger Archive.

Quentin Tarantino in firm control on the set of *Inglourious Basterds* (2009). Courtesy Jerry Ohlinger Archive.

Brad Pitt as Nazi hunter Lieutenant Aldo Raine in Quentin Tarantino's *Inglourious Basterds* (2009). Courtesy Jerry Ohlinger Archive.

Scoot McNairy and Whitney Able on the road in the "infected zone" of Mexico in Gareth Edwards's *Monsters* (2010). Courtesy Photofest.

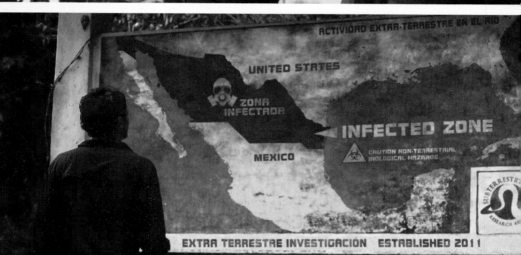

Scoot McNairy consults a roadside map of the alien invasion in Gareth Edwards's *Monsters* (2010). Courtesy Photofest.

(for better or worse) of commercial cinema, is leading the way in the shift to digital production and distribution, which is changing the way in which films are made, distributed, and shown on everything from cell phones to conventional theater screens. Movies are now composed of pixels and electrons rather than celluloid frames and colored dyes, making it easier to translate images from one medium to another. Downloading entire feature films to your computer hard drive is now relatively quick and efficient, and new downloading formats appear almost daily.

The American Film Institute recently put up a full-screen, full-time online film theater, which routinely screens classic films, uncut, over the Internet, on a regular basis, with programs changing weekly. Undoubtedly, the ease with which one can access full-screen moving images on the web will increase; it will probably be less than a year before many commercial feature films are routinely distributed in this manner. The existing regime will have to learn to do business with these distribution methods, just as they have had to accommodate sampling in pop songs (once an outlaw act, now a daily occurrence). And now Google is entering the fray, with Google TV, which, in Google's words, will "bring the web to your TV and your TV to the web" (as quoted in Patel). With a scheduled launch date of fall 2010, at this writing,

> [Google TV] isn't a single product—it's a platform that will eventually run on many products, from TVs to Blu-ray players to set-top boxes. The platform is based on Android, but instead of the Android browser it runs Google's Chrome browser as well as a full version of Flash Player 10.1. That means Google TV devices can browse to almost any site on the web and play video—Hulu included, provided it doesn't get blocked. (Patel)

Google TV "lets people visit any web site from their televisions and easily search for programming and web video without scrolling through unwieldy onscreen TV directories" (Stone B1). In short, it's a merger of the web, including YouTube, Google, Facebook, and any and all social networking devices with existing television

programming—provided, of course, that you pay for a television set that can incorporate the new technology. Many people will, no doubt; but to add the complete mass of web material on top of all the existing television channels (more than 500 on our own cable system alone) seems like an overwhelming amount of material.

But like it or not, Google has deep pockets; and thus, Google TV or something very much like what its engineers have envisioned will soon be offering a complete index to the entire image bank of the web: stills, text, music, moving images, anything that can be downloaded or uploaded. Many observers persuasively argue that we are witnessing the next step in what will be a continual evolution of moving-image delivery, which, in turn, will be followed by newer mediums of image distribution now unknown to us. The filmic medium as a separate and sacrosanct domain will merge with the digital image, melding the inherent qualities of light and color to create a new world of electronic emotion, even if it is a disconnect from the real in the classical Bazinian sense.

With Google TV, the dissemination of the moving image will become seamless, sweeping across conventional boundaries through the web to reach a newly congruent audience, which is relentlessly oriented toward pop, disposable cinema, and ephemeral, equally disposable stars. And yet, as is the case with many national cinemas, a spirit of resistance has sprung up against the Hollywood model, even as the major film studios scramble to buy up all the new distribution channels as fast as they are being introduced. What sort of a viewer does the new digital cinema anticipate?

While the platform of film may vanish, for most audiences, the "films" themselves will remain; and audiences, now adjusted to viewing moving images in a variety of different ways, will still want to see their dreams and desires projected on a large screen for the visceral thrill of the spectacle as well as the communal aspect inherent in any public performance. Film is indeed disappearing, but movies are not. If anything, they are more robust than ever. Indeed, many industry observers are predicting 2010 to "be the first $5 billion summer at the box office" (see Carter), and Mark Lynch notes,

Hollywood is everywhere, and with the right approach there is no reason it can't flourish, domestically at least, simply because entertainment is vital to our lives. I think the social network model could serve Hollywood well if implemented properly. Despite Facebook's market penetration, there is no Facebook product; it depends on the input of its members. Hollywood, on the other hand, has an abundance of product. Since movie going is largely a social activity, Hollywood should engage with its consumers.

Yet in this new world of media saturation, we are also in the midst of a global economic downturn, and Hollywood may have to cut its budgets. Disney chairman Rich Ross recently informed spectacle producer Jerry Bruckheimer that the 4th installment of the immensely popular *Pirates of the Caribbean* series (this episode subtitled *On Stranger Tides*, 2011) would have to cost ⅓rd less than the previous movie in the series, which would still keep it at about $200 million for production alone. Nevertheless, the film will have a much tighter production schedule and fewer effects shots and will emerge as a leaner film in all respects. No doubt, however, the advertising budget will be huge; and with Johnny Depp on board (in more ways than one), the film should be assured of box-office success (see Eller and Chmielewski).

With Kodak cutting back its film output drastically (the company now makes 70 percent of its revenues from digital-image capture and reproduction) and the *Pirates* series' embrace of digital special effects, it remains to be seen whether *Pirates of the Caribbean: On Stranger Tides* will do away with film in favor of digital production entirely (see Kinyanjui). That would dovetail nicely with worldwide plans to convert *all* conventional film theaters to digital projection. In Amsterdam, for example, the Palace Cinema chain is going to convert "its entire 170 screen circuit to digital projection" (Di Orio, "Palace Cinemas"). Palace, which operates movie theaters throughout Europe, is ecstatic about the changeover, which in its view is long overdue. As Palace CEO V. J. Maury enthused, "with the conversion to digital, we will be able to provide our audience [with] a full lineup of movies shown perfectly in digital on the big screen every single time, in

every language, dubbed or subtitled, in 2-D or 3-D" (Di Orio, "Palace Cinemas").

At the same time, a new and controversial wrinkle has been added to the mix with the recent decision of the Federal Communications Commission (FCC) to allow studios to deliver 1st-run features directly to subscribers through cable television. This release would be prior to DVD or Blu-ray street dates, and films might even be released on cable simultaneously with theatrical openings, thus directly cutting into theatrical revenue. The Independent Film Channel (IFC), however, has been doing this for years with its "IFC on Demand" program, which allows viewers to see (for a fee, naturally) IFC films that open theatrically only in "select cities" and thus wouldn't reach beyond New York, Chicago, Boston, Los Angeles, and San Francisco without the additional exposure. But IFC's films are resolutely small-budget affairs, many of them either American independent films in the $1 to 5 million range, or foreign pickups that sadly, in the current economic climate, have no real shot at even art-house success. As James McCormick asks, does such an instant-release program "spell an end to theater chains? [Probably] it will hurt the theaters and DVD/Blu-ray sales a bit at first. But to be honest, people thought theaters would falter when TV came about and then again when VHS was the entertainment choice. Even now, with streaming and rental services like Netflix and Redbox being a normal way of life, we still have films doing phenomenally in theaters."

The need for spectacle endures and has continued to drive mainstream film production and exhibition; for smaller films, the FCC's edict is a lifeline. These aren't the movies that make up 90 percent of the theatrical box office; these are the films that get lost in the shuffle, don't have huge advertising budgets, and need any kind of pay exposure they can get. There is also an interesting sidebar to the FCC's decision. While allowing 1st-run films to be directly disseminated to consumers and thus bypassing theaters, at the same time, the FCC also approved a new plan to "let cable and satellite TV companies turn off output connections on the back of set-top boxes to prevent . . . copying of movies" (see Tessler). This means that you could see the film, per-

haps even save it for 24 hours in your DVR, but you could never record it and make a permanent copy for yourself.

The Motion Picture Association of America (MPAA) wants the change so that studios can have a wider market for films that might prove problematic in a traditional theatrical release, where it can cost upwards of $70 million to open a single film. Who's going to spend that amount of money on a $5 million film? It makes more sense to throw your advertising and promotion dollars at *Pirates of the Caribbean IV: On Stranger Tides*, which is a pre-sold, almost certain commodity, than on a dicier independent film such as *District 9*. As Joelle Tessler comments,

> With DVD sales declining, studios are looking for new ways to deliver their content securely while still making money. In its decision . . . the [FCC] stressed that its waiver includes several important conditions, including limits on how long studios can use the blocking technology. The FCC said the technology cannot be used on a particular movie once it is out on DVD or Blu-ray, or after 90 days from the time it is first used on that movie, whichever comes first.

But for theater owners, this is a decision that could have considerable impact; and for consumers, it extends Hollywood's reach into their homes, dictating what they can and cannot record, a decision with potentially far-reaching ramifications. And yet despite all of this, the realm of the moving image is globally ubiquitous, and corporate and government decisions of the moment are continually subject to change. What works today may not work at all tomorrow; today's effective business model can be rendered obsolete by emerging technologies, hackers who find ways to circumvent government regulations, and torrent download systems that often operate from foreign locations beyond the reach of any authority. The moving image is everywhere; and with 20 new hours of video being uploaded every minute to YouTube, we may soon have an almost complete inventory of humankind's fascination with recording the lives, dreams, and destinies of cultures throughout the world, unmediated by any filter at all.

CHAPTER FOUR

The New Auteurs

The concept of the *director* as primary creator of a film or video has changed in the 21st century. While some cling to the old idea of one person directing an entire production and being principally responsible for the project's visual and/or thematic content, a new generation of filmmakers is creating mash-ups by working in groups on the web, turning out films stamped with multiple cultures and multiple visions. In addition, the idea of making a film for theatrical distribution as the primary point of sale is also rapidly changing; in the 2009 Toronto Film Festival, for example, an unusually large number of feature films with major stars failed to find a distributor in the conventional sense and must now compete with truly independent, do-it-yourself videos in the marketplace of the web, DVDs, pay-per-view, streaming video, and other distribution methods.

Peter Broderick, who has been working in cinema distribution since the 1990s with his company Next Wave Films, knows this all too well. Broderick distributed Christopher Nolan's first film, *Following* (shot in 1996, generally released in 1999), which was shot with a zero-level budget of $6,000 in 16mm black-and-white on weekends during the course of a year. At a lecture at the University of Southern California in November 2009, Broderick introduced the uninitiated to how exactly film marketing works in the 21st century. Dividing film distribution into the Old World and the New World, Broderick

read a "declaration of independence" for indie filmmakers as part of his PowerPoint presentation, which he delivered while wearing a tricorn hat, emblematic of the American Revolution of 1776. As Manohla Dargis, witnessing the presentation, wrote,

> In the Old World of distribution, filmmakers hand over all the rights to their work, ceding control to companies that might soon lose interest in their new purchase for various reasons, including a weak opening weekend. . . . In the New World, filmmakers maintain full control over their work from beginning to end: they hold on to their rights and, as important, find people who are interested in their projects and can become patrons, even mentors. The Old World has ticket buyers. The New World has ticket buyers who are also Facebook friends. The Old World has commercials, newspaper ads and the mass audience. The New World has social media, YouTube, iTunes and niche audiences. ("Declaration")

It's harder than ever to break through the Hollywood distribution monolith, Dargis argues, with the closing of niche-picture divisions of the major studios, such as Paramount Vantage and Warner Independent Pictures. For every event indie that breaks through the studio ceiling—for instance, Oren Peli's *Paranormal Activity* (2009)—there are at least 10,000 other films that will never see the light of day. Broderick, who has been helping independent filmmakers find their audiences for years, and other distribution experts, such as Richard Abramowitz, specialize in helping filmmakers distribute films themselves, sometimes with spectacular results. As Dargis points out, it's particularly ironic that theatrical distribution should remain such a barrier in an age in which production has become somewhat inexpensive. *Paranormal Activity* cost roughly $10,000 to make but required an additional ad push of $12 million to get it before the public. The odds against a repeat of this pattern are immense.

Not that Hollywood itself is doing all that well. Runaway film productions, shot throughout the United States to save money, are sapping Hollywood's production strength. Gary Credle, until recently the chief operating officer of the Warner Brothers studio, noted in

March 2009 that it had been nearly 2 years since a full-length motion picture had been shot at the facility and that television production had also dropped precipitously. The cost of maintaining a "full service studio on 110 prime acres in the heart of Southern California" has become prohibitively expensive; for as Credle put it, "certainly if this didn't exist, we couldn't afford to build it today. The models for this business are being challenged every day in every imaginable way, and nobody knows where it ends up. . . . What you see here is going away, and it's not obvious what is going to replace it" (as quoted in Pearlstein).

In Pontiac, Michigan, for example, a former General Motors (GM) auto factory is being transformed into Raleigh Michigan Studios, an offshoot of Raleigh Studios in Los Angeles, a non-union production facility right across the street from Paramount Pictures, where many independent films are made on modest budgets. To cut costs, films are often shot at Raleigh and then post-produced at Paramount, which gives films the International Alliance of Theatrical Stage Employees (IATSE) seal of approval and allows them to be internationally released without alienating union labor. Also under construction in Michigan is Unity Studios, which will be based in former buildings of the Visteon Corporation, an auto parts manufacturer in Allen Park. Both studios are taking full advantage of Michigan's 40 percent state tax credit on the construction of new motion-picture production facilities as well as another 25 percent infrastructure credit to equip the studios with state-of-the-art technology.

The facilities are of recent vintage: the GM plant that will become Raleigh Michigan was built for GM in 1999; the Visteon building was operational until 2005, when overseas outsourcing put an end to production. At the Unity location, the buyers availed themselves of a partially constructed 160,000-square-foot building, which will now become production stages and other post-production and production facilities, and plans are under way to train former workers in the techniques of film production. Unity plans to turn out 7 feature films per year once the facility is complete and sees itself as a 1-stop operation. Jimmy Lifton, head of Unity, notes that "under one roof someone can come up with an idea and at the end there is a finished product" (Paul B6). Similar facilities are being built in Louisiana and New Mexico,

and there are numerous other production facilities already in operation throughout the United States. Hollywood may still be the center of talent management, finance, and distribution, but in their desire to cut production costs to the bone, the studios are ready, willing, and able to cut the best deal possible, even if that means leaving home base.

Yet finding finance to make independent films has become more difficult than ever. Ted Hope, of Good Machine, an independent production company, identifies 4 different types of independent films that were produced in the 1980s and 1990s but also notes that 2 of the models won't work in the current marketplace:

> One was low-budget first features—from a couple of hundred thousand to a couple of million dollars—which were designed for full unveiling at Sundance with a drive for U.S. and international sales. The second was kind of a low-budget indie auteur business—the Hal Hartleys, Todd Solondzs and John Waters[es]. These films would [cost from] a couple [of] million dollars to six or seven and would be more foreign-driven but would still be looking for some kind of U.S. sale. And then there were, and I group them together, the prestige, mini-major films and the potential crossover mini-major films . . . , movies that have two or three leads and a known director. You could package these films and get them financed by U.S. distributors. The fourth strand were the few movies that we set up in the studio world. Now those first two types of films are no longer a part of the equation unless you truly shrink and make them some other way. And the third strand, those $8 million to $15 million films, has become difficult too. (as quoted in MacCauley, "Creative Destruction," 106)

As opposed to this, Matt Deutler of the South by Southwest (SXSW) Film Festival in Austin, Texas, offers a truly do-it-yourself model but argues that few people will stick with such a methodology when it becomes apparent that the chances of breaking out of micro-budgeted productions are almost impossible:

> We're talking about [films with] budgets of $5,000 to $10,000, and so for some filmmakers, it's like "you know what? If I can pay my bills and

make another one of these films next year then I'm happy with that." But there are only so many of these filmmakers . . . who [are] totally fine with being broke as long as [they] can still pay [their] bills and make [their] next film. The reality is there's not a huge windfall coming out of this [video on demand]-driven, digitally-based stuff, so to a certain degree it's about [helping filmmakers build a] brand and leveraging it to [allow them to do] something else. Look at Radiohead and Nine Inch Nails saying "okay, we can give our album away for free and we'll recoup that money by going on the road." (MacCauley, "Creative Destruction," 108)

But the problem here is that both Radiohead and Nine Inch Nails have a built-in fan base—in a sense, their work is pre-sold—and individual films that aren't part of a franchise can't take advantage of this or depend upon it. So most contemporary auteurs have to depend on the existing Hollywood framework and distribution system to promote and distribute their wares. As a consequence, most of these auteurs are, of necessity, genre filmmakers, working in horror, comedy, romance, or bromance films, many of which are either franchise films or pre-sold on the basis of stars, an inventive advertising campaign involving a great deal of web savvy pre-selling, and positive word-of-mouth through social network messaging.

Recognizing this, Amazon.com has recently entered the film production arena with a somewhat exploitative scheme to mine promising scripts from amateurs and *perhaps* turn them into feature films—a very long shot indeed. As Ben Fritz reported,

Amazon.com is launching Amazon Studios, a new website that lets users upload scripts and sample movies and then use community tools to evaluate and edit each other's work. Work judged the best by a panel of experts and company executives will be brought to Warner Bros., where Amazon has signed a first-look deal, in hopes of ultimately producing feature films under the Amazon Studios production label.

Amazon Studios director Roy Price said his company has put together the venture in order to apply digital technology to the still arcane process of submitting and developing movie projects for studios. "It's much easier now to make movies but it's still as hard as ever to

break into Hollywood," said Price, who is also Amazon's director of digital product development. "We think we can play an interesting role in changing that."

Users can submit full-length scripts or additional material ranging from storyboards to fully produced films onto the Amazon Studios site. Other users will then be able to comment or rate the content and *even revise it without permission of the original creator* [emphasis added]. In exchange for submitting material, users will give Amazon 18 months of exclusive rights, an "option" in industry parlance, to their work. That type of restriction without payment is likely to deter working filmmakers and screenwriters and make Amazon Studios a home for rookies only. . . . Amazon will then have the ability to take projects to Warner Bros. or, if it passes, other studios in hopes of getting them made. Writers or directors whose script or sample film is turned into a theatrically released film by a studio would get paid $200,000 by Amazon. ("Amazon.com")

What this means to the writer is simple. You sign all the rights away for 18 months, allow changes to your manuscript without prior consent, and 18 months later you can have your script back, utterly shopworn, with any worthwhile ideas stripped out of it. Sounds like a really promising deal—for Amazon.

But some directors are still able to break through, or game, the system to their own ends, perhaps none more so than Christopher Nolan, who went on to spectacular success (often working with his brother Jonathan as screenwriter) with such films as *Memento* (2000), a twisted tale of a young man (played by Guy Pearce) who suffers from complete short-term memory loss; *Insomnia* (2002), a Hollywood remake of director Erik Skjoldbjærg's 1997 Norwegian thriller, starring Al Pacino and Robin Williams, which was something of a misstep for the director; and *Batman Begins* (2005), a workmanlike but not particularly inspired reboot of the Batman franchise that successfully restarted the series and earned a remarkable $372,710,015 worldwide. *The Prestige* (2006), a tale of dueling magicians at the turn of the 20th century, with a sci-fi subplot involving Nikola Tesla (David Bowie) thrown in for added intrigue, was arguably his most artistically successful and personal film since *Following*; and then he achieved the monstrous success

of the second Batman film in 2008, *The Dark Knight*, which grossed an astounding $1,001,921,825 worldwide and more or less gave Nolan, only 40 years old in 2011, carte blanche to do whatever he pleased in the future.

Nolan's film *Inception* (2010) continues in the tradition of the mind-bending narratives that he is so fond of. For this film, Nolan wrote, produced, and directed the finished product, which is a tour de force of "dream within a dream" imagery, densely structured plotting, and spectacular visual effects. Like *The Prestige* and *Following*, *Inception* (starring Leonardo DiCaprio, Ken Watanabe, Marion Cotillard, and Ellen Page) is very much a personal project, only now, instead of having only $6,000 to play with, as in his first film, Nolan was given a budget of roughly $200 million and left completely to his own devices in the making of the film—something that very, very few directors in the new millennium are lucky or skilled enough to obtain. The result is an amazing psychological and visual journey that challenges and delights the viewer, even as it remains mainstream enough to ensure major commercial success.

Kevin Smith famously started out with *Clerks* (1994), which was shot with a barebones budget of roughly $22,000 in 16mm black-and-white, using stone-age, straight-ahead camera setups (that is, almost no visual spectacle) but relying on a sharp script, solid performances, and a high shock factor. While the film might have seemed resolutely uncommercial to the average observer, Harvey Weinstein, of Miramax Pictures, thought differently. He offered to buy the film, and Smith's career was launched, although, in many ways, *Clerks* was the high point of his career. Neil LaBute broke through with the acidic *In the Company of Men* (1997), which he wrote and directed; but by 2010, he was reduced to the rather pedestrian comedy *Death at a Funeral*, a remake of a British film.

Ang Lee has managed to navigate the industry backwaters of Hollywood with considerably greater skill. Born in Taiwan in 1954, Lee left his native country in 1978 to study filmmaking in the United States and, once here, began carving out a career that is commercially viable yet allows him space (on most of his projects) for personal involvement with the material at hand. Alternating between Hollywood

and Taiwan, he had his first major successes with *Xi yan* (*The Wedding Banquet*, 1993), and *Yin shi nan nu* (*Eat Drink Man Woman*, 1994), both Taiwanese imports that commanded respectable art-house grosses. This allowed Lee the passport to direct the mainstream Hollywood films *Sense and Sensibility* (1995), *The Ice Storm* (1997), and *Ride with the Devil* (1999), which were all solidly successful at the box office but left him still needing a career-defining hit. That came with the Taiwanese martial arts action film *Wo hu cang long* (*Crouching Tiger, Hidden Dragon*, 2000): despite the language barrier and the use of subtitles, which routinely derail any chance of international commercial success, the movie was a surprise runaway smash, grossing $213,525,736 worldwide on a production budget of only $17 million. Needless to say, production costs are much cheaper in Taiwan than in the United States.

With the success of *Crouching Tiger, Hidden Dragon*, Lee was free to do what he wished in Hollywood; and while he made a definite career mistake with his lackluster direction of 2003's *Hulk*, based on the Marvel Comics cartoon character, he was soon back in the game with the most successful and honored film of his entire career, the gay-themed western *Brokeback Mountain* (2005), which detailed the forbidden love affair between cowboys Ennis Del Mar (Heath Ledger) and Jack Twist (Jake Gyllenhaal) in 1963 Wyoming. The film follows them through the years until a tragic conclusion results in death for one and a lifetime of regret for the other. Lee's matter-of-fact handling of delicate material and his deeply affecting delineation of the homophobia the two men face as they try to figure out the passion that has taken hold of them made *Brokeback Mountain* a commercial and critical hit. The film took home Oscars for best director (Lee), best original score (by Gustavo Santaolalla), and best adapted screenplay (by Larry McMurtry and Diana Ossana, from a short story by Annie Proulx). It also received nominations in 5 other categories, including best actor (for Heath Ledger).

Since *Brokeback Mountain*, Lee has directed a film that failed to hit the mark either commercially or critically (the controversial sexual drama *Se, jie* [*Lust, Caution*, 2007]), and a mild comedy, *Taking Woodstock* (2009), which also performed perfunctorily at the box office. Nevertheless, in his determination to seek out and bring to the screen a series of wildly

diverse films on an international scale, to say nothing of his ability to move smoothly between Taiwan and Hollywood without missing a beat, Lee is one of the key players in the 21st-century cinema and also undeniably a serious artist. Certainly, he will be heard from again with new and challenging projects.

Brett Ratner, perhaps the most industry-friendly director one could imagine, was quoted as saying, "Why do I need final cut? Final cut is for artistes quote unquote—directors whose movies don't make a lot of money" (as quoted in Horowitz 254). He doesn't really connect himself with anything other than the bottom line, and this shows in his output: *Money Talks* (1997), *Rush Hour* (1998), *Rush Hour 2* (2001), *X-Men 3* (2006), and other strictly mainstream films. With no pretensions to making anything other than a box-office hit, Ratner fits right in because he has always been, from the start, a front-office director, eager above all to please management and make a substantial profit by doing so. But even Ratner admits that "films today are always based on the formula. They don't make movies like [Robert Altman's] *The Long Goodbye* [1973], or [Hal Ashby's] *Harold and Maude* [1971], or *Being There* [1979], which were full of heart and humanity. People don't die in the end of movies anymore. . . . Tom Cruise dying at the end of a movie? No way!" (as quoted in Horowitz 262–63).

Another example of a front-office director is Doug Liman. After his first film, *Getting In* (1994), underperformed at the box office, Liman clicked with *Swingers* (1996), a buddy comedy about three losers on their way to Las Vegas. He was once considered a maverick, but after his most ambitious and personal film, *Go!* (1999) failed at the box office, Liman turned to directing more mainstream films, such as *The Bourne Identity* (2002) and *Mr. and Mrs. Smith* (2005). Despite his protestation that "I'm not that guy who's making cookie-cutter movies," (as quoted in Horowitz 192), that's precisely what he's become.

Francis Lawrence is another dependable Hollywood action director; he began his career directing music videos and then moved on to more ambitious projects, at least in scale, if not imagination. After directing videos for Jennifer Lopez, Green Day, and Britney Spears, Lawrence made his feature-length directorial debut with *Constantine* (2005), a comic-book film featuring Keanu Reeves as supernatural detective John

Constantine, who tries to stop the forces of hell from breaking through to the mortal world. The film is mostly an exercise in style but is redeemed in large degree by a remarkable performance by Tilda Swinton as the angel Gabriel, complete with CGI wings. In 2007, Lawrence moved on to greater success with *I Am Legend*, aided immeasurably by the presence of leading man Will Smith as the last man on earth, who is fighting off a horde of flesh-eating, nocturnal zombies; Lawrence is now at work on *Water for Elephants*, starring the *Twilight* franchise's Robert Pattinson, to be released in 2011.

Joseph McGinty Nichol, who directs under the name McG, is another director who aims at the bottom line above all else, with such films as *Charlie's Angels* (2000), *Charlie's Angels: Full Throttle* (2003), and, more recently, *Terminator Salvation* (2009). Karyn Kusama started out with the interesting independent film *Girlfight* (2000) but then moved on to the comic-book adaptation *Aeon Flux* (2005) and, most recently, the feminist horror film *Jennifer's Body* (2009) with Megan Fox, which, despite a massive publicity campaign, failed to click with either critics or audiences. F. Gary Gray's career follows a similar trajectory: after the slick yet stunningly raw feminist gang-banger film *Set It Off* (1996), Gray made the transition to reliable studio craftsman with *The Italian Job* (2003) and *Be Cool* (2005). Jon Favreau, whose career started as the writer of Liman's *Swingers*, has now moved into the utterly bankable mainstream with *Iron Man* (2008) and *Iron Man 2* (2010), both of which star the once unbankable Robert Downey, Jr., who, against all odds, has transformed himself into a 21st-century action star in the *Iron Man* films as well as Guy Ritchie's *Sherlock Holmes* (2010), which reinvents Holmes as a martial arts expert with Jude Law's Dr. Watson in attendance.

The brother team of Albert and Allen Hughes have made a name for themselves with a string of idiosyncratic films that cover a wide range of topics. They began with a series of violent action films based in urban society, such as *Menace II Society* (1993), *Dead Presidents* (1995), and *American Pimp* (1999). As the new century dawned, however, the brothers began to veer away from more conventional fare with *From Hell* (2001), one of the most compelling of the many Jack the Ripper films and, even more recently, with *The Book of Eli* (2010), starring Denzel Washington as a lone prophet in post-apocalyptic America, who

battles renegade gangs and other dangers as he makes his way across the country using a sacred book as a guide. *The Book of Eli* was a success with both critics and audiences, proving that the Hughes brothers can move beyond simplistic genre entertainments into something weightier and more resonant.

Paul Greengrass has also made a name for himself as an action director. After starting out in television direction in the 1990s, he directed such films as *Bloody Sunday* (2002), *The Bourne Supremacy* (2004), *The Bourne Ultimatum* (2007), *Green Zone* (2010), and, perhaps his most successful and restrained film as a director, *United 93* (2006), which deals with the tragic events of 9/11, as passengers on a hijacked plane fight off a group of terrorists to prevent the plane from slamming into the U.S. Capitol. Shot in a near-documentary style, with little-known actors for added verisimilitude, *United 93* is everything Greengrass's other films are not: deliberate, understated, and entirely convincing. It's still hard to watch the film, particularly the scene in which the hatch door of the plane closes on the passengers on what will be their last flight; 9/11 has so transformed the social culture of the entire world that now, even a decade later, the echoes of the tragedy continue to reverberate. Greengrass's film could easily have been exploitational, but it isn't; it's a real-time record of a real-life disaster, told with attention to detail and appropriate restraint, much like his earlier *Bloody Sunday*.

All of these filmmakers are relatively young and, at some level, believe in the integrity of their work, even as they face the realities of the mainstream Hollywood marketplace. In their minds, they're independent filmmakers working within the system. As Karyn Kusama said in 2006, "I've realized I'm a strong-minded director with a very clear sense of what I want to do and I just want to be left alone to do it" (as quoted in Horowitz 163).

But unless you're a director with a high batting average of big hits, you're not going to be "left alone"; you're going to be sucked into the vortex of mainstream filmmaking. Patti Jenkins, who directed *Monster* (2003), the story of serial killer Aileen Wuornos (portrayed by Charlize Theron), to considerable acclaim, has what might arguably be considered balanced perspective on the matter of fame and fortune versus artistic freedom. Says Jenkins, "I wish I could make bucketloads of

money . . . but more than anything, I realize the only thing that makes that kind of work worth it is to be engaged" (as quoted in Horowitz 118). And Jon Favreau understands that, whether he likes it or not, the current movie market is aimed primarily at children: "[I]f I'm making a movie for forty-year-old parents of small children, I'm probably not going to spend as much money as I would if I was doing a PG movie for kids" (as quoted in Horowitz 42).

Mainstream movies used to be aimed at adults; now the comic books have taken over. But all of these filmmakers, relatively young though they may be, are in a sense dinosaurs, beneficiaries of the old-style way of doing business, not do-it-yourself distribution. When Sacha Gervasi's heavy-metal documentary *Anvil: The Story of Anvil* (2009) grossed $700,000 in domestic box office in a DIY release pattern mapped out by Richard Abramowitz, which included lots of social networking buzz, web trailers, and the real-life slog of ceaseless promotion and DVD screeners to critics far and wide (Dargis, "Indies"), it became a major independent success story. But sadly, those earnings will just about cover the cost of producing and marketing the film, leaving little to invest in Gervasi's next project. Even with pay-per-view and DVD sales added in, *Anvil* will probably gross $1 million or slightly more— enough so that nobody goes broke but not enough to ensure a vibrant future career. And *Anvil*, mind you, is one of the conspicuous success stories of the DIY movement.

Courtney Hunt, writer-director of the critically acclaimed indie film *Frozen River* (2008), put the film together on a budget of roughly $1 million and was rewarded for her efforts with two Academy Award nominations: for best actress (Melissa Leo, in a stunning performance as a poverty-stricken mother trying to get her fragmented family into a doublewide trailer) and best original screenplay (Hunt's own work). *Frozen River* also went on to win a slew of other awards, including best first film from the prestigious New York Film Critics Circle and best directorial debut from the National Board of Review, to name just a few of its many honors. But since then, Hunt has directed a television episode and has another film, *Northline*, in development. That's it. *Frozen River*, which is unflinchingly realistic (despite a somewhat optimistic ending), found favor with the critics but, without a

major studio to back it, had only limited audience acceptance; thus, it grossed just $2,503,902 in the United States and another $2,777,874 in foreign markets, for a total take of $5,281,776. These are not numbers that impress the major studios, no matter how good a film is.

And sexism is still a major obstacle within the studio system. Penelope Spheeris, who began her career at *Saturday Night Live*, made some smaller, personal films and then scored a huge commercial hit with *Wayne's World* (1992). But she found that even after a major success in the boys' club of Hollywood, her options as a director were still limited. As she told Max Messier,

> My whole career up until *Wayne's World* didn't produce any monetary funds. When I directed *Wayne's World*, I made close to $150,000—the biggest payday I had to date. My percentage points from *Wayne's World* enabled me to pay off all of the debts from my previous works, but I only came up even in the end. So I'm looking around for some coin and when someone offers you $2.5 million to direct a film, you just fucking take it. I took the money and made a bunch of movies—*The Little Rascals* [1994], *Beverly Hillbillies* [1993], *Black Sheep* [1996] and *Senseless* [1998]. After I did *Wayne's World*, I tried like hell to direct movies I had written and books that I wanted to adapt for film. I tried so hard to do something beside television remakes, but I couldn't get anything going. That is where the sexism in the film industry becomes all too apparent. If I was a guy, I swear to God I would have been able to get my own shit going after *Wayne's World*.

Nicole Holofcener, who has made a series of quirky films that have somehow made it into the mainstream in the past few years, is another director who seems to have successfully gamed the marketplace. Yet her 2010 film, *Please Give*, opened on April 30, 2010, to excellent reviews but indifferent box office and, by June 27, 2010, had grossed only $3,134,688 in domestic box-office rentals. That was roughly the budget of the film itself, minus prints and advertising, for what was Holofcener's 4th film in 14 years; the others were *Walking and Talking* (1996), *Lovely and Amazing* (2002), and *Friends with Money* (2006). *Friends with Money* has been Holofcener's biggest hit thus far, with a produc-

tion cost of $6.5 million and an international gross of $18,245,244—helped, one imagines, by the presence of Jennifer Aniston in the leading role. While this performance is hardly spectacular, *Friends with Money* at least made its money back with a small profit and allowed Holofcener to continue to script and direct her own, very personal films. And yet she is forced to continue on the margins of the industry because her films follow her personal sensibilities rather than focusing solely on how to please the audience.

Holofcener knows that she's working on the fringe of the mainstream, and she isn't entirely happy about it, though she knows it's the price she pays for her uncompromising independence and singularity of vision. As she told Melena Ryzik, "I don't need $80 million. But $12 million would be good, a few more days, a bigger art department, to pay people properly, things like that. There's movies I could've made that would've gotten me out of the indie ghetto, [but] it's too hard to fake enthusiasm and inspiration" ("Relationships"). Between feature projects, Holofcener keeps busy directing television shows, including episodes of *Sex and the City* and *The Gilmore Girls*; but, like Penelope Spheeris, she has discovered that only films that blatantly cater to audience expectations are reliable hits. Those aren't the kind of movies that Holofcener makes, and so, for the moment, her audience is limited to more thoughtful viewers.

Indeed, some filmmakers survive the realities of the 21st-century marketplace by alternating between frankly commercial films and more personal, intimate projects. Director Gus van Sant has split his time between mainstream Hollywood films such as *Good Will Hunting* (1997) and *Finding Forrester* (2000) and edgier material such as *Drugstore Cowboy* (1989), *My Own Private Idaho* (1991), and *Elephant* (2003), a dreamy, apocalyptic film dealing with the Columbine High School shooting spree. David Fincher's most accomplished films are probably *Fight Club* (1999) and *Zodiac* (2007), but he can also cheerfully crank out films such as *Panic Room* (2002), a work of no particular distinction. Wes Anderson's quirky films (*Bottle Rocket* [1996], *Rushmore* [1998], *The Royal Tenenbaums* [2001], and *The Fantastic Mr. Fox* [2009]) have attracted both critical and box-office attention. Alexander Payne scored with the brutal pro-choice comedy *Citizen Ruth* (1996), the acerbic high school

drama *Election* (1999), and later *About Schmidt* (2002), in which actuary Warren Schmidt (Jack Nicholson) faces an uncertain retirement; while Spike Jonze's *Being John Malkovich* (1999) is a completely original and unnervingly assured tour de force that he has yet to surpass.

Quentin Tarantino's finest films, *Reservoir Dogs* (1992), *Pulp Fiction* (1994), *Kill Bill, Vols. 1 and 2* (2003 and 2004), and *Inglourious Basterds* (2009), display a pulp aesthetic that is both pleasing to the eye and capable of considerable depth; his films are also highly successful at the box office, balancing personal aesthetics with audience demands. Of all the filmmakers working in Hollywood today, Tarantino, raised on video-rental-store grindhouse films, has the most distinctive personal visual style, even if his famous monologues do tend to go on at considerable length before they are punctuated by scenes of rococo violence. Todd Haynes, on the other hand, seems to follow his own instincts entirely, with such evocative masterpieces as *Safe* (1995) and *Far from Heaven* (2002), Haynes's updating of and homage to Douglas Sirk's 1955 melodrama *All That Heaven Allows*. Brothers Joel and Ethan Coen have racked up a string of memorable films since their debut with *Blood Simple* (1984), including *Raising Arizona* (1987) and *No Country for Old Men* (2007) as well as the less successful remake of *The Lady Killers* (2004). Steven Soderbergh alternates between thoughtful films such as *Sex, Lies and Videotape* (1989), *King of the Hill* (1993), *The Limey* (1998), *Bubble* (2005), and the epic *Che* (2008) and seemingly endless installments of the revived *Ocean's Eleven* franchise (2001–2007). David Lynch, who began his career with the hallucinatory horror film *Eraserhead* (1976), continued in this entirely personal and often disturbing vein with *Blue Velvet* (1986), *Wild at Heart* (1990), *Lost Highway* (1997), *Mulholland Drive* (2001), and, most recently, *Inland Empire* (2006), which Lynch shot on digital video and distributed himself.

But along with these well-known names, there are many, many directors who each made a single remarkable film and then vanished off the radar. Even though all these directors started out on the fringes of the industry, most of them gravitated to the center for 2 simple reasons: economic stability and guaranteed distribution, both hard to come by in the increasingly crowded 21st-century visual landscape. Working within the studio system, however, is a brutal experience.

As director Tim Burton, surely as successful as any contemporary Hollywood filmmaker who pursues his own vision can expect to be, once remarked, "what the studio does is beat the shit out of you, knock you down to the ground, stomp on your face, make you feel like you want to kill yourself, and then tell you to stand up and make a good movie" (as quoted in Messier). Unless you can control the entire film as a producer-director and keep an eye on the clock with ruthless efficiency, you're going to run afoul of a system that wants to stamp out every element of originality in your work. Burton has managed to create a consistently challenging body of work, often with actor Johnny Depp in the leading role, in a series of elegant and original films that push the boundaries of the cinematic experience. And yet Burton delivers hits, which are also personal films, recalling the golden age of the studio system, when genre films with a message proliferated, so long as their makers could sufficiently camouflage their true intent behind the requirements of the genre.

The DIY ethic persists because truly original visions always come from the margins. George Lucas, whose films are now a worldwide cult, was once an independent filmmaker with such films as his feature-length remake of his student film, THX-1138 (1971); American Graffiti (1973), for which Lucas was paid a mere $20,000 for his directorial chores; and, of course, Star Wars (1977), which he released through 20th Century Fox while retaining all sequel, merchandising, and other ancillary rights. When Star Wars became a box-office hit of stratospheric proportions, Lucas became a multimillionaire almost overnight but retreated from the director's chair for the subsequent Star Wars sequels to develop a vast business empire of his own. With the improbable exception of Jean-Luc Godard, Lucas has arguably embraced digital technology more fully than any other filmmaker has, returning to the director's chair for the final films in the Star Wars series, which were produced entirely in digital HD format.

Naturally, even the use of digital tape has now become obsolete, with auteurs like David Fincher, one of many possible examples, producing his film Zodiac (2007) entirely with digital hard-drive technology and eliminating any physical production medium altogether. True, the completed project had to be transferred to conventional 35mm

film for theatrical distribution, but that was in 2007. As we've seen, 35mm projection will soon disappear entirely, and "movies" will be created entirely out of electronic images, without the use of film at any point in the process.

Yet some of the most compelling contemporary films continue to use film as a production format. Kathryn Bigelow's *The Hurt Locker*, surprisingly, was shot in Super 16mm, a process in which the entire photographic area of the film is used during shooting, including the area at the edge of the frame that would normally be used for the soundtrack. The resulting image area is nearly that of a 35mm frame; and with a decent blowup to 35mm, one can hardly tell the difference. Use of Super 16mm also cuts down significantly on raw stock costs; and because the cinematographer is working with specially modified 16mm equipment, the cameras are much lighter and easier to handle than traditional 35mm cameras. The director of cinematography on the film was Barry Ackroyd; and in an interview with Mali Elfman, Bigelow discussed the process of working with Ackroyd on the film:

> I found Barry Ackroyd . . . truly . . . one of the most gifted cinematographers working in the business today. And we shot in super sixteen, which gave us this kind of life and dexterity and opportunity—in four units—which was an opportunity to cover these sets because bomb disarmament kind of dictates approximately a 300 meter containment—the ground forces sort of stop the war for you, the bomb tech to walk on whatever ordnance you are meant to disarm or blow in place, which is what it refers to. And so wanting the audience to [have] real . . . geographic sense of space and, in other words, to go from here to there, and you know this is off limits and this is on limits, and so that was really critical [to] keeping it [a] very live and "you-are-there" experience.

Indeed, the film looks like a documentary, and Ackroyd's cinematography effectively conveys the heat, confusion, monotony, and constant danger of war. Shot in Amman, Jordan, the film is presented in a mixture of English, Turkish, and Arabic, for an added air of verisimilitude. Using a very small cast, with only a few "names" (including Guy

Pearce and Ralph Fiennes, both of whom are onscreen only briefly), the film follows a bomb-disposal crew through several months of duty, in a never-apologize, never-explain format that does away with the traditional narrative arc to become almost a virtual experience rather than a work of fiction.

The film clicked resoundingly with critics and thoughtful audiences, winning 6 Academy Awards: best direction (to Bigelow), best editing, best sound, best sound editing, best screenplay, and best picture. It was also nominated in 3 additional categories: best cinematography, best original score, and best actor (Jeremy Renner, for his indelible portrayal of Sergeant First Class William James). Nor did the accolades stop there: the film picked up many additional awards, including best editing from the American Cinema Editors; best cinematography from the American Society of Cinematographers; best art direction from the Art Directors Guild; best cinematography from the Austin Film Critics Association; best cinematographer, best director, best editing, best film, best original screenplay, and best sound at the British Academy of Film and Television Arts (BAFTA) Awards; as well as numerous other awards from the Golden Globes, the Chicago Film Critics Association, the Broadcast Film Critics Association, the Directors Guild, the London Critics Film Circle, the Los Angeles Film Critics Association, the New York Film Critics Circle Awards, the National Society of Film Critics, the National Board of Review, and on and on—all in major categories, such as best director or best film.

Why are we listing these awards at such length? Because, oddly, the film has become the object of a concerted Internet hate campaign, which the reader can easily track on the web. If you look at the posts carefully, however, one thing comes through loud and clear: what these viewers miss most is the conventional story arc of the Hollywood film. They want *The Hurt Locker* to take a stand for or against the war in Iraq, which it absolutely refuses to do; and they also object strenuously to the film's opening epigraph: "War is a Drug." One person has even launched "the Internet Kathryn Bigelow Boycott," saying, "Join the internet campaign to boycott all further work of Bigelow and anyone who finances her movies! Spread the word!," while others have

commented, "Jesus Christ, I Want Two Hours of My Life Back," "I'm an Iraq Vet and This Film Sucked," "Best Picture and Director—Are You Kidding Me?," and similar epithets.

But to our surprise, eternal fan-boy Harry Knowles of *Ain't It Cool News* was impressed by the film, saying, "I really love *The Hurt Locker*," and correctly asserting that, "In many ways, this is the first apolitical Iraq war film. It doesn't judge the war, it doesn't politicize the war, it doesn't disgrace our involvement, it just deals with the working lifestyle of War. In this case, it is about an Army Bomb Squad unit that is on the tail-end of its rotation in IRAQ" (Knowles, "Harry Says That *The Hurt Locker*")—even if he does compare it to, of all things, Michael Bay's *Transformers: Revenge of the Fallen*, discussed in Chapter 1. (To his credit, *The Hurt Locker* comes out on top.)

Bigelow has directed only a handful of features, including the mesmeric *Near Dark* (1987), a country-western vampire film about a band of the undead who roam the west in a blacked-out RV; *Blue Steel* (1990), an extremely twisted film about an obsessive "love" relationship; the surfing-heist hybrid *Point Break* (1991); and the literally mind-altering *Strange Days* (1995). Continually drawn to strong male and female characters but with a seemingly psychic connection to male violence and macho behavior, Bigelow's work is unique in American cinema. She was briefly married to director James Cameron; and when the two divorced, they remained on amicable terms, although Cameron didn't seem particularly pleased when *The Hurt Locker* shut out *Avatar* at the 2010 Academy Awards. But perhaps most astounding is the fact that all of Bigelow's films have been independent productions; all of them have been negative pickup deals. As she told an interviewer,

> I've never made a studio film—which is perhaps not necessarily common knowledge. That's because studios have distributed or picked up my movies while we're in production. [H]aving access to a really terrific script [in *The Hurt Locker*], I wanted to protect it by maintaining complete creative control, final cut, and the opportunity to cast emerging talent. Those were my parameters going in. And working independently certainly gets you a long way there. (Mr. Beaks)

To those who question the accuracy of Mark Boal's screenplay, Bigelow has a ready answer:

> Mark was on a journalistic embed in Baghdad in the winter of 2004 with bomb squads. He was with various teams that would go out. You basically go out in the morning or afternoon, and . . . I think it's a solid forty-eight hours on, twenty-four hours off. It's fairly arduous and you basically move from suspicious objects to suspicious piles to suspicious wires; it's IED [improvised explosive device] to IED to IED throughout the city. . . . I remember one of the techs turned to Mark while they were out on one of their missions and said, "We are the war. It's not a ground-to-ground or air-to-air war. It's ground troops patrolling the areas, looking for suspicious objects or wires or rubble piles and calling in the bomb squad." . . . That dictated the structure of the script: that kind of reportorial, observational approach. (Mr. Beaks)

This methodical approach rachets up the film's suspense with each new encounter. Is a seemingly innocent bystander using a cell phone to trigger a bomb? Exactly how many bombs will one find in a booby-trapped car? Is a suicide bomber sincere in not wanting to go through with his lethal mission when he seeks the demolition crew's help? And, perhaps most poignantly, will the person you're talking to right now be alive in the next 15 seconds, or will he be cut down by sniper fire or blown up by a bomb? Bigelow handles all this material in a flat, matter-of-fact manner that offers more insight into the mechanics of war than any conventional film possibly could. Yet despite all the awards showered on the film, both here and abroad, *The Hurt Locker* has only racked up $17 million in its U.S. theatrical release; it's too thoughtful, too contemplative, and too straightforward for audiences weaned on synthetic thrills.

And there's another factor. In a landmark case, Voltage Pictures, the independent company that produced *The Hurt Locker*, is suing 5,000 people who downloaded the film as an illegal bit-torrent file. According to journalist Mike Moody, *The Hurt Locker* reportedly appeared online 6 months before its theatrical release, creating a viewing

opportunity that siphoned off a significant portion of the potential box office. Voltage wants monetary damages from all those whom they can identify who illegally downloaded the film. As Moody reports,

> Voltage Pictures has filed a lawsuit against up to 5,000 people who have illegally downloaded the "Best Picture" Oscar winner. The independent production company is seeking the names of computer owners by using their ISPs [Internet service provider addresses]. Voltage has petitioned the court to order downloaders to destroy all illegal copies of the film. It plans to send letters to the people identified asking them to pay $1,500 (£1,021) each. The file sharers could pay up to ten times that amount if the case goes to trial.

Indeed, digital piracy is a billion-dollar-a-year operation, in terms of profits lost by musicians, filmmakers, and the visual artists whose work is appropriated by illegal download sites and disseminated over the web. As Eric Garland, "the chief executive of Big Champagne LLC, which tracks file-sharing activity, [notes] 'the digital entertainment marketplace is overwhelmingly a pirate market'" (as quoted in Smith, "Thousands"). Needless to say, those who support illegal downloads of films and music as "sharing, not stealing," are outraged by this move, which explains some of the backlash against the film, but not all. Observers are divided over the wisdom of Voltage's actions; as Ethan Smith comments,

> Unlike earlier lawsuit campaigns by the music industry, which involved the coordinated efforts of numerous record labels and their trade organization, *The Hurt Locker* suit appears to be a unilateral effort by the film's producers, without the involvement of the Hollywood studios or their trade body. Suing individuals for file sharing blew up into a public-relations nightmare for the Recording Industry Association of America. That trade organization in 2003 launched a massive legal campaign against tens of thousands of people alleged to have distributed music illegally online. After growing numbers of sympathetic defendants were identified—very young children, old people who said they didn't own computers, even a dead person—the music industry eventually aban-

doned the campaign. Some record executives maintained that the law-suits had a deterrent effect.

For its part, the Motion Picture Association of America has definitely opted out of any participation in Voltage's action, stating categori-cally that "the MPAA and our member companies have absolutely nothing to do with these lawsuits" (as quoted in Smith, "Thousands"). In other words, the major studios seem to be sitting this particular battle out.

But then again, *The Hurt Locker*, despite the rave reviews, never got a truly wide theatrical break; it never opened in 5,000 theaters at once as most contemporary action films do. The film opened in selected cities, then platformed out in a limited pattern to middle America (where, as one might expect, it was less than enthusiastically received, primarily for its unwillingness to take a political stance on the conflict the film depicts), and faded away quickly. Bigelow's film is too unconventional for mass consumption. It is perhaps that rarest of all commodities in the contemporary cinematic marketplace: an individual vision, beholden to no one and not subjected to focus groups, on a highly controversial, hot-button topic that won the hearts of critics and, despite the naysay-ers, has managed to score a highly respectable rating, even on aggregate websites such as *Rotten Tomatoes*.

So why do so many people dislike it? Because it refuses to cater to narrative conventions, challenges people's belief systems, and avoids becoming mired in political debate. The protagonists of *The Hurt Locker* are doing a job, and that's all they know; the orders came from some-place else, sent down from above by people who will never understand the situation on the ground. But because *The Hurt Locker* maintains a de-liberately neutral stance, it infuriates ideologies on both the Right and the Left. It's a document, not a diatribe, and it doesn't tell you how to feel by means of manipulative editing or foreshadowing music cues. It exists. That's enough. You'll have to make up your own mind about what to think of it.

In stark contrast, Shawn Levy's *Date Night* (2010) is a predictable action comedy in which a married Manhattan couple (Tina Fey and Steve Carrell) go out on a date night to rekindle their marriage and

are soon involved in a series of "comic" misadventures, including a mechanically staged car chase and a mistaken-identity subplot, spinning through a raft of tired gags until the film mercifully screeches to a halt. Levy, who attended Yale's drama department and then went on to the graduate film program at the University of Southern California, is no stranger to slam-bang slapstick, as his films *Night at the Museum I* (2006) and *II* (2009) clearly demonstrate, to say nothing of his uninspired remakes of *The Pink Panther* (2006) and *Cheaper by the Dozen* (2003), both starring Steve Martin.

When asked by interviewer Jon Silberg, "would you call yourself a film buff?," Levy unhesitatingly replied, "Not a Scorsese level film buff. No. But I have studied film history, most intensely American films from about 1970 to the present" ("Shawn Levy" 20). This goes a long way to explain both the commercial success and relative emptiness of Levy's work; he knows mainstream filmmaking and how it hits all the generic bases, but there's no feeling or depth to his work. It's all superficial, shiny, and easily digestible. You don't really need to think about it, nor does Levy want you to. As he says of *Date Night*, "it does get big and loud and zany in its action, but we also set out to make a mainstream, hopefully entertaining comedy" (20), and that's exactly what he's accomplished.

If you read a large cross-section of articles by contemporary filmmakers, you'll find a consistent theme. No matter how tech-obsessed they are, nearly all of the top commercial filmmakers insist that the film's narrative is the most significant aspect of any project. As James Cameron noted in an interview in December 2009 for *Newsweek*, in which Cameron and director Peter Jackson (who worked on *The Lord of the Rings* trilogy [2001–2003] and a remake of *King Kong* [2005]) also participated,

> People often ask us about the future of filmmaking because we've both been innovators in the last few years, creating cutting-edge stuff that gets widely or narrowly adopted. I think the simple answer is that filmmaking is not going to ever fundamentally change. It's about storytelling. It's about humans playing humans. It's about close-ups of actors. It's about those actors somehow saying the words and playing the moment

in a way that gets in contact with the audience's hearts. I don't think that changes. I don't think that's changed in the last century. ("It's the Story")

Added Jackson,

There's no doubt that the industry is in a weird position. It's not just Hollywood—it's international. The loss of the independent distribution companies and the finance companies, and the lack of ability to get medium-budget films these days. The studios have found comfort in these enormous movies. The big-budget blockbuster is becoming one of the most dependable forms of filmmaking. It was only three or four years ago when there was a significant risk with that kind of film. Now, especially last summer [2009], we saw blockbuster after blockbuster released, and they all had significant budgets and they're all doing fine. It almost doesn't matter if the film is a good film or a bad film, they're all doing OK. They've lost the ability to have that happen with a low-budget movie and with midrange-budget movies. It's the story, stupid. ("It's the Story")

But since both Jackson and Cameron are in the spectacle business, this need not unduly concern them. More revealing is that the fact that both men insist that "actors will never be replaced" (Cameron claims that "the thought that somehow a computer version of a character is going to be something people prefer to look at is a ludicrous idea. It's just paranoia") and then turn around and suggest that such a replacement is precisely what audiences would embrace: CGI versions of actors, "airbrushed" to digital "perfection." As Cameron enthuses,

you can take an actor of a given age, and you can transform their age. Additive makeup can age somebody, but it's hard to make someone younger. Let's say you have a novelistic storyline where you cast an actor in their 40s, but the first time you see them they're 15 years old and the last you see them they're 80. This is (David Fincher's) *Benjamin Button* (2008) idea. Clint Eastwood could do another *Dirty Harry* movie and look the way he looked in the '70s. He would still be making all

the performance choices. It would be his voice. We'd just make him 30 years younger. ("It's the Story")

Yes, you *could* do this and thus miss out on the natural aging process and the truth of human mortality, to say nothing of the fact that Eastwood's rugged, flinty presence onscreen in his later years has worked superbly in *Unforgiven* (1992) and *Gran Torino* (2008), both modest films shot with a minimum of visual effects on short schedules with medium budgets. Eastwood, who works very quickly on the set, often printing the first take to keep the spontaneity level high, has no intention of doing another *Dirty Harry* movie; he's concerned with stories that engage and enlarge the scope of human comprehension. Cameron, on the other hand, sees a synthetic Eastwood as the ideal protagonist of yet another reliable franchise film. It's the difference between being a techie and being a humanist.

And yet while the mainstream cinema does lately seem to be composed of an endless flow of blockbusters—good, bad, or indifferent—as always it's the people at the margins who are creating works of considerable beauty, talent, and originality. There's also stuff that's just plain weird. In the 1960s, when the New American Cinema, or underground film, exploded in New York City and San Francisco, one of the hallmarks of the new style was a decisive rejection of the slick production values inherent in the dominant cinema. Thus, leader streakings, punch holes, light flames, scratches, and other film artifacts were embraced by such underground artists as Bruce Conner, Robert Nelson, Marie Menken, Jud Yalkut, and, of course, Andy Warhol. Now the YouTube generation of filmmakers is creating the same sort of visual revolution in its work, albeit in a different fashion. Virginia Heffernan reports on the new material that amateur and independent filmmakers are uploading onto the web at a torrential pace:

[W]hat's surprising is how little the homemade videos resemble the pro goods. Sure, there are parodies of mainstream clips here and there, but mostly the amateurs are off on their own, hatching new genres. . . . This hit me recently when a YouTube video called *Manhattan Bridge Piers* made the rounds on TV and blogs. A beautifully shot, silent time-lapse docu-

mentary, it showed the Manhattan Bridge dramatically wobbling when the subway crosses, as if on the verge of collapse. . . . It recalls nothing so much as *Manhatta*, another silent documentary—from 1921—by the painter Charles Sheeler and the photographer Paul Strand. . . . In both films, the filmmakers align their technology with soaring modern struc- tures and have sought vantages from which to underscore that identifica- tion. But the humans in the two movies are mostly out of sight, encased in monstrously beautiful architecture that can be truly beheld—in all its smoking, soaring, swaying, flashing sublimity—only by gods or cam- eras. ("Uploading")

Thus, far from the klieg lights of Hollywood, on a path that experi- mental filmmakers have been following since the dawn of the cinema, a new cinema is being born. With few resources, simple equipment, and an individual vision, these artists are quietly staking a claim in the usually commercial digital marketplace, and are creating elegant films of precision and grace. As Heffernan notes, there's lots of junk on You- Tube, but there's also a good deal of excellent, innovative work that once again stretches the boundaries of visual imagination.

But perhaps the most astounding archive of individual visions on the web can be found at UbuWeb (http://www.ubu.com/), which, under the direction of head archivist Margaret Smith, collects the work of thousands of filmmakers and video artists as well as musicians, graphic designers, writers, and people working in about every medium one can imagine. Here, you can find streaming downloads of the work of Laurie Anderson, Beth B, Craig Baldwin, Stan Brakhage, Robert Breer, Mar- cel Duchamp, Ed Emshwiller, Stan Vanderbeek, Cindy Sherman, Fat- boy Slim, Marie Menken, Jean-Luc Godard, Ron Rice, Pipilotti Rist, and many, many others, free from commercial intrusion in a space that is dedicated to the adventurous and unusual in the arts rather than the free-for-all that YouTube's massive collection of images represents.

This collection of independent film and video, to say nothing of the many literary texts, avant-garde music, and other cultural artifacts, is a groundbreaking achievement. For instance, it includes a complete run of the experimental 1960s "magazine in a box" *Aspen*, which incorpo- rated actual 8mm films, 33⅓ rpm recorded Flexidiscs, flipbooks, as

well as conventional texts into a sort of prototype of the web. (One of the most famous issues was designed by Andy Warhol and David Dalton.) As valuable as this renegade collection is, UbuWeb still acknowledges the limitations of its platform and urges viewers of the posted films and videos to "support these filmmakers and their distributors by purchasing [or renting] their films." The site notes that

> it is important to us that you realize that what you will see is in no way comparable to the experience of seeing these gems as they were intended to be seen: in a dark room, on a large screen, with a good sound system and, most importantly, with a roomful of warm, like-minded bodies. Most of us don't live anywhere near theatres that show this kind of fare and very few of us can afford the hefty rental fees, not to mention the cumbersome equipment, to show these films. Thankfully, there is the Internet, which allows you to get a whiff of these films regardless of your geographical location. We realize that the [copies of these] films we are presenting are of poor quality. It's not a bad thing; in fact, the best thing that can happen is that seeing a crummy shockwave file will make you want to make a trip to New York to the Anthology Film Archives [or] purchase a high quality DVD from the noble folks trying to get these works out into the world. Believe me, they're not doing it for the money. (Smith, "Archiving Ubu")

UbuWeb is thus an ambitious, nearly insanely inclusive clearinghouse for the work of independent visual artists, living and dead, offering a truly staggering array of films, poetry readings, music concerts, videos, and other works of art to the general public, free of charge. Only in the 21st century, and only with the most recent technology, would such a site be possible; and as a viewer immediately appreciates, it is blessedly free of advertising popups of any kind, in an era in which the Internet highway is becoming the Internet toll road.

But for mainstream filmmakers, there is another conundrum: they really aren't pleasing themselves when they make their films. Rather, they are pleasing an amorphous audience or target group; and to keep in touch with would-be viewers, the major studios use focus groups and test screenings to make sure that a film is comprehensible to the

widest possible audience, with no one left behind. For 21st-century Hollywood, auteurs, test screenings, reshoots, and re-edits are a fact of life; but do they really work? As industry observer Eric Snider put it in 2008, when he was discussing potential changes in Christopher Nolan's film *The Dark Knight* that were being mandated by some anonymous members of a focus group,

> I am of two minds about test audiences. On the one hand, I think it's absurd for a director to change his movie—which supposedly represents his vision—based solely on feedback he gets from a test audience, rather than sticking to his instincts. On the other hand, I think audiences in general tend to be dimwitted and superficial in their tastes and should be ignored altogether. So . . . actually, I guess I'm only of one mind.

Many would agree. But the fact of the matter is that research organizations such as DTX, Screen Engine, and NRG generate healthy corporate reviews from conducting focus screenings, comprised of "average" viewers who are solicited on the Internet to attend rough-cut screenings of films and then offer their opinion. The problem for most filmmakers is that the people who are dragooned into these screenings are pre-tested to be everyday filmgoers who have no special skills or knowledge about film at any level and are indeed prized for their ordinariness. Yet their film advice matters: before a movie can hit theaters, it has been screened and rescreened, re-edited, reshot, and engineered to reach to the lowest common denominator in the viewing audience. What with the demands of the focus groups and the demands of the bloggers and tweeters who comment after a film is released, Hollywood movies are now critiqued both coming and going.

Even worse, test screenings are designed to make sure that *no one* is confused by a film's chronology, editing structure, or plot arcs: in other words, the studios are aiming to please the densest person in the screening room. As we've seen, for a director such as Brett Ratner, this should be no problem. He wants his movies to make money above all other considerations, and test screenings are a reasonably reliable method of making certain that his final product will appeal to the broadest possible audience.

Consider this example. The makers of the *Final Destination* films (in which a group of teens is systematically slaughtered by a series of accidents) included, in the original cut of several of their films, backstory sequences on the characters so that audiences might have more empathy for them. Test screenings showed that average viewers found these scenes boring and unnecessary and wanted to move as quickly as possible from one horrific killing to the next. The film was recut to satisfy perceived audience demand and, for a generic horror film, did exceptionally well at the box office. Interestingly, the deleted sequences are shown as "extras" on the DVDs of the films, along with the explanation for their exclusion. Mass audiences wanted a mechanical killing machine, and that's what they got.

But what chance would Yasujiro Ozu, that most meditative of filmmakers, have in such a system, or Robert Bresson, Carl Th. Dreyer, or even John Ford or Howard Hawks, both studio directors during the golden age of Hollywood? Indeed, precisely to prevent such interference, Ford would often sit next to the camera during shooting and thrust his fist in front of the lens when the scene was through, both to indicate the precise cutting point to his editor (usually Otho [Otto] Lovering) and to prevent interference from studio bosses, focus groups, and bickering executives. As late as the 1960s, director Freddie Francis designed his films in long tracking shots, with no other coverage, to make certain that his films could be assembled in only one way: his way. Alfred Hitchcock famously did the same thing, storyboarding every shot of a film and using the storyboard as a bible to shoot it so that the film could be edited together only in the fashion that Hitchcock had originally designed.

In his first American film, *Rebecca* (1940), for producer David O. Selznick, Hitchcock followed the same procedure, thus frustrating Selznick's attempts to re-edit the film after the fact, something the producer was famous for. But these were more innocent times. As the budget goes up, the risk goes up; and focus groups now dominate the cinematic landscape to the exclusion of any personal vision. Yet focus-group vision is not even a corporate vision. It's the vision of the most myopic viewer in the room, the person who has to be led from point A to point B with the greatest of simplicity while at the same

time demanding that a film keep him or her continuously entertained.
It's the "wow" aesthetic writ large.

As far back as the 1980s, movie focus groups have had a measurable
impact on mainstream cinema. In the original cut of Steven Spielberg's
E.T.: The Extraterrestrial (1982), for example, E.T. died and never re-
turned home; but test audiences nixed *that* idea, and Spielberg hap-
pily reshot the ending. In the first cut of Garry Marshall's *Pretty Woman*
(1990), Julia Roberts refused Richard Gere's offer of marriage and
went back to "the life"; once again, audience test groups put a stop to
that idea. In 1997's *My Best Friend's Wedding*, directed by P. J. Hogan,
Rupert Everett had a bit part as a gay friend of Julia Roberts's char-
acter; test viewers wanted the part built up, so Everett was called
back for reshoots on hastily reconstructed sets. Perhaps most famously,
Glenn Close's psychotically possessive killer in Adrian Lyne's *Fatal At-
traction* (1987) had to be killed *twice* at the end of the film, the second
time with a gun, when test audiences found her initial death scene
insufficiently satisfying. Accordingly, since her character's death took
place in a bathtub, the entire set, which had been struck, had to be re-
created at considerable expense and Close brought back for one more
on-screen death scene. The film was a substantial hit, particularly be-
cause of the revision, because audiences felt satisfied that just retribu-
tion had been meted out (see Bay).

As Willow Bay points out, test audiences in 1939 felt that Judy
Garland's rendition of "Somewhere over the Rainbow" in *The Wizard
of Oz* slowed the movie down and wanted the scene out; cooler heads
prevailed, and the song remained intact. Robert Altman, the maverick
American filmmaker, said flatly that "it's a process I don't believe in"
(as quoted in Bay), while dependable studio mainstreamers such as Ron
Howard, on the other hand, have welcomed the input. Howard actu-
ally went so far as to say that "what I would hate to do is put [a] movie
out there, find out that the audience is confused about something or
upset about something that you could have fixed, and go, 'God, I had
no idea they'd respond that way'" (as quoted in Bay).

No, you can't afford to offend or confuse anyone; so when in doubt,
cut it out. Many test audiences are recruited from movie theater at-
tendance lines, or else (as is increasingly popular) the film is screened

in a small college town in the midwest to get the input of the perfect target group: the 18- to 24-year-old audience. After the screening, staff members work the crowd, asking audience members to fill out questionnaires on which they enumerate their likes and dislikes. Said one test-screen audience member, "[They ask you] a lot of questions, [such as] what you thought of the film, what five things you like best, what five things you liked least, which scenes you liked the most, which characters you identified with" (as quoted in Bay).

Bigger audiences are then broken up into smaller groups, where a moderator, in the words of another participant, "ask[s] people to comment on whether they liked or disliked certain characters, whether you thought certain things should have been more developed, less developed, et cetera" (as quoted in Bay). Filmmakers such as Robert Altman suffered under this regime: his 1998 thriller *The Gingerbread Man* was taken away from him after a series of disastrous test screenings and heavily recut by Polygram, the distributor. Although Altman finally got control of the film back, what emerged was less than it might have been, due, in Altman's opinion, to the invasiveness of the process.

Ron Howard, as previously noted, feels that test screenings are a way of doing business in 21st-century Hollywood. If a director has final cut, which very few do, test screenings can be onerous but endurable. But as Howard notes, "it's frightening if you're in a position where you're going to show the movie at a preview and somebody else is going to take the results of that preview and re-cut the film based on that, maybe consulting you or maybe not. That's terrifying" (as quoted in Bay). Calling the entire process "brutal, hideous," Howard admits that the "whole preview experience is not fun. Even when it's going well, it's not fun. You never want to be proven to be mistaken about anything" (as quoted in Bay).

Altman, who no longer has to fight battles with the studios since his untimely death in 2006, was less forgiving: "I just think it's wrong and destructive. I edit my film, and I take it out to people, and they can make the final judgment" (as quoted in Bay). But few filmmakers now have this luxury; and more importantly, fewer *want* final cut: they want to make money, and that's all. When it first came out, Federico Fellini's deliriously beautiful color film *Juliet of the Spirits* (1965) was a major

financial disaster and almost bankrupted the film's producer. Now, of course, it's an acknowledged masterpiece of the cinema. Would *Juliet* have fared well at the hands of a focus group? After a few test screenings, would it have emerged as the hallucinatory masterpiece that it is? Probably not.

A more recent wrinkle in focus groups is to employ out-of-work film critics to handicap a film's box-office potential; but unless the critics maintain a bottom-line mentality over all other considerations, the success of such a scheme seems doubtful (see Waxman, "Laid-Off"). And, of course, theatrical screenings are no longer the only issue. According to a survey conducted by the Epix Multiplatform entertainment service,

> As the entertainment viewing experience evolves and technology advances, consumers are changing as well, making new choices about viewing programming and forming new habits that include the ability *to watch movies on multiple screens* [emphasis added]. . . . The survey also looked at what viewers expect out of a multiplatform service in addition to those viewers' behaviors. Seventy-five percent of respondents said multiplatform availability for movie content was an important attribute. Forty-five percent ranked it as the second most valuable feature (first was access to hi-def programming). (Tanklefsky)

It seems as if one image isn't enough anymore; viewers want to be inundated with multiple images and multiple narratives, not necessarily to follow all of them in strict narrative format but to have the false sense of omniscience that accompanies constant information overload. Movies aren't necessarily just screened—a process in which they're competing, in a sense, only against themselves (and the memory of similar films seen in the past). Now they must compete against other films that are being screened at the same time, an experience comparable to being in a sports bar in which 5 or 6 games appear simultaneously on a battery of flat-screen HD televisions.

When a film becomes momentarily boring, the viewer can direct her or his gaze to another film; and if one film offers a particularly impressive or spectacular image as opposed to a routine close-up for dialogue

exposition, the more kinetic image will probably dominate viewer attention. In a way, it's like a 1960s lightshow, which was intended to bombard the viewer with a mixture of films, colored lights, moiré patterns, and random images; it was designed as a sensory overload. Now, we're multitasking, even in our leisure viewing.

This overload is everywhere in the media, and the 24/7 news cycle that has replaced the daily summary of the events of the day is designed not only to create an endless stream of programming but also to keep us in a constant state of anxiety and fear, in which we watch, mesmerized, as one disaster after another is brought to us within seconds of its happening. Luis Buñuel, the great Spanish filmmaker, recognized this when he wrote in 1980, just 3 years before his death, of the ceaseless profusion of meaningless images that confront us at every turn. As he said in "Pessimism," his final essay, "The glut of information has . . . brought about a serious deterioration in human consciousness today. If the pope dies, if a chief of state is assassinated, television is there. What good does it do one to be present everywhere? Today man can never be alone with himself, as he could in the Middle Ages. The result of all this is that anguish is absolute and confusion total" (262). Or as the French theorist Alain de Botton put it more recently, in 2010,

> The obsession with current events is relentless. We are made to feel that at any point, somewhere on the globe, something may occur to sweep away old certainties—something that, if we failed to learn about it instantaneously, could leave us wholly unable to comprehend ourselves or our fellows. We are continuously challenged to discover new works of culture—and, in the process, we don't allow any one of them to assume a weight in our minds.

This feeling of overwhelming alienation also applies to the actors who appear in 21st-century Hollywood; for instance, Kristen Stewart, just 20 years old, compared her recent fame, a result of the *Twilight* series, to "looking at someone being raped." As she said in an unexpectedly outspoken interview with *Elle* magazine's British editor, "What you don't see are the *cameras* shoved in my face . . . or the people falling

over themselves, screaming and taunting to get a reaction. I feel like I'm looking at someone being raped. . . . I never expected that this would be my life" ("Kristen Stewart: Fame").

And yet the publicity machine grinds on, and tabloids such as the *National Enquirer* are the best-selling newspapers in America. In short, we want instant access, spectacle, disaster, lurid scandals, and constant titillation in our media consumption; we want to see all of life's tragedies and celebrities now, live, televised everywhere, then constantly replayed for our leisurely delectation. The stars are very different from us, it seems; and when they took up the craft of acting, they also gave up any right to privacy. The Tiger Woods scandal gave television thousands of hours of lip-smacking coverage; but when that died down, another catastrophe or celebrity meltdown took its place. Yet sympathy seems sadly lacking. As one reader posted on the Kristen Stewart interview site, "I'm sure some West Virginia coal miner is, at this very moment, shedding a poignant, heartfelt tear for the terrible hardships that Kristen Stewart must endure."

No one seems to consider that there might be some truth to what Stewart said. Indeed, she was forced to recant her remarks almost immediately, after hundreds of "fans," eager to comment on her behavior, deluged various websites with vicious, negative remarks. "'Violated' would have been a better way of expressing the thought," Stewart said as she apologized. "People thinking I'm insensitive about [the subject of rape] rips my guts out" ("Kristen Stewart Calls"). But one should also not forget that Stewart herself "played a rape victim in Jessica Sharzer's 2004 film *Speak*, and has been a spokeswoman for the group Rape, Abuse, and Incest National Network (RAINN)" ("Kristen Stewart Calls"). It *was* a poor choice of words, but the hate that erupted in Internet chat rooms was equally inappropriate. What Stewart actually said, according to the quotation above, was that being a star was "like looking at someone being raped." This is a fairly subtle comment on alienation and voyeurism, not victimization. However, in the rush to tabloidism, this was lost in the shuffle. Clearly, we have become a culture in which snap judgment rather than compassion and reflection is the new rhetorical fallback position.

Other 21st-century actors, however, seem to bask in the glow of manufactured publicity. As Lynn Hirschberg stated in a profile of Megan Fox,

> In the age of the 24-hour news cycle and hungry blogs, Fox has supplied a seemingly endless stream of tantalizing quotes. She has detailed her fling with a stripper named Nikita; compared Michael Bay, the director of *Transformers*, to Hitler; and revealed that she has her boyfriend's name tattooed "next to my pie." Fox has a provocative way of describing any situation: her girl-on-girl kiss in her latest film, *Jennifer's Body*, is "like crazy kiddie porn"; Disney's *High School Musical* is about pedophilia (if you watch it, as she did, after getting high); and the reigning heart-throb Robert Pattinson is too young and too pretty to be sexually compelling. "I would eat Robert Pattinson," she said. Fox, who is 23, understood instinctively that noise plus naked equals celebrity. And after having appeared only in *Transformers* I and II, in which the true stars were giant robots, she created a rebellious, frankly sexual persona and talked her way into the limelight. The only problem is, having come so far so fast, how do you stay this year's girl when the year is almost over? ("The Self-Manufacture" 58)

It's a good question. After the relative failure of Karyn Kusama's *Jennifer's Body* (2009), which centered around the merchandising of Fox's physicality, her career took a definite hit. She was dropped from (or departed from, depending on whose version you believe) *Transformers 3*, the upcoming installment of the popular series, and replaced by Rosie Huntington-Whiteley, a British model who was chosen for the role by director Michael Bay. Huntington-Whiteley, a Victoria's Secret model, has no acting experience of any kind, but that didn't stop Bay from putting her into the lead role.

Further, Fox's newest film, Jimmy Hayward's *Jonah Hex* (2010), features only brief glimpses of her in the trailer for the project; instead, it was sold primarily as a Josh Brolin vehicle, with John Malkovich as backup. The marketing approach didn't matter: the film flopped almost immediately. But Fox still has numerous projects in the hopper, such as Mitch Glazer's *Passion Play* (2010); a cameo appearance as a mermaid

in Rob Marshall's *Pirates of the Caribbean: On Stranger Tides* (2011); *The Crossing*, a thriller with no director yet; and the lead role in *Fathom*, based on Michael Turner's comic-book character (and no relation to the 1967 Raquel Welch comic spy thriller *Fathom* directed by Leslie H. Martinson).

So certainly, it's much too early to count Fox out. But as she told Hirschberg, "women tear each other apart. Girls think I'm a slut, and I've been in the same relationship since I was 18. The problem is, if they think you're attractive, you're either stupid or a whore or a dumb whore. The instinct among girls is to attack the jugular" ("The Self-Manufacture" 59). In the wake of recent events, Fox's management team is trying to readjust that image, but she remains convinced that it will be a tough sell. "All women in Hollywood are known as sex symbols. You're sold, and it's based on sex. That's OK, if you know how to use it," she told Hirschberg, adding,

> it's been a crazy year. I've learned that being a celebrity is like being a sacrificial lamb [which certainly echoes Kristen Stewart's comments about rape]. At some point, no matter how high the pedestal that they put you on, they're going to tear you down. And I created a character as an offering for the sacrifice. I'm not willing to give my true self up. It's a testament to my real personality that I would go so far as to make up another personality to give to the world. The reality is, I'm hidden amongst all the insanity. Nobody can find me. (59)

But in truth, this is a very limited way of looking at things. Not every woman in Hollywood is sold and marketed as a sex symbol; Meryl Streep, Glenn Close, Laura Linney, and Kathy Bates, to list just four examples, are matched to their roles through their skills as actors. But Megan Fox's celebrity is based on what she admits is an entirely artificial construct designed for dissemination in the Internet age, a 21st-century media personality in every sense of the word. The problem she faces is that the construct has replaced the real in the minds of the public; and once established, a media persona is hard to recalibrate.

What happens next in Fox's career will be a result of careful

management, a thoughtful choice of roles, and perhaps a complete makeover in terms of her public self, which she could effect by dropping out of sight for a while and then resurfacing as an entirely recreated public figure. Jennifer Connelly, for example, started her career as an out-and-out sex symbol in such films as Joe Johnston's *The Rocketeer* (1991) and Lee Tamahori's *Mulholland Falls* (1996); and her early roles involved considerable nudity, casting her primarily as an object of male desire. However, she successfully managed to reinvent herself in Darren Aronofsky's *Requiem for a Dream* (2000) and Ron Howard's *A Beautiful Mind* (2001), and clicked with both audiences and critics as a conscientious actor of considerable depth and range. In the web era, you have to constantly adapt to public perceptions and shifts in taste in order to survive and build your career.

While there's no such thing as privacy for any of us in the 21st century, and the web seems to contain a record of every peccadillo in all our collective pasts, news cycles have accelerated to the point that breaking news of considerable magnitude, such as Michael Jackson's death or the BP oil-rig disaster (it's sad to list the death of a popular entertainer and a vast personal and ecological tragedy in the same sentence, but both got roughly the same amount of "news" coverage), provides an opportunity for those who wish to "disappear" to resurface with an entirely new persona. As evinced by David Bowie, Madonna, Lady Gaga, and Sean Combs, constant reinvention is the key to longevity in the 21st-century media marketplace; those who remain in stasis do so at considerable risk.

As a 21st-century medium, video games are also adapting to changing tastes. Once upon a time, point-and-shoot games such as *Doom* and *Grand Theft Auto III* ruled the public consciousness; now, a more complex and nuanced approach is required. *Red Dead Redemption* (2010), for example, is a video game set in the American west of the 1800s, with a strong resemblance to Sam Peckinpah's epic film *The Wild Bunch* (1969). Certainly, there is considerable violence in the game but also an attention to detail and a depth and resonance that is missing from competing projects. As with any contemporary video game, there are versions for both PlayStation 3 and Xbox 360 consoles; but as Seth

Schiesel puts it, *Red Dead Redemption* "does not merely immerse you in its fiction. Rather, it submerges you, grabbing you by the neck and forcing you down, down, down until you simply have no interest in coming up for air" ("Way Down Deep" C1).

Created by video game giant Rockstar on a budget of $80–140 million, *Red Dead Redemption* is, in Schiesel's words, the company's attempt to "demonstrate that it can create a blockbuster out of more than the profanity-spewing drug dealers and submachine-gun-toting thugs who populate the world of *Grand Theft Auto*" (C6). Rockstar's president and creative head Dan Houser commented that it was about time that a fully detailed western video game hit the streets, inasmuch as "Westerns are about place. They're not called outlaw films. They're not even called cowboys-and-Indians films. They're called westerns. They're about geography. We're talking about a format that is inherently geographical, and you're talking about a medium, videogames, the one thing they do unquestionably better than other mediums is represent geography" (C6).

The game delivers on its promise with a remarkable density of detail that has to be experienced to be fully appreciated. At the same time, *Red Dead Redemption* is arguably more complex than many motion pictures because of the layered texture of both the landscape and the narrative line, which one can participate in, or not, as one chooses. As Schiesel accurately notes, there is a considerable difference between the construction of a film and a video game:

> [In] non-interactive entertainment—be it a play, film or television program—the director controls exactly what the audience sees at every single moment. That is why it makes sense to build sets that are nothing more than plywood facades: if the audience can't see it, it has no reason to exist. By contrast, [*Red Dead Redemption*] allows players to roam the frontier as they please. See that outcropping over there in the distance? You can climb it if you like, or just keep riding. When you come into one of the many towns and villages there may be dozens of buildings to explore, and they are all populated with folks going about their daily lives, even if you never visit. (C6)

This intensity of interactivity, together with the attention to detail and smoothness of character movement, makes the game a real step forward in video-game technology, to the point where its multifaceted, multi-option narrative becomes completely immersed and demands that the player co-create the game as he or she experiences it. This is one of the key differences between the cinema and a truly innovative video game: while there may be a finite set of possible plot outcomes encoded within the game, it is not a closed set, the way a conventional film is.

Video games are a fairly recent phenomenon, just barely out of their primitive stage, much as the motion picture evolved from Edison and Lumière's 1-minute silent, short films into films of 1 reel's duration (10 minutes), then into 4 reels (approximately 40 minutes), and so on through sound, color, and the various screen formats (CinemaScope, VistaVision, Cinerama, and the like). Some of these formats were gimmicks and lasted only a short time before the public tired of them. Others, such as CinemaScope and its related anamorphic processes (Panavision, for one), have proven more durable because they fundamentally expand the possibilities of the medium itself. *Red Dead Redemption* seems to be moving beyond the simplistic, nearly violent narratives of earlier games and staking out new territory altogether.

Yet despite all the emerging and competing mediums, movies still seem to be the dominant form of entertainment, whether seen in a theater or on a cell phone, a flat-screen TV, or a computer. Peter Cherwin, chairman and CEO of 20th Century Fox, acknowledges that "I don't think it's an overstatement to say that it's been the most revolutionary period in the history of mass media. . . . [W]e now have infinitely more ways to tell our stories and connect them to an audience" (as quoted in Gunther). And the people who are going to make these stories keep coming forward, either on their own, through sheer nerve and chutzpah (as Quentin Tarantino has done), or through the more traditional route of a conventional film school.

Despite the ferocious competition, film-production schools are thriving, as distinct from film history, theory, and criticism programs that exist primarily to train archivists to preserve existing programming, which all too often faces benign neglect in favor of the next blockbuster release. But film schools aren't cheap. As of this writing,

Full Sail University charges $72,000 for a 21-month B.S. degree program in film and video production, an education that may be comprehensive but is certainly quite an investment; while the Seattle Film Institute charges $21,500 for a 10-month program (see Shatkin). One is tempted to say, "Why not just pick up a camera, get some solid actors and a good script, and do it yourself?" Then, for distribution, put it on the web. If it's good enough, as in the case of Fede Alvarez's *Panic Attack*, the studios will take notice.

Perhaps you're destined for a smaller audience; that's OK, too. Not every vision is designed for mass consumption. The 21st-century auteurs who are the most original will inevitably be consigned to the margins until their work becomes fashionable; but as always, new ideas drive the business. 20th Century Fox's Jim Gianopulos notes, "you can't keep making the same old movies. They're boring," while Tom Rothman, also at 20th Century Fox, adds "we are fiscally conservative so we can be creatively reckless. And we marry very carefully the movie to a specific audience" (as quoted in Gunther). This is the way movies will be made in 21st-century Hollywood; a continuous stream of action blockbusters allows no room for invention. The cinema has to be a creative workshop as well as a business; if not, one is just strip-mining existing concepts and genres until literally nothing is left.

At the 63rd Cannes Film Festival in 2010, Thai filmmaker Apichatpong "Joe" Weerasethakul's *Uncle Boonmee Who Can Recall His Past Lives* (2009) walked off with the Palme d'Or; it's a quirky film about a dying man "whose past lives and ghostly relatives" (Dargis, "Thai Filmmaker" C1) confront him on his deathbed. The win was something of an upset; but Tim Burton, the president of the jury, persuasively argued on the film's behalf, with effective results. He no doubt saw much of himself in Weerasethakul's film. The other prizes went to a variety of international films (Grand Prix to Xavier Beauvois's *Of Gods and Men* [2009]; Jury Prize to Mahamat-Saleh Haroun's *A Screaming Man* [2009]; best director to Mathieu Amalric for *Tournée* (On Tour, 2009]; and acting awards to Juliette Binoche in Abbas Kiarostami's *Certified Copy* [2009], Javier Bardem in Alejandro González Iñárritu's *Biutiful* [2010], and Elio Germano in Daniele Luchetti's *Our Life* [2009])

that demonstrated the incredible range of contemporary filmmaking—
although much of it, as you should already be aware, will never see
even a token U.S. release (Dargis, "Thai Filmmaker").

But while that's regrettable on one level, it demonstrates conclu-
sively that there are multiplicities of visions still operating outside the
Hollywood studio system. The jury, comprised of a truly international
mix of film artists, including Indian director and actor Shekhar Kapur,
French director Emmanuel Carrere, Spanish director Victor Erice,
Puerto Rican actor Benicio Del Toro, French composer Alexandre Des-
plat, Italian actor Giovanna Mezzogiorno, U.S. director Tim Burton,
British actor Kate Beckinsale, and the head of Italy's national film mu-
seum, Alberto Barbera, are to be envied: they got a chance to see the
world's finest filmmakers at the peak of their respective powers; and
the ever-widening circles of influence created by the Cannes awards
will put these prize-winning films on Hollywood's radar. Who knows
what the eventual impact will be, 10 or 20 years from now?

One final note here on technological advances in the field of moving-
image production; the question of holographic films. Holographs—
3-dimensional images that seem to float in space as ghostly simulacra
of the real—are still in their absolute infancy, but advances are being
made. Joseph Perry of the Georgia Institute of Technology notes that,
with recent advances in holographic technology, scientists are moving
ever closer to the goal of a truly 3-dimensional image on stage, although
this may be 50 to 100 years in the future (see Greenfieldboyce). But
think of the potential: plays could "tour" without even leaving their
home-base theater; concerts could be performed by musicians whose
only presence is on the holographic recording; and films, of course,
would exist with an entirely new set of grammatical rules because con-
cepts of editing, off-screen space, continuity, and set design would be
radically altered by the potential of the medium.

As Perry notes, audiences want "compelling 3-D displays they
can enjoy without wearing clumsy glasses" (as quoted in Greenfield-
boyce) and the attendant eyestrain. No matter how you slice it, current
3-D technology is an illusion based on our binary visual perception;
and as we've learned, it can involve considerable eyestrain and possible
health risks. But holographic movies would be, in and of themselves,

inherently 3-dimensional, requiring no software or glasses. Naturally, as with all other technologies, holographic cinema, when and if it becomes a reality, could easily be abused (and in all probability, will be) by exploitative filmmaking; imagine the *Saw* franchise in holographic detail, for instance. But as Dennis Gabor, the British-Hungarian scientist who first developed holographic technology in 1947, coining the name "from the Greek words 'holos,' meaning 'whole,' and 'gramma,' meaning 'message'" ("The History"), envisioned it, the hologram, when fully developed, will indeed present the whole message to those who view it. It will be a perfect 3-dimensional replication of life itself.

French filmmaker Jean-Luc Godard is one of the great free spirits of the cinema, defining the anarchic spirit of the 1960s in such films as *Breathless* (1960), *Masculine/Feminine* (1966), *La Chinoise* (1967), and *Weekend* (1968). At age 79, he presented a new film at Cannes, *Film Socialisme* (2010). Ever since his final break with traditional cinema in 1968, when he created the Dziga Vertov Collective with Jean-Pierre Gorin, Godard has been making progressively more radical films, and *Film Socialisme* is no exception. But Godard's incredibly complex cinematic tapestries require a great deal of concentration, patience, and interpretation, as well as multiple viewings, to get to the core of their being. Thus, *Film Socialisme* was all but ignored at Cannes, although Godard, as usual, seemed completely uninterested in mundane aspects of the cinema such as festivals, awards, and even distribution. As he told Daniel Cohn-Bendit, he has abandoned the cinema altogether:

[I]t's all just a bygone era. Anne-Marie [Miéville, Godard's partner in life and cinema] did it before I did. It's over—you can barely create anything. The cinema is a small society that was formed a hundred years ago, in which there were all these human connections, money relationships, relationships having to do with women—and that's gone. The history of the cinema isn't one of films, just like how the history of painting isn't one of canvases. . . . [T]he production [of *Film Socialisme*] went very smoothly. But afterward, you stumble into distribution, circulation, and it's a whole other story. . . . I wanted to distribute it like this: you take a boy and a girl, or two or three small groups, you give them video copies, you drop them out of an airplane by parachute, they

have a map of France, they don't know where they're going to land, and you let them sort things out, go into cafés, show it a few hundred times. (Keller)

There's something paradoxically hopeful yet final about Godard's pronouncements here; his distribution method, while on one level an elaborate joke, is also designed to assure his film's anonymity and un-availability, two things that the director has prized throughout his quixotic career. Obviously, someone will grab a print of the film and post it on the web, probably long before the DVD published, and make it legally or illegally available to the general public. And considering that *Film Socialisme* was shot on a budget of 300,000 euros, which even for a small-scale Hollywood film would only cover on-set meals for cast and crew during production, Godard can truly be said to be one of the last of the independents.

But his impact on the cinema as a whole has been enormous. Hollywood absorbed his idea of the jump cut almost immediately (which he first employed in *Breathless* to speed up the pace of the narrative), and his bold mixture of political agitprop and cinema invention has left its mark on 2 generations of commercial filmmakers, both in the United States and abroad. Nevertheless, while the cinema of the 20th century may be "a bygone era," as Godard puts it, the cinema of the 21st century is just beginning. And the promise and risk it holds is immense; the very substance of the moving image has been irrevocably transformed by the digital revolution, and who knows what further technical and aesthetic touchstones may be ahead? The truth is that the cinema, like all the arts, is constantly dying and constantly being re-born. The future of the moving image, particularly in the instantaneous dissemination of images and information, is limited only by our collective imagination.

CHAPTER FIVE

The Moving Image
Is Everywhere

While the traditional platforms of movie distribution and reception may be vanishing and transforming, audiences are rapidly adjusting to viewing moving images in a variety of ways. We now get to see our dreams and fantasies projected both on large screens as spectacle and on small screens as portable, communal, socialized mini-spectacle. Film, as it was defined in the 20th century, may arguably be disappearing; but moving images are everywhere all at once. The availability of media is almost overwhelming. Media spectacle, multiplatformed as it is rapidly becoming, is benefiting from a mind-boggling explosion of formats; and a plethora of myriad platforms and delivery systems is emerging and morphing at an almost unprecedented speed.

Indeed, the rapid evolution of media-delivery systems is forcing us to redefine the auteur and moving us to question our received notions. Who is the audience? Who is the spectacle? Who is actually controlling and distributing images and selves? In some ways, it seems as if there may be a breakdown of the old model of the consumer of images, who is beholden to the advertisers and media moguls who control what we view in order to sell us things. Now the audience appears to be the advertising conglomerates, who spend an inordinate amount of time and money watching us, the viewers, who have become the spectacle.

Privacy is so 20th century. Every time we browse the web, click on

anything, map our daily lives on Facebook, purchase anything, watch anything on YouTube, call a customer-service rep, drive under the eyes of Google Earth, wander into a store, we are subject to behavioral tracking. So many entities are tracking our every move, our every purchase, our personal likes and dislikes, that we have failed to notice that we have become the attraction: we are the movies. Natasha Singer, writing on behavioral tracking, notes that retailers now have cameras that watch you shopping and record your behavior, from trying on a particular pair of jeans to walking out of a store without a purchase. Even the words you type into a search engine are used to alert retailers, who then identify you on the bar codes of web coupons, sometimes with added information that they have found on Facebook and other networking sites. We are movies that have a predictable ending, so much so that "mobile marketers can find you near a clothing rack, and send ads to your cell phone based on your past preferences and behavior" (Singer 5).

In a world where we are much more predictable and profitable than the box office of any movie, it is no wonder, then, that we have become the spectacle and our behavioral patterns are free for the taking or traded among companies with little or no regard for "that quaint old notion of informed consent" (5). Consumers often take little notice that their personal information and consumption practices are being recorded, disseminated, and used to sell us more of what we are already buying. New media have evolved so quickly that much of this tracking is completely unregulated, at least in the United States. In Europe, Singer notes, commissions are set up to regulate privacy intrusions, but the United States has been slow to impose guidelines or policies. Meanwhile, files are adding up and are tracking everything from our purchases on Amazon.com to our location according to our cell phones.

We the consumers are not just being pitched product online and in every other venue, but we are also feeding into the system by producing product. We are the spectacle; we are narcissistically emerging with the product and morphing into product. Consider, for example, the emergence of a new viral phenomenon in which audiences make the advertisement for the product that they are selling to themselves. Julie

Bloom, in "You at Home, Put a Viral Spin on It," traces the manner in which amateurs, "inspired by the pros, make YouTube videos that in turn inspire others" (AR10). Lady Gaga's "Telephone," Beyoncé's "Single Ladies (Put a Ring on It)," and Usher's "OMG" have all inspired countless homemade yet professional-looking uploaded dance videos that are themselves imitated, mashed up, and played endlessly online, free and powerful advertising for record companies and the artists they promote.

These viral videos are taken quite seriously by their corporate beneficiaries, and they are often slick, creative, and arguably better material than that put out officially as advertisement. Dance and the unprecedented reemergence of professionally choreographed moves often drive these videos. Particular singers are associated with particular dances in a way not seen since the 1950s. As Bloom notes, dance sells music. She quotes the head of Jive records, Jeff Dodes: "We know we can do more things with records that already have dances attached to them, including doing viral videos, whether it be official music videos or even more lower production videos where the artists are literally teaching the dance moves" (AR10).

Not only are the consumers becoming the advertisers, but the artists are in some ways becoming more like the homemade viral stars. Laurie Ann Gibson, a choreographer for Lady Gaga and other major artists, told Bloom that one of the reasons for the popularity of Lady Gaga is that she is, ironically, "less polished than the typical pop star": "I created the movement with someone who isn't so perfect. I think that's what a lot of people identify with. You don't have to be perfect when you do the 'Bad Romance' dance or 'Poker Face'" (Bloom AR10, AR16). Gibson's uncanny understanding of the new model of consumption as a cycle of narcissism and identification with imperfection is important in understanding the rapid rise of Lady Gaga as a pop phenomenon. The manner in which she transforms herself by the minute with hairstyle changes, wigs, and increasingly outrageous costumes is reminiscent of a young girl playing dress-up. Her manufactured perfection is itself full of human-like traits. For the narcissist consumer, she is ideal; she's just like one of us. She's available to us on video, on Twitter, in filmic form,

in any number of platforms, just as we are available to her and her promoters. We sell her to ourselves. She is the perfect viral consumer of us as product and vice versa.

Emerging platforms that allow us not only to be like our favorite stars but also to inscribe ourselves as the product are emerging in all areas of popular media in a host of arenas. Interactivity is key. *American Idol* and numerous other television programs such as *Dancing with the Stars* use interactivity to enable audiences to become part of the spectacle. This is accompanied by an advertising strategy that uses average people (our new "interactive friends") to sell digital prototypes of new products to the viewer. You're not buying from some stranger; you're buying from a friend—or at least that's what advertisers want you to think.

"News stories" about new products sound no different in tone, style, or language than 21th-century-style advertisements, often playing up the newly possible applications of a product with articles that sound exactly like ad copy, with little time for discussion of whether the consumer even needs the new product. Indeed, "need" is the real reason for the article's existence. Many new products in image projection are seen as absolutely necessary in a world in which the consumer is obliged to keep up with new technology, purchasing every new gadget as it appears on an almost daily basis, in much the same way that we now post our every movement on Facebook and our narcissist tweets on Twitter.

Not for a moment, for example, does author Anne Eisenberg of the *New York Times* question the need for a pair of eyeglasses that have miniaturized video projectors hidden inside their frames ("Inside These Lenses" B4). It is assumed that, if you can afford it, you ought to get ready to line up for the newest app and the latest gizmo. So what if it ends up thrown in a drawer, like that useless set of ab crunchers you purchased at 2 A.M. on QVC? Eisenberg, in her article on projection eyeglasses, takes the tone of one of the professional copywriters on the fictional show *Mad Men*: "Earbuds can pipe audio directly from a portable player to the ear. But did you ever imagine that eyeglasses or contact lenses could deliver images directly from a smart phone to the retina? . . . The technology uses a process called holographic optics. Light-emitting laser diodes in the projector, stored in the side of the

frame, shoot their highly concentrated beams forward to the eyeglass surface" (B4).

New media are so immersive, and so rapidly growing, especially with young people, that sociologists and psychologists are beginning to wonder if the amount of time spent typing, texting, and digitally engaging is actually changing young people's ability to engage in pre-21st-century-style social behavior, such as talking face to face, socially engaging, playing, and even talking on the phone. Hanging out and actually conversing are viewed as hopelessly out of date. In "Antisocial Networking," Hilary Stout finds that "even chatting on cell phones or via e-mail is passé. . . . [T]he give and take of friendship seems to be conducted increasingly in the abbreviated snatches of cell phone texts and instant messages, or through the very public form of MySpace bulletins" (1).

Young Americans spend now 7 to 8 hours a day connected to some sort of electronic device, so much so that many are concerned about their intellectual, social, and physical development. As Stout notes, researchers wonder whether viral relationships provide social cues such as eye contact. Asking this generation, which juggles texts and chats with multiple handheld gizmos, to sit down and passively watch a movie projected on a big screen or to read a book with full attention applied to a single narrative is increasingly difficult. Some think it's a positive thing that young people can seemingly text while watching several narratives or conversations simultaneously; but others, more alarmist perhaps, wonder if this behavior is a form of textual attention deficit or overload behavior.

Still others cater to the behavior. Movie theaters, for example, are quickly adapting to the behavior of a new generation that demands several things to be going on at once. Although these practices are not yet generic and widespread, exhibitors are creatively finding ways to become more interactive. For example, CrowdGaming, first introduced in 2007, is one of the more interesting participatory audience experiences:

> In the summer 2007 MSNBC.com introduced the first ever in-theater audience participatory video game concept: CrowdGaming. Modeled

after classic video games, *NewsBreaker Live* combined live MSNBC.com
RSS newsfeeds, the movement of the audience (tracked with motion-sensor technology) as a human joystick, and the big screen as a game
board to bust audiences out of their pre-movie doldrums with an inter-active game that delivered real-time news headlines to kick start the
movie going experience. (van Veenendaal, "Movie Theaters")

As Paul van Veenendaal recounts, Volvo has used motion-sensor
technology to involve viewers in participatory ad making in British
movie houses:

> In October 2007 carmaker Volvo followed MSNBC's example. In 12
> UK cinemas the audience was simultaneously waving their arms in the
> air to guide the new virtual Volvo XC70 around the screen, each aim-ing to collect the most points and win the game. Carlton Screen Adver-tising sourced and developed motion-sensor technology that tracked the
> audience's combined movements via a wireless video camera set up at
> the front of the theatre. ("Movie Theaters")

"Volvo created the perfect way to communicate Volvo's 'Life is
Better Lived Together' brand message," according to van Veenendaal.
Thus, interactivity, wherein audience members not only watch an ad
but take part in it, is no longer limited to YouTube or online media but
is being brought to big-screen spectacle experiences. As early as 2006,
Fiat tried an interactive movie-ad experience called "The Fiat Idea Ad-venture," in which participants were encouraged to vote by simultane-ous media, the outcome of an advertising-based narrative:

> The audience in fashionable cinemas in Rio de Janeiro and Sao Paulo
> got to determine, by voting by SMS [short message service], how the
> adventures of John would unfold, a busy man whose day is about to
> turn into an adventure. Based on the most voted combination of answers
> the audience was shown a six-minute film, compiled from the 16 dif-ferent versions possible. . . . The campaign helped position Fiat as an
> innovative car brand and gained extensive editorial coverage in national

and international magazines and newspapers as well as on TV. ("Movie Theaters")

These interactive games (basically forms of advertisement) are taking place in theaters, online, and in any viable platform as ideas move in and among platforms. As van Veenendaal notes, another viral game, "The Chamber of Torture," was used to promote Darren Lynn Bousman's 2007 film *Saw IV*. In the game, players get to "torture" a variety of celebrities, from Paris Hilton to Victoria Beckham to Britney Spears. Players select their torture implements from a list of devices such as a chainsaw, drills, meat cleavers, and bats. And it doesn't stop there: "you can also upload pictures of friends and family so that you can torture them too" ("*Saw IV*").

A blogger dubbed Groggy Wanderer, commenting on Veenendaal's post on February 22, 2008, sees the promotion as good clean fun for the twisted yet at the same time implies that the game/ad is somehow beneath *Saw* fans:

> First off, this is just good-natured fun for people with a slightly twisted sense of humor. Anyone who would actually do something like this is crazy to begin with, and is just using the game as what either they or the "voice in their head" decided was the influence. Secondly, this game should be in no way related to *Saw*. The point of *Saw* is for people to escape from intricate traps that have been set up. This is just torturing people for entertainment. This should be more closely related to *Hostel*.

Groggy Wanderer so easily conflates his or her own identity with *Saw*'s product (as opposed to the *Hostel* films and ancillary branded product) that one could easily argue that this viewer, like so many millions, is yet another ancillary product of the *Saw* franchise. In his or her post, Groggy Wanderer merges personal commentary with advertising (arguably doing a better job at pushing *Saw* than any paid advertisement might). This is the ultimate goal of all advertising in the 21st century: affiliation with product so complete that it crosses the boundary between product and the individual.

Given that moving images are everywhere and that image making of many kinds is multifaceted, co-owned, and co-operated, doomsayers who herald the end of film and movie theaters seem to be missing the point. Granted, the experience of quietly sitting in a 20th-century-style movie theater and watching a moving picture may be a thing of the past, but smart franchises and smart distributors are rapidly recognizing the manner in which entertainment is becoming viralized and audiences are self-distributing, co-advertising, and, in a way, co-owning movies, games, music, television, and other forms of moving-image content.

Mark Sells's article in *Movie Maker*, "Judgment Day for Movie Theatres," sounds the alarm while it cautiously dips a toe into the digital ocean: the unknown future of movie theaters is "a scary scenario. . . . [L]ike music before it, the movie theater is battling for its very existence in a highly volatile environment. . . . [T]heatrical survival will depend upon how well these crucial battles are fought." Despite the fact that box office receipts and movie attendance are going up, some critics remain alarmist when it comes to the future of the movie theater. Mark Rollins's "Is the Age of the Traditional Movie Theaters Over?" is another diatribe synched to media-led paranoia about movie-theater tradition; but when looked at closely, these articles paint a picture in which movie theaters will ultimately survive and even thrive in the new digital age, if only exhibitors are smart enough to adapt to new media and new forms of spectatorship.

Sells's suggestions typify and encapsulate the forward-thinking approach to the emerging problem. Exhibitors must take several actions in order to survive the battle. They must upgrade to digital projection, HD projectors, and so on. Additionally, they must move toward 3-D, IMAX, and interactivity. Most observers agree with Rollins that, in the end, movie houses will adapt and respond to the digital revolution: after all, "movie theaters are more than just a place for entertainment. They are social gatherings. The digital age will never kill them, but it will make them evolve in order to survive."

In some ways, traditional movie spectatorship has already evolved considerably. Watching a movie on the big screen is changed and altered when one is surrounded by many viewers who chat and text

while they view the film. Often they are chatting live in conversation about the film they are watching. On the one hand, their chat may be giving away valuable plot points or even ruining the film's viability in terms of box office, especially if their live blogs and tweets are negative and they have built a loyal following. But they may also be selling the film to other prospective filmgoers, a point often missed by anxious distributors and exhibitors. It seems no accident that the box-office trajectory of a given film can now be accurately predicted earlier and earlier, due partially to the live digital audience criticism that goes on in the earliest shows.

How much effect will digitization and access have on artsy films seeking a smaller, smarter audience? Many independent films are now distributed through on-demand services and alternate live-streaming video online and will no doubt find even more viable alternative (if small-screen) distribution methods. Hollywood moguls like a sure thing: when they hit upon something that works, they try to sell it again and again. New media exist in a much more interactive and viral world where predictability no longer holds sway.

Rollins, Sells, and others have a good point in comparing the fall of the music industry with the perils of theatrical film distribution. The music industry, faced with the challenges of free music file sharing, initially held fast to old-style and old-school models of distribution instead of rapidly adapting to the new technology; but eventually they developed new platforms that sell their music at 99 cents a song. The wild west age of the Internet is clearly over; now, you pay for content. Even though Hollywood is losing a tremendous amount of money to illegal downloads, the film industry is desperately trying to outpace the pirates and learn from the music industry's mistakes.

The biggest lesson learned, according to Brian Stelter and Brad Stone, is that the industry must "provide the video on the platform that users want it" (A19). And as Chris Anderson noted in a September 2010 article in *Wired*, which he co-authored with Michael Wolff, more people than ever are using the web for movie downloads and distribution, and they are uploading material at a truly staggering rate. At the same time, users are living in a new world in which the old browser rules simply don't apply:

Over the past few years, one of the most important shifts in the digital world has been the move from the wide-open Web to semiclosed platforms that use the Internet for transport but not the browser for display. It's driven primarily by the rise of the iPhone model of mobile computing, and it's a world Google can't crawl, one where HTML doesn't rule. And it's the world that consumers are increasingly choosing. . . . The applications that account for more of the Internet's traffic include peer-to-peer file transfers, email, company VPNs, the machine-to-machine communications of APIs, Skype calls, *World of Warcraft* and other online games, Xbox Live, iTunes, voice-over-IP phones, iChat, and Netflix movie streaming. Many of the newer Net applications are closed, often proprietary, networks.

This is exactly the sort of distribution arrangement that the movie studios are looking for. While the music industry took years to offer and develop legal download sites of music for web users, the movie industry is developing and offering legal video download options at a rapid pace, through Netflix, Hulu, and Blockbuster (the three key sites at the moment) as well as a host of other new outlets. As Eric Garland, CEO of Big Champagne, a download site, asserts, "That's how you start to marginalize piracy—not just by using the stick, but by using the carrot" (as quoted in Stelter and Stone A19).

While movie executives figure out more and more viable download solutions, television executives such as Leslie Moonves of CBS are picking up on their strategy, arguing that "the internet is our friend, not our enemy" (as quoted in Stelter, "Water-Cooler Effect"). For one thing, Moonves and others recognize the importance of the Internet's water-cooler effect on TV ratings. The 2010 Super Bowl was "the most-watched television program in United States history" (Stelter, "Water-Cooler Effect"), largely thanks to the fact that viewers now enjoy tweeting and emailing as they watch TV. They also post their opinions about TV on Facebook and other sites, creating an online chat/blog community that has a positive effect on TV viewing habits.

According to Stelter, "if viewers cannot be in the same room, the next best thing is a chat room or something like it." It's evident that more platforms and more choices actually help old media in unexpected

ways, largely because of the popularity of online social networking. Thus, far from killing spectacle, new media are actually contributing to the development of new arenas of spectacle. As Chris Sladden, a director at Twitter, states, "in the future, I can't imagine a major event where the audience doesn't become part of the story itself" (as quoted in Stelter, "Water-Cooler Effect"). Steve Lohr, writing in the *New York Times*, agrees, finding the new social messaging services both ubiquitous and unavoidable:

> Up, for example, sprout social networks—Facebook, Twitter, Tumblr, Foursquare and others—that are hybrids of communication, media distribution and unvarnished self-expression. New versatile digital devices—whether iPhone or Android smartphones, iPod players and iPad tablets—nurture more innovation and experimentation. . . . Attention spans evolve and shorten, as even the most skilled media jugglers can attest. "I love the iPad," admits [critic Nicholas] Negroponte, "but my ability to read any long-form narrative has more or less disappeared, as I am constantly tempted to check e-mail, look up words or click through."

And yet, as Lohr notes, while "photographic film [has been replaced by digital video,] people take more pictures than ever. CD's no longer dominate, [but] music is more and more distributed online." Books are now being Kindled at an increasingly rapid rate; and so reading continues, but digitally rather than between the covers of a book. Newspapers and magazines are also shifting online and are starting, hesitantly, to charge online viewers for the content they seek. These are the changes and shifts inevitable in any revolution, but the digital era has created a platform replacement of such incomparable swiftness and force that it leaves many observers blindsided.

Spectacle is no longer defined by walls of movie houses or stadiums of sport and music events. Nor is spectacle defined by the number of people watching in an audience. Images and information are mutable and shape-shifting, available everywhere, anywhere. To many, this can seem overwhelming; for as Voltaire wrote, "Madness is to think of too many things in succession too fast, or of one thing too exclusively." Perhaps the surprising thing is that, instead of going mad, the more we

immerse ourselves in information and spectacle, the more we demand even more platforms for watching and being watched.

Projection itself, once limited by bulky immobile projectors, is now being supplemented by inexpensive handheld projection devices, including both dedicated projectors and cameras with built-in projectors. An ironic and interesting fact about this "new" development is that it is really a reintroduction of a platform device used in the earliest invented movie camera in the late 19th century. Early cameras included the ability to record, develop, and project images; only later were these processes separated, industrialized, and formalized as separate platforms. Now cameras include built-in projectors so that sharing images no longer means cramming a group of people awkwardly around your camera or handheld device.

With the Nikon Coolpix or a similar projection camera, you can screen films on a wall, on people's bodies, or on pretty much any surface you wish and thus create a mini-spectacle. Mireille Hakkenberg, detailing Nikon's ad campaign for the Coolpix, "[the] world's first projector camera," describes it as giving "its new camera a kind of coolness, appealing to the trendsetters and trying to make the world's first projector camera a must have gadget." *Coolness, newness, must-haveness,* and the promotion of a spectacle-centered community are stressed in the advertising materials.

As we've noted, social gaming is growing exponentially in many directions and forms. What's curious is that often the newest and trendiest social gaming platforms offer simulacra that recall realities from the past and suggest a nostalgia for pre-21st-century narratives of down-home, down-on-the-farm America. A good example of this phenomenon is the social network called Farmville, which, as of May 2, 2010, boasted 80 million active users (see Beuker). One might reasonably ask, "Why virtual farming? Why is it the most popular Facebook game, and how could it possibly generate income?" As Beuker explains,

> In the virtual farmland of Farmville, farmers must first create their own avatar (a virtual image representing themselves). According to the rules there are six plots of land, four of which are in the process of grow-

ing, and two (eggplant and strawberries), which are fully grown. As in real life farming, the market calls the shots [about] where items can be purchased such as seeds, trees, animals, buildings, decorations, vehicles and more using farm coins.

Farmville takes a page from the fad for the once-popular pet rock (taking care of something that is, in reality, an object that requires no attention) but viralizes, commercializes, and expands it, combining nostalgia, a postmodern camp aesthetic, and the demand for online community to market what has become a massively popular online habit. Farmville is designed to seem benign, family-friendly, nonviolent, and highly interactive; the players themselves, in a sense, provide the content as much as they pay for it. But as user statistics show, the game is amazingly addictive, usurping the time that one might put into creating a real farm with real crops, real customers, and a real impact on a world that can certainly use more food.

Facebook itself is replacing and transforming pre-21st-century notions of audience, spectacle, and community: it can even bring about a social revolution, as it did in 2011 in Egypt, toppling long-time dictator Hosni Mubarak (see Qaddumi). Perhaps the most interesting feature on Facebook is the "poke." In nonvirtual reality we share notes and phone calls, and sometimes we physically nudge or poke one another. Now, in virtual space, Facebook offers members the facsimile of such a poke. "Poking someone on Facebook is a simple way to let someone know that you are thinking about them. You can use the poke feature to say hello to a friend, flirt with a stranger or just let someone know that you are still around and using Facebook" (eHow). The social etiquette around Facebook behavior, including poking, is already replicating and simulating the rules of social behavior in nonvirtual real life. The poke doesn't sound all that different in concept from the cell phone "ping," a popular application used in Europe, especially the Netherlands, and among Blackberry users. The ping is essentially a messengered poke. It can be sent along with an emoticon, an image, or a message (Bianchi, "Newest").

Members of the newly wired generation see themselves as the stars of their lives. Like an endlessly mirrored ball of the self, social

media use generates even more use on other platforms. Ethan Bloch has discovered that, "compared to the average web user, mobile [cell phone] users socialize more online." Writing in March 2010, Bloch notes that "the number of cellular phone users in general connecting to Facebook through a mobile browser grew by 112 percent from a year ago, while Twitter experienced a 347 percent jump." As it turns out, Facebook users who access Facebook via their cell phone are "twice as active on Facebook than [are] non-mobile users" (Bloch). These statistics demonstrate how gadgets seem to promote the use of other gadgets, especially those that let one be in the real world yet detached from it at the same time. The majority of users want mobility in their social browsing worlds; and they also spend a good deal of time maintaining their virtual worlds, creating web pages, games, blogs, and interactive websites as well as uploading videos.

Endless hours are spent communicating, sniping, snarking, and blogging and reading posts, responses, and reviews. A process known as Really Simple Syndication (RSS) is used to collect and collate web pages and cull information. Podcasts are recorded and listened to, endless activity is generated on social and professional sites, and vast amounts of time are spent on consumer platforms and on gathering and purchasing online services and products. Because so much personal information is available on the web, it is easier than ever to target specific groups and to locate specific audiences by gender, income, age, and education level.

Privacy lines are routinely crossed in the digital world, and the invasion of privacy is not only relegated to online socializing but is leaking over into ordinary life and nonvirtual privacy issues. Privacy itself seems a fairly antiquated term—in particular, with regard to the lives of celebrities, especially, and perhaps ironically, when the issue involves their real bodies and the possibility that they have undergone plastic surgery. With alarming viciousness, "fans" routinely attack stars such as Nicole Kidman because of their alleged plastic surgery and other bodily enhancements. For example, Richard Shears's March 13, 2009, column in the Daily Mail opened with the headline, "Botox is turning Nicole Kidman into a 'bat face,' says cosmetic guru." The article included side-by-side photographs of Kidman and an actual bat with a

caption that read, "Unfortunate resemblance?" The backlash against stars who allegedly use Botox and plastic surgery is widespread in all media, including television, where VH1 runs a program called *Plastic Surgery Obsession*; and online, Topsocialite.com posts the very popular "15 Worst Celebrity Plastic Surgery Disasters You Will Ever See."

In our youth-obsessed culture, it's encouraging to note that older folks are benefiting from the new digitally driven world. Veteran actress Betty White, at age 88, has experienced an unexpected surge in visibility, job offers, and popularity as a result of completely unsolicited viral events. A Facebook page titled "Betty White to Host *SNL* (please?)!" was started by fan David Mathews on December 30, 2009. At the time, White had been doing a great deal of publicity for Anne Fletcher's 2009 romantic comedy *The Proposal*, in which she co-starred with Sandra Bullock and Ryan Reynolds. The Facebook page eventually worked, and Betty White hosted *Saturday Night Live* May 8, 2010, on the eve of Mother's Day. In the meantime, she scored a remarkable amount of television and online attention for her appearance in a Super Bowl ad for the candy bar Snickers. The commercial was rerun countless times, not just online but on CNN, Fox, and the regular broadcast networks, which treated it as a "news" item celebrating White's longevity in the business.

But White knows that her current moment of celebrity is a combination of luck, longevity, the embrace of new technologies, and sheer persistence. She was one of the first to adapt to the then-new medium of television, with a daily live show, and later a filmed series, *Life with Elizabeth* (1952–1955), which she created, produced, and starred in. She's adept at moving from one new medium to the next, and she embraces each new shift in technology and popular culture. It's a case of adapt or be left behind; and what holds for media personalities also is a fact of life for producers, distributors, and retailers. For example, on February 22, 2010, Wal-Mart purchased Vudu, a streaming video service that effectively does away with DVDs at the retail level. As Erica Ogg reported,

Vudu has a catalog of 16,000 video titles that can be downloaded to several different brands of TVs and Blu-ray players, either as a rental

or purchase. Wal-Mart Vice Chairman Eduardo Castro-Wright said of the service . . . , "combining Vudu's unique digital technology and service with Wal-Mart's retail expertise and scale will provide customers with unprecedented access to home entertainment options as they migrate to a digital environment."

Buying DVDs for home use has become outmoded; streaming downloads are the wave of the future. Google is preparing a new ultra-high-speed Internet service that will radically decrease download times, allowing the consumer to access an entire feature film in a matter of minutes rather than hours. And that's just one example of the system's potential benefits: Google claims that the new fiber network will completely transform the landscape of the moving image in the 21st century. As Google envisions it, the applications will be nearly limitless:

Imagine sitting in a rural health clinic, streaming three-dimensional medical imaging over the web and discussing a unique condition with a specialist in New York. Or downloading a high-definition, full-length feature film in less than five minutes. Or collaborating with classmates around the world while watching live 3-D video of a university lecture. Universal, ultra high-speed Internet access will make all this and more possible. . . . We're planning to build and test ultra high-speed broadband networks in a small number of trial locations across the United States. We'll deliver Internet speeds more than 100 times faster than what most Americans have access to today with 1 gigabit per second, fiber-to-the-home connections. (Ingersoll and Kelly)

Most striking about this announcement is what it potentially represents: a completely new technology that will make contemporary high-speed download connections feel like dialup systems. Once again, the future is reinventing itself with breathtaking speed, minute by minute. Amazon, for example, introduced in late June 2010 an updated version of its popular Kindle reader, which incorporates hyperlinks, short videos, and sound clips into the "books" that Amazon offers. So reading a book now becomes a multimedia experience in which text is just the starting point (see Evans).

The only thing we can be sure of in such a world is the concept of perpetual obsolescence; as film gave way to digital technology, so digital technology continues to reinvent itself, increasing consumer accessibility to movies, television shows, and web-based series at blinding speed. In short, one can't possibly keep up with these advances, because each new enhancement seemingly erases all that came before it. In an era in which 5-minute HD downloads of theatrical motion pictures becomes the new norm, what new distribution and exhibition formats will open up? And how will these technological changes transform the movie going experience itself?

Consider these statistics: there were, as of April 27, 2010, 560 million registered users of Skype, the interactive visual messaging service. In 2009, 47 billion instant messages (IMs) were sent each day from 2.5 billion IM accounts worldwide—roughly 53 IM messages per user per day (see Bianchi, "All Facts"). Audiences are no longer content to sit passively in their seats and watch a film; they text-message instant reviews to their friends, capture screen snapshots with their cell phones (despite the fact that this is manifestly illegal and vigorously discouraged by theater owners) for sharing via the web, and in a very real sense become a part of the film and its commercial and/or critical future, even as the images unspool on the screen.

On July 7, 2010, Ridley Scott (functioning as a producer) and director Kevin Macdonald announced what may have been the most ambitious interactive group filmmaking project in the history of the medium: a documentary entitled *Life in a Day*, which consisted "entirely of footage shot during the 24 hours of July 24, 2010."

Anyone in the world can participate and then upload their content to [YouTube]. Participants will be credited as co-directors if their footage makes it into the finished film. The doc will premiere at the 2011 Sundance Film Festival, and 20 of the participants will be flown to Park City, Utah, for the event. . . . "*Life in a Day* is a time capsule that will tell future generations what it was like to be alive on the 24th of July, 2010," [said Macdonald]. "It is a unique experiment in social filmmaking, and what better way to gather a limitless array of footage than to engage the world's online community." (Ditzian, "Ridley Scott")

The multi-continent shoot went off without a hitch. More than 80,000 video submissions were taken in for the project, totaling 4,600 hours of material, with the filmmakers aiming for a rough cut of 100 hours (!) and a final film that would be 2 hours long. Submissions came from 197 countries in 45 languages, proof positive, as if any were needed, of the global reach of the web ("YouTube's *Life in a Day*"). The end result was dazzling and is another indication of the trend toward forming new communities online in ways that previous generations could never have imagined.

Certainly, the film was slicked up in the final editing process to favor the most user-friendly imagery; but still it's clear that Scott, Macdonald, and their colleagues had a heck of a lot of footage to wade through before they created the final cut of the project. In many ways, *Life in a Day* recalls a similar project by the now-defunct *Life* magazine in the late 1970s: the journal sent hundreds of photographers around the world to photograph the events of a single day and then edited the results down into one oversized issue. Now the community has grown much larger, and anyone, not just professionals, can participate.

Some trends in the cinema may not last. But no matter what the future offers in the way of technological advances, the future of the moving image is assured. In the 21st century, the movies are everywhere, as are amateur videos, experimental "pods," television programs, made-for-cable or -web programming, on an ever-expanding playing field. And the technological ante is always being upped: on July 7, 2010, researchers at the Massachusetts Institute of Technology, led by Vincent Chan, successfully demonstrated the prototype of an Internet delivery system that is roughly 100 times faster than the existing system yet cheaper for the consumer (see Bindra). This means that one could download a feature-length movie in seconds, and such speed of access would call into question everything that has gone before. But the Internet is in its infancy, and new technological developments are happening daily. While Chan and his colleagues feel that there is no immediate need for the new service, within a few years, who can tell?

In the end, movies in the 21st century will demand what films have always insisted upon: an audience. Theaters will always be with us as showcases for spectacles that no flat-screen television can ever con-

tain, no matter how large, as well for use as communal meeting places where friends and family can gather to share the experience of "going to the movies." Recently, a new group of film showcases has opened up, thanks to an unlikely collaboration between independent record producers and truly independent filmmakers working with budgets in the $5,000 range or less. R. Alverson, for example, made *The Builder* (2010) on a shoestring and then turned to Jagjaguwar, a small indie record label, to see if the staff might be interested in setting up some screenings for the film.

One such viewing took place in the summer of 2010 at Zebulon, a small bar in Williamsburg, Brooklyn. As Melena Ryzik described the scene, "The story of a contemplative Irish immigrant, [*The Builder*] moved slowly, driven by atmosphere rather than dialogue, but the audience watched patiently at small candle-lit tables, beers in hand. It was the antithesis of a typical summer-movie outing, but that was sort of the point. 'It's just great to see people with drinks and candles,' said R. Alverson, the film's director. 'It's so much more personal than seeing it in a theater.'" (Ryzik, "D.I.Y.").

For Jagjaguwar, the whole thing was an experiment. Chris Swanson, head of the record label, told Ryzik frankly that, "as a film distributor, we have no experience. We're approaching it the same way we did music, like, find a nice room and put the work on display in a dignified manner." But the venture was a success, and Jagjaguwar plans to back Alverson's next feature, which will be similarly budgeted, and to look for other similar deals in the future.

Factory 25, another small record label, is also entering the low-budget film distribution field but is taking a slightly different approach. The label's first venture into this area is *Make-Out with Violence* (2008), a do-it-yourself film created by the Deagol brothers along with a group of musicians who subsequently toured in support of the film. Factory 25 released a DVD of the film packaged with a CD of its music track and also organized small-scale screenings, with significant success. Todd Sklar, a 26-year-old cinematic entrepreneur, has created an even more informal distribution system, Range Life, which tours the country in Sklar's 1986 Toyota, presenting a slate of 14 indie films in 40 states at a number of small, off-beat venues, an approach that recalls

the 1960s underground film circuit. Interestingly, except for using the Internet as a promotional tool, Range Life has eschewed digital distribution of the films themselves, at least for the moment (Ryzik, "D.I.Y").

The latest development in motion picture delivery, however, is a complete move away from DVDs into streaming-only territory. Netflix built its business model on delivering DVDs to the doorstep of its customers; this effectively killed Blockbuster Video's brick-and-mortar, go-to-the-store model, just as the Amazon model wiped out a large number of independent bookstores and even large chains throughout the world. More recently, on November 22, 2010, the company announced it would offer a streaming-only service to viewers and simultaneously hike the subscriber price of physical DVDs that are rented through the mail. Clearly, Netflix wants to do away with DVDs altogether. CEO Reed Hastings said in a new statement of company policy, "We are now primarily a streaming video company delivering a wide selection of TV shows and films over the Internet" (as quoted in Edwards and Rabil). As *Bloomberg News* reported:

> The price increase lets Netflix pass on rising postage costs and protect average revenue per customer as more subscribers choose streaming only, which is more profitable. . . . The streaming-only plan, priced at $7.99 a month, had been tested in the U.S. after a similar option started in Canada two months ago surpassed expectations. . . . The subscription price for unlimited streaming and one mail-order DVD at a time will increase to $9.99 a month from $8.99, Netflix said. The cost to have more DVDs at a time will also go up. The price change takes effect now for new customers and in January [2011] for existing customers. (Edwards and Rabil)

As Verne G. Kopytoff notes, "Internet-only subscribers [will] have access to a far smaller library of films and fewer Hollywood blockbusters than with the DVD plan. Roughly 20,000 films are available for streaming, or about one-fifth the number of films that can be watched on DVD [through Netflix]" (B2). But what about all the classic films that aren't available as streaming video? In essence, they will cease to exist. Netflix is banking on the fact that most people have no real

knowledge of film history so they'll content themselves with streaming only the most recent and popular films. This would be akin to Amazon's deciding to do away with physical books altogether and offering everything only on Kindle. No doubt Amazon is thinking about this possibility and would love to do it, but such an action would marginalize hundreds of thousands of books.

After killing off all the brick-and-mortar stores for DVDs, CDs, and books, Amazon and Netflix seem poised to do away with all vestiges of the real and enter the digital-only domain. What will be lost in the process is not only the physical reality of books and DVDs but also the many titles that won't make it to Kindle or streaming video simply because they're not popular enough. In short, we'll have the top-10 classics, and the rest of film history—many superb, remarkable films—will gather dust on the shelf. If you can just click and stream, why wait for the mailman?

Wall Street predictably cheered the Netflix announcement; but for those of us who love the medium of film, it's rather alarming to realize that, in effect, vast sections of film history will now simply cease to exist for the viewer. Adventurous and difficult films will now find it that much harder to locate an audience, and mainstream product will dominate the marketplace even more than it already does. As Richard Kastelein observed,

> In 2010, streamed videos outnumbered DVD rentals for the first time in Netflix's history. . . . But the online move has cost Netflix at least $1.2 billion, according to CNET. That's the amount Netflix has committed to paying Hollywood studios for the rights to stream their movies and TV shows. And it's up from $229 million three months ago, the company disclosed in an SEC filing [on October 28, 2010]. Most of that leap comes from a five-year deal that Netflix previously announced with the Epix pay channel, which is thought to be in the $900 million to $1 billion range. But that number could jump again within the next year, when Netflix's deal with the Starz pay channel expires.

Nor is this number likely to decrease in the future: analysts with the Hudson Square Research Group note that, "given that major

studios are very likely to expect increasing rates to obtain streaming only rights, we fully expect Netflix's content costs to rise further" (as quoted in Hayden). "Netflix has been aggressively acquiring streaming content. This year alone, it's signed licensing deals with NBC Universal, Warner Bros., 20th Century Fox, Epix, Relativity Media and Nu Image/Millennium Films" (see Seitz). And because the price for these deals is bound to increase in the future, this cost will have to be passed on to consumers. But Netflix is hardly alone in its quest for digital dominance. As Seitz notes, "Netflix isn't the only game in town. Besides Redbox, Hulu just launched a premium streaming video service for $7.99 a month. Deep-pocketed companies like Apple, Amazon, Google and Wal-Mart are aiming to take a slice of the market as well."

A side effect, of course, is that DVD players will become obsolete in an all-streaming world. Yet despite the easy availability of films that can be viewed on iPhones, iPads, streaming videos, and other nascent platforms, there will always be people who want to create a more intimate atmosphere for their viewing pleasure, one that is removed from the busy arena of filmic commerce. In all five boroughs of New York City, rooftop cinemas have started to proliferate, in which a handful of people band together to purchase a cheap video projector, shoot it into a homebrew sound system, and screen DVDs for their friends and families. Some rooftop cinemas, like the drive-ins of the 1950s, charge admission and are resolutely commercial enterprises. Others, however, exist on a more egalitarian scale: the event is more like having friends over for an evening's entertainment but with the enhanced experience of a relatively large-screen viewing image. This isn't illegal; it's screening a film for your friends at your house, without charging admission and showing it on the roof, with food and beverages conveniently at hand in a cooler. Michael Wilson wrote of one such evening in Manhattan:

> Imagine sitting in a movie theater, but seeing, to the left of the screen—where a glowing exit sign would usually be—the entirety of Lower Manhattan. The Statue of Liberty stands behind you, looking away, like an usher, maybe, or another theatergoer waiting for a friend. The group spread out plastic bags, and pillows. Four pizzas arrived. It was finally dark, and the [projector] was fired up. The wall was suddenly

filled with the subject of *Man on Wire*: Philippe Petit, who walked a tightrope between the towers of the World Trade Center, which once dominated the view from this roof. (26)

In London, a new wave of underground screenings known as the Secret Cinema screens classic films in site-specific locations with interactive theater events as part of the package, an experience that recalls the rave culture of the 1990s; the location of the screening is secret, and the audience doesn't know in advance what it will be seeing. But once they arrive at the location, several hundred viewers are treated to an immersive cinema experience with other, equally committed viewers, one that's very different from watching a DVD on a flat-screen TV in one's own apartment, either alone or with a few friends. In short, in both London and New York, community is being restored, which is what the cinema is ultimately all about, and something that we believe can never be replaced by an online experience. Seeing films with hundreds of strangers in a darkened auditorium, concentrating on the images in front of you, and sharing the experience with others: this is the essence of cinema. Indeed, this is why film progressed from early peepshow machines to full-blown projection salons—a need to embrace humanity as a whole.

Cinema in the 21st century is omnipresent and portable, programmed not only by professionals but also by amateur cineastes; it's an even more democratic version of the 16mm film societies that used to dot the landscape throughout the world, when film prints cost hundreds of dollars and projection was technically cumbersome. The digitization of the moving image puts the cinema within the realm of all, rich or poor, young or old, devotee or neophyte. As the century progresses and new forms of image storage and retrieval are created, they will no doubt transform the cinematic horizon even more, to the point at which everyone will be his or her own programmer, critic, archivist, and curator. Yet while the future of the cinema is ever-changing, one thing will remain constant: our desire for dreams, for escape, for enlightenment, for an experience outside ourselves. In the 21st century, the cinema, in whatever form it may take, will continue to provide this, as it always has in the past.

BIBLIOGRAPHY

Abaius, Cole. "Interview: *Monsters* Director Gareth Edwards on Pushing His Actors, Delays Caused by Prison Riots, and Stretching a Micro Budget." *Film School Rejects* 28 Oct. 2010. Web. 30 Nov. 2010.

Acker, Kathy. "The End of the World of White Men." *Posthuman Bodies.* Ed. Judith Halberstam and Ira Livingston. Bloomington: Indiana UP, 1995. 57–72. Print.

Adler, Shawn. "Original Screen Queen Decries *Birds* Remake As Foul." *MTV Movies Blog* 16 Oct. 2007. Web. 3 May 2010.

Adler, Tim. "Europeans Now Watch 8,600 TV Channels." *Deadline Hollywood* 13 Jan. 2010. Web. 30 Apr. 2010.

Agger, Michael. "The Geek Freaks: Why Aaron Lanier Rants against What the Web Has Become." *Slate.com* 3 Jan. 2010. Web. 30 Apr. 2010.

Als, Hinton. "Mama's Gun: The World of Tyler Perry." *New Yorker* 26 Apr. 2010: 68–72. Print.

Anderson, Chris, and Michael Wolff. "The Web Is Dead. Long Live the Internet." *Wired* (Sept. 2010). Web. 23 Aug. 2010.

Andrews, Marke. "Movie Theatres Must Appeal to Changing Audience, Vancouver Conference Told." *Vancouver Sun* 1 Apr. 2010. Web. 1 May 2010.

Angier, Natalie. "Bringing New Understanding to the Director's Cut." *New York Times* 2 Mar. 2010: D2. Print.

Ansen, David, with N'Gai Croal, Corie Brown, and Donna Foote. "You Oughta Be in Videos." *Newsweek* 24 Jan. 2000: 61, 63–64.

Ascher, Steven, and Edward Pincus. *The Filmmaker's Handbook: A Comprehensive Guide for the Digital Age.* New York: Plume, 1999. Print.

Atkinson, Michael. "The Eternal Return." *Village Voice* 21 Nov. 1995, Film sec.: 4–5. Print.

———. "Sheer Synergy: Selling Off the Dream Factory." *Village Voice* 4 Aug. 1998: 106. Print.

Aufderheide, Pat. "The Future of Hollywood: Creators, Conglomerates and Culture." *Center for Social Media* Oct. 2003. Web. 30 Apr. 2010.

Bajwa, Hashem. "Interactive Movie Theater Experience." *Brainsells.blogspot* 17 Oct. 2006. Web. 1 July 2009.

Barnes, Brooks. "Ad Budget Tight? Call the P. R. Machine." *New York Times* 22 Nov. 2009, Arts and Leisure sec.: 7. Print.

———. "Blowing the Pixie Dust off Disney's Archive." *New York Times* 9 Sept. 2009: C1, C5. Print.

BIBLIOGRAPHY

———. "A Hollywood Brawl: How Soon Is Too Soon for Video on Demand?" *New York Times* 20 Dec. 2010: B1, B5. Print.

———. "Warner Shifts Web Course, Shouldering Video Costs." *New York Times* 10 Sept. 2007. Web. 17 Sept. 2007.

Barrot, Pierre, ed. *Nollywood: The Video Phenomenon in Nigeria*. Bloomington: Indiana UP, 2008. Print.

Baudrillard, Jean. *The Illusion of the End*. Trans. Chris Turner. Stanford: Stanford UP, 1994. Print.

Bay, Willow. "Test Audiences Have Profound Effect on Movies." CNN.com with *Entertainment Weekly* 28 Sept. 1998. Web. 6 June 2010.

Bearman, Joshuah. "Can D.I.Y. Supplant the First-Person Shooter?" *New York Times Magazine* 15 Nov. 2009: 62–66. Print.

Bell, Gordon, and Jim Gemmell. *Total Recall: How the E-Memory Revolution Will Change Everything*. New York: Dutton, 2009. Print.

Beuker, Igor. "Farmville: The Hottest Land on Facebook?" *ViralBlog.com* 2 May 2010. Web. 4 May 2010.

Bianchi, Laurens. "All Facts and Figures about Instant Messaging." *ViralBlog.com* 27 Apr. 2010. Web. 4 May 2010.

———. "Newest Social Media Hype on Mobile: PING!" ViralBlog.com 15 Apr. 2010. Web. 4 May 2010.

Bierly, Mandi. "Betty White's TV Land Pilot: The Closest We'll Get to a New *Golden Girls*." *EW.com* 1 Jan. 2010. Web. 5 May 2010.

Biggs, John. "The Pluses, and Oddities, of 3-D TV." *New York Times* 4 Feb. 2010: B9. Print.

Bindra, Ashok. "MIT Researchers Demonstrate 100 Times Faster Internet While Consuming Less Energy." *Intermedia Hosted Exchange Community* 7 July 2010. Web. 7 July 2010.

Birdie. "More Independent Bookstores Closing." *Librarian and Information Science News* 28 Apr. 2005. Web. 2 July 2009.

Biskind, Peter. *Down and Dirty Pictures: Miramax, Sundance and the Rise of Independent Film*. New York: Simon and Schuster, 2004. Print.

Bloch, Ethan. "How Are Mobile Phones Changing Social Media?" *Flowtown* 30 Mar. 2010. Web. 4 May 2010.

Bloom, Julie. "You at Home, Put a Viral Spin on It." *New York Times* 30 Apr. 2010: AR10, AR16. Print.

Borenstein, Seth. "One Giant Misstep for NASA." *Lincoln Journal Star* 17 July 2009: A1–A2. Print.

Boucher, Geoff. "Alan Moore on *Watchmen* Movie: 'I Will Be Spitting Venom All over It.'" *Los Angeles Times* 18 Sept. 2008. Web. 8 July 2010.

———. "*The Wolfman* Finally Gets a Chance to Howl." *Los Angeles Times* 12 Feb. 2010. 30 Apr. 2010. Web.

Boulenger, Gilles. *John Carpenter: Prince of Darkness*. Beverly Hills: Silman-James, 2003. Print.

Bowles, Scot. "Flip Through This Rough Guide to Cameron's *Avatar*-land." *USA Today* 20 Dec. 2009. Web. 30 Apr. 2010.

———. "3-D: The Next Generation." *USA Today* 14 Mar. 2008: E1–E2. Print.

Bradshaw, Peter, Xan Brooks, Molly Haskell, Derek Malcolm, Andrew Pulver, B. Ruby Rich, and Steve Rose. "The World's 40 Best Directors." *Guardian* 14 Nov. 2003. Web. 1 June 2010.

Brew, Simon. "75 Movie Remakes and Reboots Currently in the Works." *Den of Geek* 2 Apr. 2010. Web. 23 Nov. 2010.

Brooke, Simon. "Animal Cruelty Films on YouTube." *Times Online* 19 Aug. 2007. Web. 31 Dec. 2007.

Brooks, Ian. "Is James Cameron's 3-D Movie *Avatar* the Shape of Cinema to Come?" *Guardian* 20 Aug. 2009. Web. 31 May 2010.

Browne, Nick, ed. *Refiguring American Film Genres: History and Theory.* Berkeley: U of California P, 1998. Print.

Bryner, Jeanna. "Today's College Kids Lack Empathy: Compared to 30 Years Ago, It's All about Me, Study Finds." *MSNBC.com* 28 May 2010. Web. 31 May 2010.

Bryner, Michelle. "*Star Wars*-like Holograms Nearly a Reality." *MSNBC.com* 2 Nov. 2010. Web. 2 Nov. 2010.

Buchanan, Kyle. "Bret Easton Ellis on *American Psycho*, Christian Bale and His Problem with Women Directors." *Movieline* 18 May 2010. Web. 24 May 2010.

Bunn, Austin. "Machine Age." *Village Voice* 4 Aug. 1998: 27. Print.

Buñuel, Luis. "Pessimism." *An Unspeakable Betrayal: Selected Writings of Luis Buñuel.* Trans. Garrett White. Berkeley: U of California P, 1995. 258-63. Print.

———, with Jean-Claude Carrière. *My Last Sigh.* New York: Vintage, 1984. Print.

Caine, Michael. *Acting in Film.* New York: Applause, 1990. Print.

Cairns, David. "Intertitle of the Week: The Ninth Day." *Shadowplay* 20 Sept. 2009. Web. 31 May 2010.

Carr, David. "A Hollywood Blogger Feared Not by Starlets, but Executives." *New York Times* 17 July 2009: A1, A3. Print.

Carr, Nicholas. "The Price of Free." *New York Times Magazine* 19 Nov. 2009: 26-27. Print.

Carter, Bill, and Brian Stelter. "CBS Cancels *As the World Turns*, Procter and Gamble's Last Soap Opera." *New York Times* 9 Dec. 2009: C1, C6. Print.

Carter, Kelly L. "Will This Be the First $5 Billion Summer at the Box Office?" *CNN.com* 11 May 2010. Web. 13 May 2010.

Carvajal, Doreen. "The New Video Arcade in Spain Might Be the Movie Theater." *New York Times* 26 Feb. 2007: C4. Print.

Case, Sue Ellen, Philip Brett, and Susan Leigh Foster, eds. *Cruising the Performative: Interventions into the Representation of Ethnicity, Nationality, and Sexuality.* Bloomington: Indiana UP, 1995. Print.

Casey, Laura. "Video Résumés Can Launch a Job, College Career." *Contra Costa Times* 28 Apr. 2010. Web. 9 May 2010.

Cashmore, Pete. "Woman Arrested for Facebook Poke." *Mashable.* 10 Oct. 2009. Web. 4 May 2010.

Catsoulis, Jeannette. "Geriatric Delinquents, Rampaging through Suburbia." *New York Times* 12 May 2010. Web. 13 May 2010.

"Center Tries to Treat Web Addicts" *New York Times* 6 Sept. 2009: 17. Print.

Chen, Gina. "Women Use Social Media More Than Men: What's News Orgs Response?" *Nieman Journalism Lab* 5 Oct. 2009. Web. 2 May 2010.

Cieply, Michael. "The Afterlife Is Expensive for Digital Movies." *New York Times* 23 Dec. 2007. Web. 26 Dec. 2007.

———. "Resistance Forms against Hollywood's 3-D Push." *New York Times* 2 Aug. 2010. Web. 9 Aug. 2010.

Cieply, Michael, and Brooks Barnes. "Americans Flock to the Movies, Seeking a Silver-Screen Lining." *New York Times* 1 Mar 2009: 1, 16. Print.

Cieply, Michael, with Bill Carter and Colin Moynihan. "Writers Reach Tentative Deal with Producers." *New York Times* 10 Feb. 2008. Web. 13 Feb. 2008.

Clark, Josh. "Narcissism Epidemic Spreads among College Students." *Discovery News* 23 Mar. 2010. Web. 4 May 2010.

Coates, Paul. *Film at the Intersection of High and Mass Culture.* New York: Cambridge UP, 1994. Print.

Cocteau, Jean. *The Art of the Cinema.* Trans. Robin Buss. London: Boyars, 2001. Print.

Cohen, Noam. "Through Soldiers' Eyes, 'The First YouTube War.'" *New York Times* 23 May 2010. Web. 12 Nov. 2010.

Colker, David. "Facebook Fights Back, Disallows the Suicide Machine." *Los Angeles Times* 4 Jan. 2010. Web. 30 Apr. 2010.

Cook, David A. *A History of the Narrative Film.* 3rd ed. New York: Norton, 1996. Print.

Crary, David. "Study: College Students More Narcissistic." *Boston.com News* 27 Feb. 2007. Web. 4 May 2010.

Cringeley, Robert X. "Facebook's Anti-Privacy Backlash Gains Ground." *PC World* 7 May 2010. Web. 7 May 2010.

Curtis, David. *Experimental Cinema.* New York: Universe, 1971. Print.

Dargis, Manohla. "Declaration of Indies: Just Sell It Yourself!" *New York Times* 17 Jan. 2010. Web. 30 Apr. 2010.

———. "Stars or Not, Cannes Finds Glamour." *New York Times* 14 May 2010: C1, C14. Print.

———. "Thai Filmmaker Wins Palme d'Or at Cannes." *New York Times* 24 May 2010: C1, C5. Print.

Dargis, Manohla, and A. O. Scott. "Exploring New Routes to the Indies." *New York Times* 13 Sept 2009, Arts and Leisure sec.: 35, 54. Print.

Debord, Guy. *The Society of the Spectacle.* Trans. Donald Nicholson-Smith. New York: Zone, 1995. Print.

de Botton, Alain. "On Distraction." *City Journal* (Spring 2010). Web. 6 June 2010.

Delpeut, Peter, dir. and writer. *The Forbidden Quest.* Amsterdam: Ariel Film and KRO Television, 1993. Film.

———. *Lyrical Nitrate.* Amsterdam: Yuca Film and Nederlands Filmmuseum, 1991. Film.

Denby, David. "Big Pictures: Where Are the Movies Heading?" *New Yorker* 8 Jan. 2007: 54–63. Print.

Desautels, Edward. "Long on Face, Short on Book," *Maximum Friction* 8 Apr. 2009. Web. 30 Apr. 2010.

Desowitz, Bill. "Fede Alvarez Talks *Panic Attack!*" *Animation World Network.* 16 Apr. 2010. Web. 4 May 2010.

Di Orio, Carl. "Europe Digital Cinema Rollout Hung Up on Funding: Exhibitors Air Frustrations at Annual Cinema Expo Confab." *Film Journal* 22 June 2009. Web. 30 Apr. 2010.

———. "Palace Cinemas to Get Total Digital Overhaul." *Film Journal* 23 June 2009. Web. 30 Apr. 2010.

"Director Ronald Neame Dies Aged 99." *BBC News* 18 June 2010. Web. 18 June 2010.

Ditzian, Eric. "*Clash of the Titans* Begs the Question: Does 3-D Quality Matter?" *MTV News* 15 Apr. 2010. Web. 30 Apr. 2010.

———. "*Iron Man 2* Pulls in $7.5 Million at Midnight Screenings." *MTV Movie News* 7 May 2010. Web. 7 May 2010.

———. "Ridley Scott Plans User-Generated YouTube Documentary." *MTV News* 7 July 2010. Web. 7 July 2010.

Dixon, Wheeler Winston. "Twenty-five Reasons Why It's All Over." *The End of Cinema As We Know It.* New York: New York UP, 2001. 356–66. Print.

Doherty, Thomas. "The Death of Film Criticism." *Chronicle of Higher Education* 28 Feb. 2010. Web. 1 May 2010.

Downey, Kevin. "Hollywood Ending: Test Screenings Put Films to the Test." *Change Agent* (Apr. 2004). Web. 6 June 2010.

"Dr. Horrible's Sing-Along Blog." *Wikipedia.* Web. 8 Apr. 2009.

Drummond, Katie. "Pentagon Looks to Breed Immortal 'Synthetic Organisms,' Molecular Kill-Switch Included." *Wired* 5 Feb. 2010. Web. 30 Apr. 2010.

Dubner, Stephen J. "Steven the Good." *New York Times Magazine* 14 Feb. 1999. Web. 30 Apr. 2010.

Dwyer, Jim. "Four Nerds and a Cry to Arms against Facebook." *New York Times* 12 May 2010: A19. Print.

Ebert, Roger. "Death to the Film Critics! Hail to the CelebCult!" *Chicago Sun Times* 26 Nov. 2008. Web. 1 May 2010.

———. "The Golden Age of Movie Critics." *Chicago Sun Times* 30 Apr. 2010. Web. 17 May 2010.

———. "*Variety:* This Thumb's for You." *Chicago Sun Times* 9 Mar. 2010. Web. 1 May 2010.

———. "Why I Hate 3-D (and You Should Too)." *Newsweek* 29 Apr. 2010. Web. 30 Apr. 2010.

Edwards, Cliff, and Sarah Rabil. "Netflix Surges on Streaming-Only Option, DVD Price Increase." *Bloomberg News* 22 Nov. 2010. Web. 22 Nov. 2010.

Egan, Maura. "Screen Savers." *New York Times Style Magazine* 13 Sept. 2009: 54. Print.

eHow. "How to Poke a Friend on Facebook." Web. 2 May 2010.

Ehrenreich, Ben. "Jaron Lanier: Loss of the Virtual Dream." *Los Angeles Times* 10 Jan. 2010. Web. 30 Apr. 2010.

Ehrlich, Brenna. "Betty White to Appear on SNL, Facebook Fans Rejoice." *Mashable* 8 Apr. 2010. Web. 4 May 2010.

Ehrlich, Linda C., and David Desser, eds. *Cinematic Landscapes: Observations on the Visual Arts and Cinema and Japan.* Austin: U of Texas P, 1994. Print.

Eisenberg, Anne. "The Ever-Widening World of Tiny Projectors." *New York Times* 9 May 2010, Business sec.: 3. Print.

———. "Inside These Lenses, a Digital Dimension," *New York Times* 26 Apr. 2009: B4. Print.

———. "When a Camcorder Becomes a Life Partner." *New York Times* 6 Nov. 2010. Web. 30 Nov. 2010.

Elfman, Mali. "Interview with Kathryn Bigelow for *The Hurt Locker.*" *Screencrave.com* 23 June 2009. Web. 30 Apr. 2010.

Eller, Claudia, and Dawn C. Chmielewski. "Not Even Bruckheimer Movies Can Escape Budget Cuts" *Los Angeles Times* 3 May 2010. Web. 13 May 2010.

Evangelista, Benny. "Poll: Relationship and Cultural Attitudes Shift in 25 Years of Dot Com Life." *Technology Chronicles* 24 May 2010. Web. 31 May 2010.

Evans, Joel. "iPhone Kindle Reader Gets Audio and Video Playback." *ZDNet* 28 June 2010. Web. 28 June 2010.

Everett, Anna. "Africa, the Diaspora, Cinema and Cyberspace: Are We Ready for the 21st Century?" *Screening Noir* (Spring 1995): 1, 10. Print.

"Facebook Privacy Settings to Be Made Simpler." *BBC News* 25 May 2010. Web. 27 May 2010.

"Featured Web Sites." *IP Video Curator*. Web. 1 May 2010.

"The 15 Worst Celebrity Plastic Surgery Disasters You Will Ever See." *Top Socialite.com* 27 Sept. 2007. Web. 30 Apr. 2010.

"Film. No Compromise." Kodak advertisement. *Filmmaker* (Fall 2008): 3. Print.

Finke, Nikki. "The End of Movie Theaters? FCC Will Allow Studios to Send First-Run Films Directly to Consumers Over Secure TV." *Deadline Hollywood* 7 May 2010. Web. 13 May 2010.

———. "It's a Bird! It's a Plane! It's Chris Nolan! He'll Mentor *Superman* 3.0 and Prep 3rd *Batman*." *Deadline Hollywood* 9 Feb. 2010. Web. 30 Apr. 2010.

———. "19.7 Million *Avatar* Blu-ray and DVDs Sold." *Deadline Hollywood* 11 May 2010. Web. 18 May 2010.

Fischbach, Bob. "Will They Still Call Them Films?" *Omaha World Herald* 11 Oct. 2007: E1, E2. Print.

Fischer, Russ. "FCC Will Allow Movie Studios to Broadcast Directly to Your Home: What Does This Mean for Theaters?" *Slashfilm.com* 7 May 2010. Web. 13 May 2010.

Fisher, Bob. "Man Eater." *International Cinematographers Guild Magazine* (Mar. 2010): 52–59. Print.

Fleeman, Michael. "Film: The End of an Era." *Classic Images* (May 1999): 50. Print.

Fleming, Mike. "Legal Wrangle: More Research Films OTX and Screen Engine Square Off in Court." *Deadline Hollywood* 25 Mar. 2010. Web. 6 June 2010.

Florence, Penny, and Dee Reynolds, eds. *Feminist Subjects, Multi-Media, Cultural Methodologies.* Manchester: Manchester UP, 1995. Print.

Foresman, Chris. "3D High-Def Movies Coming to Your Living Room on Blu-ray." *Arstechnica.com* 20 Dec. 2009. Web. 30 Apr. 2010.

"Formspring.me: The Sociopathic Crack Cocaine of Oversharing." *Gawker.com* 3 Jan. 2010. Web. 13 May 2010.

Frankel, Daniel. "And the Winner Is . . . Facebook." *Wrap* 8 Oct. 2009. Web. 30 Apr. 2010.

———. "Friends of Facebook: Studio Marketers." *Wrap* 8 Oct. 2009. Web. 30 Apr. 2010.

———, and Sharon Waxman. "*Variety* Drops Chief Film and Theater Critics." *Wrap* 8 Mar. 2010. Web. 1 May 2010.

French, Cameron. "Filmmakers Eye Web, TV as Alternate to Theaters." *Reuters* 23 Jan. 2010. Web. 30 Apr. 2010.

Friend, Tad. "The Cobra: Inside a Movie Marketer's Playbook." *New Yorker* 19 Jan. 2009: 41–49. Print.

Fritz, Ben. "Amazon.com Going into Movie Producing with New Website, First Look at Deal with Warner Bros." *Los Angeles Times* 16 Nov. 2010. Web. 17 Nov. 2010.

———. "Viacom Bets Big on the Beatles." *Lincoln Journal Star* 6 Sept. 2009: C1–C2. Print.

Front page. *Ain't It Cool News* 13 May 2010. Web. 17 May 2010.

Gabler, Neal. "The End of the Middle." *New York Times Magazine* 16 Nov. 1997: 76–78. Print.

Gardner, Nic. "New Tech: Are Too Many 1's and 0's Leaving Us Soulless?" *International Cinematographer's Guild Magazine* (Apr. 2009): 66–68. Print.

Garrahan, Matthew. "Hollywood Braced for Budget Cuts." *FT.com* 6 Oct. 2009. Web.
30 Apr. 2010.

Gaudiosi, John. "3-D: The Next Leap in Video Games." *USA Weekend* 18–20 Dec. 2009:
11. Print.

Gaylord, Chris. "*Avatar* DVD and Blu-ray Smash Sales Records." *Christian Science Monitor*
26 Apr. 2010. Web. 1 May 2010.

Gilsdorf, Ethan. "Role Playing Games Pull Reluctant School Kids into a Supportive
Crowd." *Christian Science Monitor* 9 Apr. 2010. Web. 4 May 2010.

———, and Jacob Shafer. "The Escapism Nation: Is Escapism Bad For Us?" *Mauitime*
2 Jan. 2010. Web. 4 May 2010.

Giroux, Henry A. *Disturbing Pleasures: Learning Popular Culture.* New York: Routledge,
1994. Print.

Gladwell, Malcolm. "The Formula: What If You Built a Machine to Predict Hit Mov-
ies?" *New Yorker* 16 Oct. 2006. Web. 30 Apr. 2010.

Goldman, Michael. "Going Tapeless." *Digital Content Producer.com.* Web. 31 Dec. 2007.

Goldstein, Patrick. "*Avatar* Arouses Conservatives' Ire." *Los Angeles Times* 5 Jan. 2010.
Web. 30 Apr. 2010.

———. "Is This a Box-Office Record with an * ?" *Los Angeles Times* 30 Jan. 2010. Web.
30 Apr. 2010.

Goodell, Gregory. *Independent Feature Film Production: A Complete Guide from Concept to Distribu-
tion.* New York: St. Martin's, 1982. Print.

"Google Closes $A2B YouTube Deal." *The Age.com.au* 14 Nov. 2006. Web. 31 Dec.
2007.

Greenfieldboyce, Nell. "Scientists One Step Closer to Holographic Movies." NPR 8 Feb.
2008. Web. 7 June 2010.

Grimes, William. "Max Palvesky, 85, A Pioneer in Computers." *New York Times* 7 May
2010: B13. Print.

Gronlund, Melissa. "Artfilm's New Haven." *Sight and Sound* (Jan. 2007): 29. Print.

Grover, Ron. "300's Lessons for Hollywood." *Business Week* 9 Apr. 2007. Web. 30 Apr.
2010.

Gunther, Marc. "Fox the Day After Tomorrow." *CNN Money* 17 May 2006. Web.
30 Apr. 2010.

Haberstam, Judith, and Ira Livingston, eds. *Posthuman Bodies.* Bloomington: Indiana UP,
1995. Print.

Hakkenberg, Mireille. "Nikon—the World's First Projector Camera." *ViralBlog.com*
7 Oct. 2009. Web. 4 May 2010.

Hale, Mike. "A Parallel Universe to TV and Movies." *New York Times* 12 Nov. 2010.
Web. 14 Nov. 2010.

Handy, Bruce. "How 3-D Lost Its Wow." *New York Times* 23 Nov. 2008, Week in Re-
view: WK5. Print.

Harley, David. "*Monsters*: Director Gareth Edwards." *Bloody Disgusting.com.* Web. 30 Nov.
2010.

Harrison, Ian. *The Book of Lasts.* London: Octopus, 2005. Print.

"Harry Knowles." *Wikipedia.* Web. 18 May 2010.

Harwitz, Matt. "Bad Moon Rising." *International Cinematographers Guild Magazine* (Feb.
2010): 30–39. Print.

Hayden, Erik. "Netflix Aims to Finish Off the DVD." *Atlantic Wire* 23 Nov. 2010. Web.
28 Nov. 2010.

BIBLIOGRAPHY

Hayes, R. M. *3-D Movies: A History and Filmography of Stereoscopic Cinema.* Jefferson, NC: McFarland, 1989. Print.

Heffernan, Virginia. "The Death of the Open Web." *New York Times Magazine* 23 May 2010: 16–17. Print.

———. "The Medium: Artists Only; *Quarterlife.*" *New York Times Magazine* 23 Dec. 2007. Web. 26 Dec. 2007.

———. "Uploading the Avant-Garde." *New York Times Magazine* 3 Sept. 2009. Web. 30 Apr. 2010.

Helft, Miguel. "Critics Say Google Invades Privacy with New Service." *New York Times* 13 Feb. 2010. Web. 30 Apr. 2010.

Hendrix, Grady. "The Blockbusters of China." *Slate* 6 July 2009. Web. 2 May 2010.

Hernandez, Eugene. "Welcome Todd McCarthy!" *Indiewire* 30 Apr. 2010. Web. 25 May 2010.

Heuring, David. "Matt Weiner." *International Cinematographer's Guild Magazine* (Feb. 2009): 24–26. Print.

Hirschberg, Lynn. "Core Values." *New York Times Magazine* 6 Dec. 2009. Web. 30 Apr. 2010.

———. "The Man Who Changed Everything." *New York Times Magazine* 16 Nov. 1997: 112–116. Print.

———. "The Self-Manufacture of Megan Fox." *New York Times Magazine* 15 Nov. 2009: 56–61, 68. Print.

"The History and Development of Holography." *Holophile.* Web. 7 June 2010.

Holson, Laura M. The Tell-All Generation Learns to Leave Some Things Offline." *New York Times* 9 May 2010: 1, 4. Print.

Honeycutt, Kirk. "How I Ended This Summer—Film Review." *Hollywood Reporter* 17 Feb. 2010. Web. 8 May 2010.

Hope, Ted. "Indie Film Is Dead." *Filmmaker* (Fall 1995): 18, 54–58. Print.

Hopkins, Jim. "Surprise! There's a Third YouTube Co-Founder." *USA Today Online* 11 Oct. 2006. Web. 31 Dec. 2007.

Horn, John. "The Film That Jolted Spielberg into 'Yes.'" *Kansas City Star* 11 Oct. 2009. Web. 30 Apr. 2010.

———, with Juliette Funes. "*Transformers* Director Michael Bay As Audience Darling." *Los Angeles Times* 29 June 2009. Web. 30 Apr. 2010.

Horowitz, Josh. *The Mind of the Modern Moviemaker: 20 Conversations with the New Generation of Film Makers.* New York: Plume, 2006. Print.

Hruska, Joel. "Movie Industry Eyeing 3D Movies for Home Theater." *Ars technica.com* 22 July 2008. Web. 30 Apr. 2010.

"Hulu." *Wikipedia.* Web. 8 Apr. 2009.

"The Independent Filmmaker: How to Make It Big in Hollywood, Baby!" *Film Industry Bloggers* 21 Aug. 2008. Web. 30 May 2010.

Ingersoll, Minnie, and James Kelly. "Think Big with a Gig: Our Experimental Fiber Network." *Official Google Blog* 10 Feb. 2010. Web. 5 May 2010.

"International Box Office Results by Country." *Box Office Mojo International* 20 Apr. 2010. Web. 1 May 2010.

Internet Archive. Web. 9 Sept. 2007.

"Is 3-D TV Hazardous to Your Health?" *New York Post* 14 Apr. 2010. Web. 31 May 2010.

"It's the Story, Stupid," *Newsweek* 21 Dec. 2009. Web. 30 Apr. 2010.

BIBLIOGRAPHY

Jac. "Samsung Issue Health Warning about 3-D TV." *Geek with Laptop* 17 Apr. 2010. Web. 31 May 2010.

Jacobs, Gina. "Narcissism Epidemic Spreading among College Students." *SDS Universe News* 21 Apr. 2009. Web. 4 May 2010.

Jin-seo, Cho. "Phone to Carry Video Projector." *Korea Times* 13 Apr. 2006. Web. 14 Jan. 2007.

Jonas, Susan, and Marilyn Nissenson. *Going Going Gone: Vanishing Americana*. San Francisco: Chronicle, 1994. Print.

Jones, Charisse. "Princess Tíana Joins Disney Royal Family." *USA Today* 16 Feb. 2009: 4B. Print.

Juhasz, Alexandra. "Learning the Five Lessons of YouTube: After Trying to Teach There, I Don't Believe the Hype." *Cinema Journal* (Winter 2009): 145–150. Print.

Kafka, Peter. "Time Warner Cable Shows Subscribers How to Cut the Cord." *Media Memo* 31 Dec. 2009. Web. 30 Apr. 2010.

Kakutani, Michiko. "Designer Nihilism." *New York Times Magazine* 24 Mar. 1996: 30, 32. Print.

Kastelein, Richard. "Netflix Streaming-Only Subscriptions in the Pipeline, but It Will Cost Them." *AppMarket* 29 Oct. 2010. Web. 28 Nov. 2010.

Kaufman, Anthony. "French Film *est mort*? *Non*! The Next Wave." *Indie* (July–Aug. 1998): 15, 17. Print.

———. "Is Foreign Film the New Endangered Species?" *New York Times* 22 Jan. 2006. Web. 2 May 2010.

Kaufman, Debra. "Jon Landau," *International Cinematographers Guild Magazine* (Mar. 2010): 18, 20. Print.

———. "One Wild Tea Party." *International Cinematographers Guild Magazine* (Mar. 2010): 38–43. Print.

Kawin, Bruce. *Telling It Again and Again: Repetition in Literature and Film*. Boulder: UP of Colorado, 1989. Print.

Keen, Andrew. *The Cult of the Amateur: How Today's Internet Is Killing Our Culture*. New York: Broadway, 2007. Print.

Kehr, David. "Film Riches, Cleaned Up for Posterity." *New York Times* 15 Oct. 2010: C2. Print.

———. "3-D's Quest to Move beyond Gimmicks." *New York Times* 10 Jan. 2010. Web. 30 Apr. 2010.

Keller, Craig, trans. "Jean-Luc Godard Speaks with Daniel Cohn-Bendit: A Smile That Dismisses the Universe." *Cinemasparagus* 16 May 2010. Web. 24 May 2010.

Kellner, Douglas. *Media Culture: Cultural Studies, Identity and Politics Between the Modern and Postmodern*. London: Routledge, 1995. Print.

Kelly, Cathal. "YouTube Short Leads to $30M Hollywood Deal." *The Star.com* 17 Dec. 2009. Web. 4 May 2010.

Kershaw, Sarah. "Google Tells Sites for 'Cougars' to Go Prowl Elsewhere." *New York Times* 16 May 2010, Style sec.: 12. Print.

Kiley, Brendan. "Ten Things Theatres Need to Do Right Now to Save Themselves." *Stranger.com* 30 Apr. 2009. Web. 30 Apr. 2010.

Kincaid, Jason. "On Formspring.me, Anyone Can Ask You Anything. And You'll Love It." *Techcrunch.com* 4 Jan. 2010. Web. 13 May 2010.

"Kinetoscope." *Wikipedia*. Web. 9 Sept. 2007.

Kinyanjui, Kui. "End of Era for Film As Kodak Gives Way to Digital Imaging." *Business Daily* 1 July 2009. Web. 30 Apr. 2010.

Kirbey, Jeremy. "Feel Like Screaming! Check Out the New Interactive Movie Theater." *Standard* 16 Mar. 2007. Web. 30 Apr. 2010.

Kirkpatrick, Marshall. "Poll: US Attitudes about Internet Are Insane." *ReadWrite Web* 25 Oct. 2007. Web. 31 May 2010.

Kit, Borys. "*Titans* Director Underwhelmed by 3D Conversion." *Reuters* 5 Apr. 2010. Web. 30 Apr. 2010.

Klawans, Stuart. "Summer Celluloid Meltdown II: The Sequel." *Nation* 9 Sept. 1991: 276–279. Print.

Klinger, Barbara. *Beyond the Multiplex: Cinema, New Technologies and the Home.* Berkeley: U of California P, 2006. Print.

Knowles, Harry. "Harry's DVD Picks & Peeks: 1st Wk of May 2010: *Doctor Zhivago* and Some Other Stuff." *Ain't It Cool News* 4 May 2010. Web. 18 May 2010.

———. "Harry Says *Serbian Film* Will Be the Best Film You Won't Likely See in Theaters This Year!" *Ain't It Cool News* 8 Apr. 2010. Web. 18 May 2010.

———. "Harry Says That *The Hurt Locker* Is the Better Military and Robot Film This Weekend." *Ain't It Cool News* 24 June 2009. Web. 3 June 2010.

Koning, Dirk. "No Sex, Please: Congress and the Courts Threaten Censorship of Cable Access, Internet." *Independent* (Dec. 1995): 6, 7. Print.

Kopytoff, Verne G. "A Cheaper Plan at Netflix Offers Films for Online Only." *New York Times* 23 Nov. 2010: B2. Print.

Kozlov, Vladimir. "Russian Films 2010 Preview." *Passport* (Feb. 2010). Web. 8 May 2010.

"Kristen Stewart Calls Rape Remark 'Enormous Mistake.'" *ABC News* 4 June 2010. Web. 6 June 2010.

"Kristen Stewart: Fame Is Like Being 'Raped.'" *US Weekly* 2 June 2010. Web. 6 June 2010.

Kulish, Nicholas. "Author, 17, Says It's 'Mixing,' Not Plagiarism." *New York Times* 12 Feb. 2010. Web. 30 Apr. 2010.

Lane, Anthony. "Third Way: The Rise of 3-D." *New Yorker* 8 Mar. 2010: 68–74. Print.

Lanier, Jaron. *You Are Not a Gadget.* New York: Knopf, 2010. Print.

Lasar, Matthew. "Can We Have Fair Use without Fair Use Technology?" *Arstechnica.com* 14 May 2010. Web. 18 May 2010.

Lasch, Christopher. *The Culture of Narcissism: American Life in an Age of Diminishing Expectations.* New York: Norton, 1978. Print.

Lee, Nathan. "Nollywood Babylon." *New York Times* 3 July 2009: C6. Print.

Lee, Nathan, Kent Jones, and Paul Arthur. "Movies That Mattered." *Film Comment* (Jan.–Feb. 2007): 38–39. Print.

Leopold, Todd. "Are Social Media Killing Film Criticism?" *CNN.com* 7 May 2010. Web. 8 May 2010.

———. "*Money Never Sleeps* Could Be the Motto of Sequels." *CNN.com* 13 May 2010. Web. 18 May 2010.

Leupp, Thomas. "Summer Movie Guide 2010: Eight Burning Questions." *Hollywood.com* 7 May 2010. Web. 13 May 2010.

Levins, Hoag. "Imagining a World of Interactive Movie Theatres." *Advertising Age* 18 Aug. 2008. Web. 1 July 2009.

Levy, Emanuel. *Cinema of Outsiders: The Rise of Independent Film.* New York: New York UP, 2001. Print.

Lewin, Tamar. "Teenage Insults Scrawled on Web, Not on Walls." *New York Times* 5 May 2010. Web. 13 May 2010.

Lewis, Jon. "Independence in Contemporary Hollywood," *Filmreference.com.* Web. 1 June 2010.

———. *The Road to Romance and Ruin: Teen Films and Youth Culture.* New York: Routledge, 1992. Print.

Lieberman, David. "Credit Freeze Stunts 3-D Films' Growth." *USA Today* 20 Nov. 2009: B1. Print.

Lifetime Staff. "Lifetime and Mary Kay Announce Media and Marketing Partnership for Hit Series." *MyLifetime.com* 5 June 2009. Web. 2 May 2010.

Lohr, Steve. "Now Playing: Night of the Living Tech." *New York Times* 21 Aug. 2010. Web. 23 Aug. 2010.

Lord, Rosemary. *Hollywood Then and Now.* San Diego: Thunder Bay, 2003.

Lumenick, Lou. "Woody: I'm Done Wooing." *New York Post* 16 May 2010. Web. 24 May 2010.

Lynch, Mark. "What If Hollywood Doesn't Survive As a Global Player?" *Wrap* 20 Apr. 2010. Web. 2 May 2010.

MacCauley, Scott. "Creative Destruction." *Filmmaker* (Fall 2008): 106–111, 129–131. Print.

———. "The Numbers Game: An Interview with Darren Aronofsky and Eric Watson." *Filmmaker* (Summer 1998): 26–30. Print.

Maddow, Ben. "Acts of Friendship." *Gerard Malanga: Screen Tests, Portraits, Nudes, 1964–1996.* Ed. Patrick Remy and Marc Parent. Göttingen: Steidl, 2000. 120–25. Print.

Magary, Drew. "Conservatives Hate *Avatar*, Peaceful Blue Aliens." *NBC San Diego.com* 5 Jan. 2010. Web. 30 Apr. 2010.

Maine, Charles Eric. *Escapement.* London: Hodder and Stoughton, 1956. Print.

Malkin, Marc. "Neil Patrick Harris on Betty White: 'I'm Getting Physically Aroused.'" *E! Online* 2 June 2009. Web. 5 May 2010.

Markoff, John. "Fight of the (Next) Century: Converging Technologies Put Sony and Microsoft on a Collision Course." *New York Times* 7 Mar. 1999, sec. 3: 1, 11. Print.

Martin, Joe. "Four Percent of Gamers Play for 50 Hours a Week." *Bit-Tech-Net* 28 May 2010. Web. 29 May 2010.

Martin, Kevin H. "The 3rd Dimension." *International Cinematographers Guild Magazine* (Apr. 2009): 52–55. Print.

Mathews, Jack. "Movies at the Cutting Edge." *New York Daily News* 11 Apr. 1999, New York Now sec: 2. Print.

McCabe, Joseph. "Exclusive: We Chat with Hammer Chief Simon Oakes about Christopher Lee's Return to Horror and the *Let the Right One In* Remake!" *FEARnet* 3 July 2009. Web. 2 May 2010.

McCarthy, Caroline. "Do Facebook's New Privacy Settings Let It off the Hook?" *CNET News* 26 May 2010. Web. 27 May 2010.

McClean, Shilo T. *Digital Storytelling: The Narrative Power of Visual Effects in Film.* Cambridge: MIT, 2007. Print.

McCormick, James. "FCC Allows Hollywood to Send Their New Movies Straight to Your Home." *Criterion Cast* 7 May 2010. Web. 13 May 2010.

MCN Staff. "Major Market Launches Lift Lifetime Movie Network to 75 Million Homes." *Multichannel News Service* 31 Jan. 2010. Web. 2 May 2010.

Means, Sean P. "The Departed: No. 65, Todd McCarthy." *Salt Lake Tribune* 9 Mar. 2010. Web. 17 May 2010.

"Megan Fox Being Replaced by Victoria's Secret Model in *Transformers.*" *Infotipguide.com* 5 June 2010. Web. 6 June 2010.

Merkin, Daphne. "The Aspirational Woman." *New York Times Magazine* 20 Dec. 2009: 30–37, 44, 46. Print.

Messier, Max. "Penelope Spheeris: Selling Her Soul for Cinema." *AMC Filmcritic.com* 19 Feb. 2002. Web. 24 June 2010.

"A Milestone Performance in Television Measurement." Ipsos Otx MediaCT press release, 11 May 2010. Web. 3 Dec. 2010.

Mollman, Steve. "For Online Addicts, Relationships Float Between Real, Virtual Worlds." *CNN.com* 29 Jan. 2008. Web. 4 May 2010.

Moody, Mike. "*Hurt Locker* Producers Sue Filesharers." *DigitalSpy.com* 2 June 2010. Web. 3 June 2010.

Morgan, Kim. "Michael Bay: The Exterminating Angel." *Huffington Post* 25 June 2009. Web. 30 Apr. 2010.

Mozes, Alan. "Today's College Students More Likely to Lack Empathy." *Bloomberg Business Week* 26 Apr. 2010. Web. 1 June 2010.

Mr. Beaks. "Kathryn Bigelow Talks *The Hurt Locker* with Mr. Beaks." *Ain't It Cool News* 26 June 2009. Web. 3 June 2010.

"MSNBC.com Goes Interactive in Movie Theaters." *Cyberjournalist.net* 10 May 2007. Web. 30 Apr. 2010.

Newcomb, Peter. "Hollywood's Top 40." *Vanity Fair* (Mar. 2010): 272–275. Print.

Nichols, Bill. *Blurred Boundaries: Questions of Meaning in Contemporary Culture.* Bloomington: Indiana UP, 1994. Print.

Nietzsche, Friedrich. *Ecce Homo.* Trans. R. J. Hollingdale. London: Penguin, 1992. Print.

Nolasco, Stephanie. "Betty White Draws Line With Judith & Marijuana But Hopes For Beer Pong Rematch on SNL." *Starpulse* 5 May 2010. Web. 5 May 2010.

Nolte, John. "James Cameron on Why He Might Lose the Oscar to Kathryn Bigelow: She's a Girl." *Big Hollywood* 22 Feb. 2010. Web. 2 May 2010.

The Northlander. "The Northlander Sits down with the Writer of *Let the Right One In.*" *Ain't It Cool News* 23 Oct. 2008. Web. 2 May 2010.

O'Brien, Geoffrey. *The Phantom Empire.* New York: Norton, 1993. Print.

———. "What Does the Audience Want?" *New York Times Magazine* 16 Nov. 1997: 110–11. Print.

Ogg, Erica. "Updated: Wal-Mart to Buy Vudu Video Service." *Circuit Breaker* 22 Feb. 2010. Web. 30 Apr. 2010.

Olsen, Mark. "From *Cloverfield* to *Let the Right One In.*" *Los Angeles Times* 21 June 2009. Web. 2 May 2010.

"Online Resources." *IP Video Curator.* Web. 30 Apr. 2010.

Orange, Michelle. "Taking Back the Knife: Girls Gone Gory." *New York Times* 6 Sept. 2009: 7, 8. Print.

Orden, Erica. "Sir, There's a Camera in Your Head." *Wall Street Journal* 16 Nov. 2010: A23. Print.

Page, Clarence. "One Very Big Thumbs Down: Balcony Closed, Idiot Floodgates Open." *Chicago Tribune* 14 Apr. 2010. Web. 25 May 2010.

BIBLIOGRAPHY

Papadopoulos, George. "What Audiences Want." *Senses of Cinema* (2001). Web. 1 May 2010.

Parisi, Paula. "The Trouble with Harry." *Hollywood Reporter* 24 Aug. 1999. *All Business.com* n.d. Web. 18 May 2010.

Patel, Nilay. "Google TV: Everything You Ever Wanted to Know." *Engadget* 21 May 2010. Web. 27 May 2010.

Paul, Donna. "In Michigan, Dream Factories Aim to Replace Auto Sites." *New York Times* 9 Sept. 2010: B6. Print.

Pavičić, Jurica. "Moving into the Frame: Croatian Film in the 1990s." *Central Europe Review* 15 May 2000. Web. 7 May 2010.

Pearlstein, Steven. "In Hollywood, Reshaping a Business Model That Emerged with the Talkies." *Washington Post* 27 Mar. 2009. Web. 30 Apr. 2010.

Peers, Martin. "Internet Killed the Video Star." *Wall Street Journal* 5 Feb. 2009: C10. Print.

Pierson, John. *Spike, Mike, Slackers and Dykes: A Guided Tour across a Decade of Independent Cinema.* New York: Hyperion, 1995. Print.

Poirier, John. "U.S. Approval Allows First-Run Movies to TV Sets." *Reuters* 7 May 2010. Web. 7 May 2010.

"Popular Film Channels around the World." *Google Answers* 27 Sept. 2006. Web. 1 May 2010.

Poster, Steven. "One World, Three Dimensions." *International Cinematographers Guild Magazine* (Mar. 2010): 6. Print.

Postman, Neil. *Amusing Ourselves to Death: Public Discourse in the Age of Show Business.* New York: Penguin, 1986. Print.

"Public Knowledge Disappointed with Media Bureau Ruling." *Public Knowledge* 7 May 2010. Web. May 7, 2010.

Qaddumi, Tammer. "Facebook Revolution in Egypt Ultimately Will Be Good for Capitalism." *Oil & Gas Journal* 2 Mar. 2011. Web. 4 Mar. 2011.

Rader, Dotson. "The Mixed-Up Life of Shía LaBeouf." *Parade* 14 June 2009: 4–5. Print.

Radosh, Daniel. "Can a Dose of Beatlemania Transform the Video Game?" *International Herald Tribune* 17 Aug. 2009: 1, 14. Print.

Rainer, Peter. "*Iron Man 2*: Review." *Christian Science Monitor* 7 May 2010. Web. 7 May 2010.

"Reconstructed Original Cut of Fritz Lang's *Metropolis* to Celebrate Its Premiere at the Berlinale 2010," press release for the 60the Internationale Filmfestspiele Berlin, 29 Oct. 2009. Web. 30 Apr. 2010.

RED Cameras. Web. 30 Apr. 2010.

Redhead, Steve. *Unpopular Cultures: The Birth of Law and Popular Culture.* Manchester: Manchester UP, 1995. Print.

"Reed Hastings Interview." *BBC Digital Revolution Blog* 7 Dec. 2009. Web. 30 Apr. 2010.

Reitan, Ed. "CBS Field Sequential Color System" (1997). *Novia.* Web. 30 Apr. 2010.

————. "RCA Dot Sequential Color System" (1997). *Novia.* Web. 30 Apr. 2010.

Renoir, Jean. "Memories." *Le Point* (Dec. 1938). *Jean Renoir* by André Bazin. New York: Simon and Schuster, 1973. 151–152. Print.

Ressner, Jeffrey. "The New Movie Extras." *USA Weekend* 27–29 Nov. 2009: 16. Print.

Rich, Motoko. "HarperCollins Buys Series from James Frey." *New York Times* 1 July 2009. Web. 30 Apr. 2010.

Richey, Warren. "Supreme Court Rejects Animal Cruelty Law, Upholds Free Speech." *Christian Science Monitor* 20 Apr. 2010. Web. 30 Apr. 2010.

Robey, Tim. "Shhhh: It's Secret Cinema." *Telegraph* 17 June 2010. Web. 28 June 2010.

Roddick, Nick. "Back to Basics." *Sight and Sound* (July 2010): 28–30. Print.

Rohrer, Finlo. "The Rise, Rise and Rise of the *Downfall* Hitler Parody." *BBC News* 13 Apr. 2010. Web. 30 Apr. 2010.

Rollins, Mark. "Is the Age of the Traditional Movie Theaters Over?" *Associated Content* 30 Apr. 2009. Web. 30 Apr. 2010.

Roper, Jonathan. "The Heart of Multimedia: Interactivity of Experience?" *Convergence* (Fall 1995): 23–28. Print.

Rosen, David. *Off-Hollywood: The Making and Marketing of Independent Film.* New York: Independent Feature Project; Burbank: Sundance Institute, 1987. Print.

Roumen, Matthijs. "Five Most Essential Social Media Infographics." *ViralBlog.com* 2 May 2010. Web. 4 May 2010.

Rudnick, Paul. "Fun with Nuns." *New Yorker* 20 July 2009: 37–41. Print.

Rushkoff, Douglas, and Rachel Dretzin. *Digital Nation* 2 Feb. 2010. Web. 30 Apr. 2010.

Russell, Jamie. "The Rules of the Game." *Sight and Sound* (Dec. 2009): 9. Print.

Russian Ark website. Web. 31 Dec. 2007.

Ryzik, Melena. "D.I.Y. Music Labels Embrace D.I.Y. Film." *New York Times* 20 Aug. 2010. Web. 23 Aug. 2010.

———. "Relationships and Other Possessions." *New York Times* 23 Apr. 2010. Web. 18 June 2010.

Salam, Reihan. "The Case against *Avatar.*" *Forbes.com* 21 Dec. 2009. Web. 30 Apr. 2010.

Sandoval, Greg. "Virgin's Music Stopped Paying Long Ago." *CNET News* 16 Mar. 2009. Web. 2 July 2009.

Schaefer, Eric. *Bold! Daring! Shocking! True! A History of Exploitation Films, 1919–1959.* Durham: Duke UP, 1999. Print.

Schiesel, Seth. "New in Gadgetry: 3-D Escapades without Glasses." *New York Times* 21 June 2010: C1, C7. Print.

———. "Way down Deep in the Wild, Wild West." *New York Times* 17 May 2010: C1, C6. Print.

Schonfeld, Erick. "Wipe the Slate Clean for 2010, Commit Web 2.0 Suicide." *TechCrunch* 31 Dec. 2009. Web. 30 Apr. 2010.

Schwartz, Mike. "CableLabs Develops 3D Test Support, Opens Laboratory for 3D TV Technology." *CableLabs News* 5 Jan. 2010. Web. 30 Apr. 2010.

Scott, A. O. "And You'll Be a Moviegoer, My Son." *New York Times* 5 Jan. 2007: B1, B22. Print.

Segal, David. "Royalty Clinging to Their Thrones." *International Herald Tribune* 17 Aug. 2009: 13. Print.

Seitz, Patrick. "Netflix Hits Record on Streaming Plan, By-Mail Rate Hikes." *Investor's Business Daily* 22 Nov. 2010. Web. 28 Nov. 2010.

Sells, Mark. "Judgment Day for Movie Theaters." *Moviemaker* 1 June 2007. Web. 30 Apr. 2010.

Seltzer, Mark. *Bodies and Machines.* New York: Routledge, 1992. Print.

Seymour, Gene. "Black Directors Look beyond Their Niche." *New York Times* 11 Jan. 2009, Arts and Leisure sec.: 11, 15. Print.

Shadid, Anthony. "In a Baghdad Cinema, Celebrating a Return of Iraqi Culture." *New York Times* 6 May 2010. Web. 7 May 2010.

Sharma, Richa. "Addicts of the Virtual World Could Have Behavioural Problems." *Entertainment Daily* 18 Apr. 2010. Web. 4 May 2010.

Shatkin, Elina. "Let's Get Provincial." *International Cinematographers Guild Magazine* (Dec. 2008): 67–80. Print.

Shaviro, Stephen. *The Cinematic Body.* Minneapolis: U of Minnesota P, 1993. Print.

Shears, Richard. "Botox Is Turning Nicole Kidman into a 'Bat Face,' Says Cosmetic Guru." *Daily Mail* 13 Mar. 2008. Web. 30 Apr. 2010.

Shefter, Milton, and Andy Maltz. *The Digital Dilemma: Strategic Issues in Archiving and Accessing Digital Motion Picture Materials.* Los Angeles: AMPAS, 2007. Print.

Shiels, Maggie. "Facebook Downplays Privacy Crisis Meeting." *BBC News* 14 May 2010. Web. 20 May 2010.

———. "Mr. Hollywood at CES: Katzenberg on 3D." *BBC News* 8 Jan. 2010. Web. 30 Apr. 2010.

———. "3D TV to Be 'Savior' of Industry." *BBC News* 8 Jan. 2010. Web. 30 Apr. 2010.

Siegel, Lee. *Against the Machine.* New York: Spiegel and Grau, 2009. Print.

Silberg, Jon. "Shawn Levy." *International Cinematographer Guild Magazine* (Apr. 2010): 18, 20. Print.

———. "Shooting Oscar." *International Cinematographers Guild Magazine* (Feb. 2009): 50–55. Print.

Silverstein, Melissa. "Guess What? Women Buy More Movie Tickets Than Men." *Huffington Post* 11 Mar. 2010. Web. 2 May 2010.

———. "What Is This, 1950? Women Are Missing As TV Creators." *Women and Hollywood.com* 29 Jan. 2010. Web. 2 May 2010.

Simon, Mallory. "HP Looking into Claims Webcams Can't See Black People." *CNN Tech* 23 Dec. 2009. Web. 30 Apr. 2010.

Singel, Ryan. "Facebook's Gone Rogue: It's Time for an Open Alternative." *Wired* 7 May 2010. Web. 13 May 2010.

Singer, Natasha. "Shoppers Who Can't Have Secrets." *New York Times* 2 May 2010, Business sec.: 5. Print.

Sisario, Ben. "Retailing Era Closes with Music Megastore." *New York Times* 15 June 2009. Web. 2 July 2009.

Skeggs, Beverly, ed. *Feminist Cultural Theory: Process and Production.* Manchester: Manchester UP, 1995. Print.

Smith, Daniel B. "Is There an Ecological Unconscious?" *New York Times* 3 Feb. 2010. Web. 30 Apr. 2010.

Smith, Ethan. "Thousands Are Targeted over *Hurt Locker* Downloads." *Wall Street Journal. com* 31 May 2010. Web. 3 June 2010.

Smith, Margaret. "Home." *Archiving Ubu* 5 May 2010. Web. 6 June 2010.

———. "Legal and Financial Issues." *Archiving Ubu* 5 May 2010. Web. 6 June 2010.

———. "UbuWeb: Film & Video." *Ubu.com.* Web. 6 June 2010.

Snider, Eric D. "Hey *Dark Knight*, Test Audiences Are Dumb, Don't Listen to Them." *Film.com* 15 Apr. 2008. Web. 6 June 2010.

Snider, Mike. "Demystifying Blu-ray." *USA Today* 5 Dec. 2008: D1, D4. Print.

"Social Media and Young Adults: Summary of Findings." *Pew Internet* 3 Feb. 2010. Web. 18 May 2010.

Sontag, Susan. "The Decay of Cinema." *New York Times Magazine* 25 Feb. 1996: 60–61. Print.

BIBLIOGRAPHY

Stacey, Jackie. "The Lost Audience: Methodology, Cinema History and Feminist Film Criticism." *Feminist Culture Theory: Process and Production*. Ed. Beverly Skeggs. Manchester: Manchester UP, 1995. 97–118. Print.

Stein, Elliott. "Focus, Please!" *Village Voice* 21 Nov. 1995, Film sec.: 5. Print.

Stelter, Brian. "Hulu Offers a $9.99 Subscription to Full Seasons of Current TV Shows." *New York Times* 30 June 2010: B4. Print.

———. "Rise of Web Video, beyond 2-Minute Clips." *New York Times* 6 July 2009: B1, B8. Print.

———. "Water-Cooler Effect: Internet Can Be TV's Friend." *New York Times* 23 Feb. 2010. Web. 30 Apr. 2010.

Stelter, Brian, and Brad Stone. "Digital Pirates Winning Battle with Major Hollywood Studios." *New York Times* 9 Feb. 2009: A1, A19. Print.

Sterngold, James. "A Preview of Coming Attractions: Digital Projectors Could Bring Drastic Changes to Movie Industry." *New York Times* 22 Feb. 1999: C1–C2. Print.

St. George, Donna. "Unhappy People Watch More TV." *Lincoln Journal Star* 24 Nov. 2008: A5. Print.

Stone, Brad. "Calling on Sony and Others, Google Makes a TV Move." *New York Times* 21 May 2010: B1, B4. Print.

Stout, Hilary. "Antisocial Networking?" *New York Times* 2 May 2010, Style sec.: 1, 10. Print.

Strawn, Linda May. "Interview with William Castle, December 6, 1973." *Kings of the Bs: Working within the Hollywood System*. Ed. Todd McCarthy and Charles Flynn. New York: Dutton, 1975. 287–298. Print.

Streisand, Betsy. "Chris Walker: A Man and His Suit Reanimate Animation." *U.S. News and World Report* 28 Dec. 1998–4 Jan. 1999: 56–57. Print.

Stross, Randall. "When History Is Compiled 140 Characters at a Time," *New York Times* 2 May 2010, Business sec.: 5. Print.

"Study Shows 3D Can Cause Headaches, Eye Strain." *6abc.com* 17 Feb. 2010. Web. 31 May 2010.

Suárez, Juan, and Millicent Manglis. "Cinema, Gender, and the Topography of Enigmas: A Conversation with Laura Mulvey." *Cinefocus* 3 (1995): 2–8. Print.

Sutter, John D. "The Top 10 Tech Trends of 2009." *CNN Tech* 22 Dec. 2009. Web. 30 Apr. 2010.

Sydell, Laura. "Indie Video Game Developers Have Room to Play." NPR 30 Apr. 2009. Web. 30 Apr. 2010.

Tanklefsky, David. "Epix Survey: Multiplatform Viewing Reflects Mass Market Behavior." *Broadcasting and Cable* 10 May 2010. Web. 6 June 2010.

Taubin, Amy. "Unseated." *Village Voice* 21 Nov. 1995, Film sec.: 8–9. Print.

Tedeschi, Bob. "P.&G., the Pioneer of Mixing Soap and Dramas, Adds a Web Installment." *New York Times* 15 Oct. 2007: C1, C7. Print.

Terryfic. "Yahoo! and YouTube Host Web Series Awards." *Anchorcove.net* 14 Mar. 2008. Web. 8 Apr. 2009.

Tessler, Joelle. "FCC Allows Blocking of Set-Top Box Outfits." *Associated Press* 7 May 2010. Web. 7 May 2010.

Thompson, Carolyn. "Kodachrome Fades Out." *Lincoln Journal Star* 23 June 2009: A4. Print.

Thornton, Patrick. "Women Use Social Media More Than Men." *Beat Blogging* 3 Oct. 2009. Web. 8 Nov. 2010.

TMZ.com. Web. 31 Dec. 2007.

Toffler, Alvin. *Future Shock*. New York: Random House, 1970. Print.

Top10virals.com. Web. 9 Sept. 2007.

Triches, Robert. "Tråkigt med myiinspelning." *Aftonbladet* 9 Mar. 2009. Web. 2 May 2010.

Truffaut, François, with Helen G. Scott. *Hitchcock*. Rev. ed. New York: Simon and Schuster, 1983. Print.

Twene, Jean. *Generation Me*. New York: Free Press, 2006. Print.

Twene, Jean, and W. Keith Campbell. *The Narcissism Epidemic*. New York: Free Press, 2009. Print.

Ullrich, Chris. "SXSW Interview: Director Gareth Edwards Talks *Monsters*." *Flick Cast* 18 Mar. 2010. Web. 30 Nov. 2010

Umstead, Thomas. "Challenge of a Lifetime." *Multichannel News* 26 Apr. 2010. Web. 2 May 2010.

Usai, Paolo Cherchi. *The Death of Cinema: History, Cultural Memory and the Digital Dark Age*. London: BFI, 2001. Print.

Vaknin, Sharon. "Teens Abuse, Find Comfort in Anonymity on Formspring.me." CNET 1 Apr. 2010. Web. 13 May 2010.

Van Buskirk, Eliot. "YouTube: Over One Billion Videos Served Per Day." *Wired.com* 9 Oct. 2009. Web. 24 May 2010.

Van Veenendahl, Paul. "Movie Theaters Get Interactive." *Viral Blog* 19 Apr. 2009. Web. 30 Apr. 2010.

———. "*Saw IV* Viral Game: Torture Victoria Beckham." *Viral Blog* 13 Oct. 2007. Web. 30 Apr. 2010.

Vaz, Mark Cotta, and Patricia Rose Duignan. *Industrial Light & Magic: Into the Digital Realm*. New York: Del Rey, 1996. Print.

Vinterberg, Thomas. "Dogma 95: The Vow of Chastity." *LA Weekly* 23–29 Oct. 1998: 51. Print.

Viral Videos.com. Web. 8 Apr. 2009.

Voltaire [François-Marie Arouet.] "Madness is. . . ." Quoted on *Thinkexist.com*. Web. 18 Nov. 2010.

Wankoff, Jordan. "Michael Schultz." *Answers*.com. Web. 2 May 2010.

Waxman, Sharon. "Laid-Off Movie Critics, the New 'In' Focus Group." *Wrap* 8 Dec. 2009. Web. 6 June 2010.

———. "McCarthy Fired after 31 Years at *Variety*: 'It's the End of Something.'" *Wrap* 8 Mar. 2010. Web. 1 May 2010.

"Web 2.0 Suicide Machine—Meet Your Real Neighbors Again!" *Suicide Machine*. Web. 30 Apr. 2010.

Weeks, Janet. "Hollywood Is Seeing Teen: Younger Set Favors Movies above All." *USA Today* 22 Dec. 1997: D1, D2. Print.

Weinraub, Bernard. "Two Mediums Make Like One." *New York Times* 19 July 1998, sec. 2: 1, 20. Print.

Weiss, Aaron. "Film Criticism Is Not Dead, Primitive Media Outlets Are Dying." *Cinema Funk* 3 Apr. 2010. Web. 17 May 2010.

Welkos, Robert W. "Market Research Expert Kevin Goetz Launches Screen Engine LLC." *HollywoodNews.com* 25 Feb. 2010. Web. 6 June 2010.

White, Armond. "Do Movie Critics Matter?" *First Things* 19 Mar. 2010. Web. 1 May 2010.

BIBLIOGRAPHY

"Why Women Are the Target Market, Not Just the Niche Market." *New Media Strategies* 28 Jan. 2009. Web. 2 May 2010.

Wice, Nathaniel. "Once upon a Time in Chinatown." *Village Voice* 21 Nov. 1995, Film sec.: 14, 17. Print.

Wiegman, Robyn. *American Anatomies: Theorizing Race and Gender.* Durham: Duke UP, 1995. Print.

Willis, Holly. "A Bug in the System: Part Two, Electronic Hollywood." *RES* 2.4 (Fall 1999): 14–16.

Willmore, Alison. "*Serbian Film*: Giving New Meaning to the Term Torture Porn." IFC. *com* 15 Mar. 2010. Web. 18 May 2010.

Wilson, Michael. "In Brooklyn, Home Theater under the Stars and with a View." *New York Times* 6 Sept. 2009: 26. Print.

Winslow, Ron. "Watching TV Linked to Higher Risk of Death." *Wall Street Journal* 12 Jan. 2010. Web. 30 Apr. 2010.

Wloszczyna, Susan, and Anthony De Barros. "Movie Critics, Fans Follow Surprisingly Similar Script." *USA Today* 25 Feb. 2004. Web. 1 May 2010.

Wolf, Cary. "The Data-Driven Life." *New York Times Magazine* 2 May 2010: 38–45. Print.

Wood, Edward D., Jr. *Hollywood Rat Race.* New York: Four Walls Eight Windows, 1998. Print.

"Worldwide Grosses: All Time Box Office." *Box Office Mojo* 1 May 2010. Web. 1 May 2010.

Yates, James P. "Movie Theaters Reinvent Themselves to Compete with TV." *silive.com* 20 Sept. 2009. Web. 1 May 2010.

Yoskowitz, Andre. "Warner to Release all Blu-rays as BD/DVD Combos." *Afterdawn.com* 20 Dec. 2009. Web. 30 Apr. 2010.

"YouTube." *Wikipedia.* Web. 9 Sept. 2007.

"YouTube Serves Up 100 Million Videos a Day Online." *USA Today Online* 16 July 2006. Web. 31 Dec. 2007.

"YouTube's *Life in a Day* Project Nets 80K Entries." *Associated Press* 5 Aug. 2010. Web. 23 Aug. 2010.

"YouTube Video Leads to Hollywood Contract." *BBC News* 17 Dec. 2009. Web. 30 Apr. 2010.

INDEX

INDEX

audience share, 6
auteurs. *See* directors; filmmakers
Avatar, 40
awards, 135, 141, 163–164

Babluani, Géla, 63
Barnes, Brooks, 40, 45
Barrot, Pierre, 91, 93
Bay, Michael, 38, 41
Bay, Willow, 153
Bayer, Samuel, 12
Becky Sharp, 12
behavioral tracking, 168
Belka i Strelka. Zvezdnye sobaki (Space Dogs 3D), 96
Bergman, Ingmar, 26
Bernard, Jami, 106
Beuker, Igor, 178
Bieber, Justin, 24
Big Champagne [download site], 144, 176
Bigelow, Kathryn, 140, 141–143
Biggs, John, 78
Bilal, Wafaa, 116–117
The Birds remake, 61
bit-torrent downloads, 143
black-and-white films, 63
black: audiences, 59–60; filmmakers, 55–56, 58–60
Bloch, Ethan, 180
Blockbuster [video distributor], 13
blockbusters, 66, 147, 148; Chinese, 89; necessity for, 163
bloggers, 50, 103, 105, 173; influence of, 103, 176
Blomkamp, Neill, 74
Bloom, Julie, 169
Blum, Jason, 42
Blu-ray format, 83
Boal, Mark, 143
book as multimedia experience, 182
bookstores, 5
The Bounty Hunter, 97
box office: independent films, 137–138; international, 95; in North America, 86
Boyle, Susan, 24
Brazil, 97
Brew, Simon, 61
Britt, Glenn, 6

Broderick, Peter, 124–125
Brokeback Mountain, 131
Bryner, Jeanna, 113
Bryner, Michelle, 18
budgets, 45–47
The Builder, 185
Buñuel, Luis, "Pessimism" [essay], 156
Burnham, John, 52
Burton, Tim, 76, 139

The Cabin in the Woods, 82
cable television, 122; interactive, 22; on-demand services, 98
Cadillac Records, 56
Caine, Michael, 34
cameras, 84, 116, 117–118, 178. *See also* video: cameras
Cameron, James, 53, 146–147
Campanella, Juan José, 95
Carell, Steve, 41
Carlton Screen Advertising, 172
Carpenter, John, 105
Carr, David, 50
Castle, William, 108
Castro-Wright, Eduardo, 182
CBS, 176
celebrities, 26, 158–159, 180–181; on the web, 24
Cell Phone (Shou ji), 89
cell phones. *See* mobile phones
Center for Study of Women in TV and Film, 53
Chan, Vincent, 184
chatting, influence of, 175, 176
Cherwin, Peter, 162
Chico Xavier, 97
Chinese cinema, 88–90
Chloe, 97
Chronicle of Higher Education, 100
Cieply, Michael, 32, 40
Cinegames, Madrid, 16–17
cinema: alternatives to, 14; and change, 12; and community, 189; history, 16; and video, 35. *See also* films; movie theaters
Cinema Funk [website], 104
Clark, Mike, 106
Clash of the Titans (2010), 81

INDEX

Edwards, Gareth, 110–112

Eiga Doraemon: Nobita no ningyo daikaisen, 97

Eisenberg, Anne, 116, 170

Ejiro, Chico, 93

Elevator [web series], 21

Elley, Derek, 100

empathy, 113–114

entertainment as goal, 60

Epic Movie, 22

Epix Multiplatform [entertainment service], 155

escapism, 41, 105

E.T.: The Extraterrestrial, 105, 153

exhibitors. *See* movie theaters

experimental films, 149

Facebook, 179–181; and revolution in Egypt (2011), 179

Factory 25 [record label], 185

fantasy, 96

Farmville [online game], 178–179

Fatal Attraction, 153

Favreau, Jon, 82, 133, 135

Federal Communications Commission (FCC), 122

La Fée aux Choux (*The Cabbage Patch Fairy*), 63

Fei Cheng Wu Rao (*If You Are the One*), 89

fetish films, 10

Fiat, advertisements, 172

film: changing definition, 22; critics, 99–107; and digital media, 120; distribution, 20, 119, 124–125, 135, 166, 175–177, 185; editing, 48–49; history, endangered, 187; industry news, 50, 107; marketing, 124–125; production, 16, 32–35, 94, 128, 139; schools, 162–163; showcases, 185; studios, 126, 150–151

filmic medium, 8–13, 120, 140; qualities of, 10–12

filmmakers, 124–166; experimental, 148–149; mainstream, 146, 150; visual style, 138. *See also* black: filmmakers

filmmaking: avant-garde, 148–149; exploitative, 165; group participatory, 183; holographic, 18; as self-representation, 92. *See also* video: filmmaking

films: access, 26–27, 155; advertising, 106–112; audience "participation," 183; budgets, 121, 126, 185; on cable, 122; commercial, 108–110; costs, 63, 94, 108, 126–127, 140; digital production and distribution, 119; future of, 120; historic, 20, 27; instant-release programs, 122; low-budget, 185; marketing, 99, 135; marketplace, 87–99, 105, 107, 124, 137; persistence, 162; platforms, 18, 155; preservation, 8, 20; pre-sold, 128; production facilities, 126–127; projection, 22; quantity, 107; shot structure, 48–49; theatrical presentation, 14–16, 47, 85–86, 122; user reviews, 104. *See also* action films; blockbusters; comedy; cruelty films; documentaries; fetish films; Nollywood films; public-domain films

Film Socialisme, 165

final cut, 154

Final Destination films, 152

Fincher, David, 33, 137, 139

Finke, Nikki, 50–51

First Amendment rights, 25

Fithian, John, 2, 16, 86

focus groups, 151–155

Following, 124

The Forbidden Quest, 10

Ford, John, 152

foreign films in the U.S., 66, 98

Foster, Greg, 82

Fox, Megan, 158–159

Fox. *See* 20th Century Fox

Fox Searchlight, 56

franchise films, 44–45, 76

Francis, Freddie, 152

Frankel, Daniel, 106

Friend, Tad, 107–109

Fritz, Ben, 128

front-office directors, 132

Frozen River, 135

Full Sail University, film and video production programs, 163

games, interactive, 173. *See also* social gaming

gaming culture, 72–73

INDEX

INDEX

ABOUT THE AUTHORS

Wheeler Winston Dixon is the James Ryan Endowed Professor of Film Studies and a professor of English at the University of Nebraska, Lincoln, and, with Gwendolyn Audrey Foster, editor-in-chief of the *Quarterly Review of Film and Video*. His most recent books are *A History of Horror* (Rutgers UP, 2010); *Film Noir and the Cinema of Paranoia* (Rutgers UP, 2009); *A Short History of Film*, co-written with Gwendolyn Audrey Foster (Rutgers UP, 2008); and *Film Talk: Directors at Work* (Rutgers UP, 2007).

Gwendolyn Audrey Foster is a professor in the film studies program at the University of Nebraska, Lincoln, and the author of numerous books, including *Class Passing: Social Mobility in Film and Popular Culture* (Southern Illinois UP, 2005), *Identity and Memory: The Films of Chantal Akerman* (Southern Illinois UP, 2003), and *Performing Whiteness: Postmodern Reconstructions in the Cinema* (State U of New York P, 2003), which was cited by the journal *Choice* as "Essential . . . one of the outstanding books of the year" in 2004.